# MIDDLE-EARTH
# Envisioned

# MIDDLE-EARTH
## Envisioned

## Paul Simpson
## and Brian J. Robb

Race Point
PUBLISHING

*For Sophie Simpson*

*and*

*Cameron Robb*

*—the next generation.*

Race Point
PUBLISHING
A division of Book Sales, Inc.
276 Fifth Avenue, Suite 206
New York, NY 10001

Authors: Paul Simpson and Brian J. Robb
Editorial Director: Jeannine Dillon
Copyeditor: Jackie Bondanza
Picture Research: Lesley Hodgson
Cover Designer: Rosamund Saunders
Interior Designer: Heidi North

Front Cover Illustration © Wes Talbott

ISBN: 978-1-937994-27-3

Printed in China

2 4 6 8 10 9 7 5 3 1

www.racepointpub.com

# CONTENTS

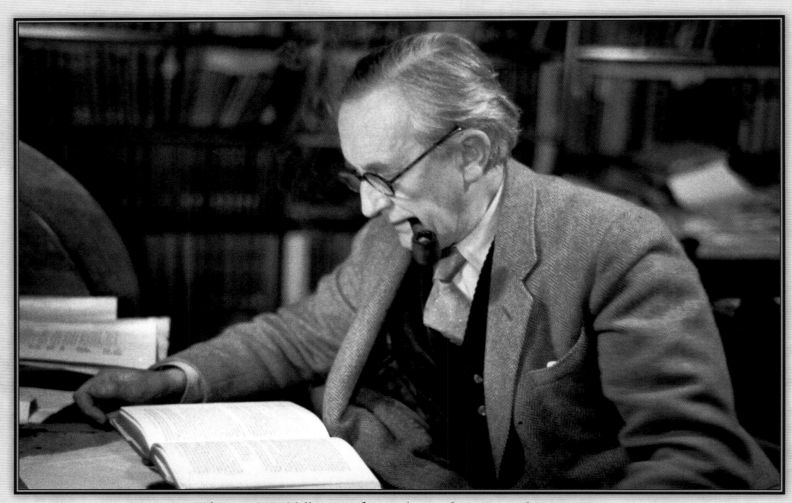

*Above: J.R.R. Tolkien reading in his study on December 2, 1955.*

# INTRODUCTION

For nearly sixty years, Professor J.R.R. Tolkien wrote about a land he called Middle-earth, where Elves, Hobbits, and Dwarves lived, fearsome dragons roamed, and there was One Ring to rule them all. During his lifetime, he published two key books set within that world: *The Hobbit*, in 1937, and *The Lord of the Rings*, in three volumes, in 1954–1955. They were widely popular even before New Zealand director Peter Jackson's film adaptations were on the drawing board. Millions of readers have become entranced by the adventures of Bilbo and Frodo, and each individual has conjured up a specific vision of how Middle-earth looks and sounds.

Some have taken that a step further, painting or drawing the visions they see, or adapting Tolkien's works for radio, television, or the big screen. It is the creations of these people that *Middle-earth Envisioned* celebrates.

As audiences encounter the epic scale that Peter Jackson brings to his interpretation of *The Hobbit*, we explore the diversity of the adaptations that came before—from the simple reading of Bilbo's first adventures for an audience of children on the BBC's *Jackanory* to the multidiscipline spectacle of the Toronto and London stage production of *The Lord of the Rings*. Very "English" books have spawned a truly international phenomenon: ballets from Finland, television adaptations from Russia, and music from South America, Asia, and Africa.

Appropriately, then, our story doesn't start in England, but in South Africa at the end of the 19th century . . .

*Above: Portrait of J.R.R. Tolkien taken during the 1940s.*

Although the name "J.R.R. Tolkien" is printed on the front of every copy of *The Hobbit* and *The Lord of the Rings* that has been sold over the past eight decades, the author himself would be the first to admit that he was not the sole person responsible for the creation of Middle-earth. Its origins lie in myths and legends that have been told over countless centuries, as well as in the life of Tolkien himself.

John Ronald Reuel Tolkien was born on January 3, 1892, in Bloemfontein, part of the Orange Free State in South Africa, where his father was manager of the local branch of the Bank of Africa. He was taken to England in April 1895 for what should have been a summer break, but which became a permanent move after the unexpected death of his father in February 1896.

For four years, Tolkien's mother Mabel brought up Ronald (as he was known in the family) and his younger brother Hilary in Sarehole, a village just outside Birmingham, which was at that point still countryside. The boys played in the local woods, picked blackberries in the Dell, had encounters with the local miller and his son, and visited his aunt at Bag End—all elements that would contribute to the creation of Middle-earth. He enjoyed reading

traditional children's books, as well as Andrew Lang's *Red Fairy Book* collection, and the fairy stories of George MacDonald.

When Ronald was accepted for King Edward's School in Birmingham, the family moved to the city; around this time, his mother converted to Catholicism, causing a split with her parents and in-laws. She died in 1904 from acute diabetes, after one final summer spent in the countryside in a house owned by the Birmingham Oratory, where they worshipped. The boys were left in the care of their parish priest, Father Francis Xavier Morgan, although they lived with their Aunt Beatrice in Edgbaston for a few years before moving to the house of the Faulkners, parishioners at the Oratory in 1908.

*Above: A first edition of Andrew Lang's* The Red Fairy Book, *published in 1890, a collection enjoyed by J.R.R. Tolkien.*

Their fellow lodger was Edith Bratt, with whom Ronald fell in love. This distracted him from his studies, and he was forbidden from contacting her until he reached the age of twenty-one. On the evening of that birthday, he wrote to Edith asking her to marry him. Although she was already engaged, believing Ronald had forgotten her, she broke off that relationship and agreed to marry him, even converting to Catholicism. By this stage, Ronald was studying at Exeter College, Oxford. He initially took Classics, but after comparatively poor exam results, he was encouraged to switch to English Language and Literature. He gained First Class honors in June 1915.

*Above: The Sarehole Mill in Sarehole, a village outside of Birmingham, England, where the Tolkien boys (Ronald and Hilary) frequently played in their younger years.*

Ronald delayed joining the British Expeditionary Force after the outbreak of the Great War in August 1914, although he did enlist in the Officer's Training Corps at Oxford to fulfill his draft requirement. Once his degree was complete, he started his

basic training, and then took special instruction as a signaler. He married Edith on March 22, 1916, and three months later was posted to the Front, arriving in time to become part of the carnage of the Battle of the Somme. One of Ronald's closest friends, Rob Gilson, was among the 19,000 men killed on the first day of the battle, and when Tolkien learned of his death and of other school friends, it left a lasting impression of the horrors and costs of war, which can be seen in his depictions of warfare and the Dead Marshes in *The Lord of the Rings*.

First Lieutenant Tolkien fell ill with trench fever and was invalided back to Birmingham in November 1916. He spent the next two years recuperating, during which time Edith fell pregnant; their son John Francis Reuel was born in November 1917. Ronald was moved around the country to various training camps, with his family finding accommodation nearby on most occasions. On November 12, 1918, the day after the German Army surrendered, Tolkien asked to be allowed to move back to Oxford.

Ronald had a love of language and poetry—one of his earliest favorites was the Nordic saga of Beowulf, on which he became an acknowledged expert with his 1936 lecture "Beowulf: The Monsters and the Critics"—and as early as 1914 was writing "The Voyage of Earendel the Evening Star" in which there are mentions of Westerland, the home of the immortals in *The Silmarillion*. Other parts of *The Silmarillion* followed during his battle back to health and over the years to come, but Tolkien would never accept that this first major work was ever complete.

After working on the letter "w" for *The New English Dictionary* in Oxford, Ronald accepted a post as Reader in English Language at the University of Leeds, although he initially disliked it and tried to find alternate work quickly. He was offered the De Beers Professorship at the University of Cape Town, but turned it down, deciding to make the best of Leeds, particularly following the birth of his second son, Michael. During his five years there he worked with junior scholar Eric Gordon on a new edition of the Middle English poem "Sir Gawain and the Green Knight," and the pair created a Viking Club whose purpose was both serious and social. The Tolkiens' third son, Christopher—who would

become a fierce guardian of his father's literary estate—was born in November 1924, a month after Ronald was appointed Professor of English. (Their final child, Priscilla, followed in 1929.)

Ronald would not hold the post for long. In early 1925, the Chair of Anglo-Saxon at Oxford, known as the Rawlinson and Bosworth Professorship of Anglo-Saxon, became vacant,

**Above: C.S. Lewis with his pipe in the early 1960s. Tolkien and Lewis were part of the Oxford literary Society, The Inklings, and they frequently critiqued each other's work.**

and, rather to his surprise, Ronald was selected for the post. He settled into life at Oxford very easily, working hard as a lecturer and administrator, writing stories for his children (illustrating them himself with drawings and watercolor paintings), and enjoying the social life of the university, notably with a group of like-minded friends including the creator of Narnia, C.S. "Jack" Lewis, and others who initially formed an Icelandic reading-group called the *Kolbiter* ("coal-biters"), and then took over the name of another Oxford literary society, The Inklings. Tolkien, Lewis, and other male writers including Charles Williams and

Nevill Coghill, would meet regularly and critique each other's works. *The Hobbit* and the three books of *The Lord of the Rings* were all exposed to this intellectual rigor, but Tolkien took exception to Lewis's Narnia stories and was forthright in his criticisms. Additionally, although he was instrumental in Lewis's conversion to Christianity, he did not approve of the zeal with which Lewis tried to evangelize in print.

*The Hobbit* was already underway by 1931, but it was only completed in the summer of 1936 after Tolkien lent the manuscript to a former student who was friends with an editor at publishers Allen & Unwin. After Tolkien made various revisions at the proof stage, *The Hobbit* was published in September 1937 and quickly sold out. An American edition followed, with color illustrations by Tolkien himself. Although his publishers on both sides of the Atlantic wanted a quick sequel, it would be a decade and a half before it would be printed.

The opening of *The Lord of the Rings* was indeed written very soon after *The Hobbit*, but the rest of the book took much longer. By the spring of 1938 Tolkien had decided on the central conceit of a quest linking the hobbits, the Dark Lord Sauron (briefly alluded to in *The Hobbit*), and the ring Bilbo had found. However, as he worked on the story, Tolkien realized the new book—*The Lord of the Rings*—would be on a much grander scale than its predecessor, and would look to his various earlier writings for its foundations. The writing continued during World War II, when there were many calls on Tolkien's time, including the hospitalization of his son Michael. The story would be continued in bursts of energy, divided by months of inactivity. When the war ended in summer 1945, Tolkien was appointed Merton Professor of Language and Literature, and over the next two years, he reached a point when he was ready to show parts of it to others outside the Inklings. Encouraged by the feedback he received from Stanley Unwin's son Rayner, who had been instrumental in persuading his father to buy the rights to *The Hobbit*, Tolkien continued to rewrite sections for two more years. In fall 1949, he presented Jack Lewis with the completed manuscript. Lewis loved it.

It still took five more years for *The Lord of the Rings* to see print.

Tolkien wanted it to be published simultaneously with *The Silmarillion*, but Unwin seemed uninterested in the latter. Tolkien was also unhappy with the way his publishers had presented his tale, *Farmer Giles of Ham*—which was not set in Middle-earth—and there followed a period when he broke off relations with George Allen and Unwin and tried to persuade William Collins publishers to print the books. This, too, never came to happen, and

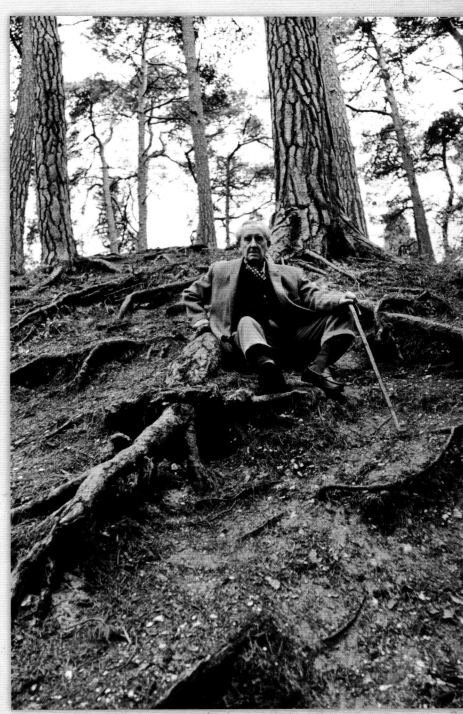

**Above: J.R.R. Tolkien sitting in the woodlands near his Bournemouth home in 1971.**

Tolkien had to accept, albeit reluctantly, Unwin's stipulation that *The Lord of the Rings* be divided for publication, and *The Silmarillion* left out of the equation. Tolkien prepared the manuscript and added appendices, taken as necessary from *The Silmarillion*.

*The Fellowship of the Ring*, the first volume, appeared in August 1954 in the UK; *The Two Towers* followed three months later; *The Return of the King* was published in October 1955. Stanley Unwin

two decades of his life. When the hardback book became a hit with American college students in the mid-1960s, Ace Books produced a pirated paperback edition. An authorized edition with amendments—and a royalty to the author—followed swiftly from Ballantine Books, and sold 1,000,000 copies within six months thanks in part to the publicity garnered by popular complaints over the piracy.

Tolkien retired from Oxford University in 1959. However by 1968, the publicity Ronald attracted for *The Lord of the Rings* meant he and Edith had to move somewhere more private—Poole, near Bournemouth on the English South Coast—where he could continue work on *The Silmarillion*. They stayed there until Edith's death in 1971, after which Ronald moved back to Oxford. He was awarded the Commander of the British Empire (CBE) medal, and created an Honorary Doctor of Letters by Oxford University.

J.R.R. Tolkien died on Sunday September 2, 1973, at age 81. In its obituary, the *New York Times* quoted his appreciation of a good story: "However wild its events, however fantastic or terrible the adventures, it can give to child or man that hears it, when the 'turn' comes, a catch of the breath, a beat and lifting of the heart, near to (or indeed accompanied by) tears, as keen as that given by any form of literary art, and having a peculiar quality."

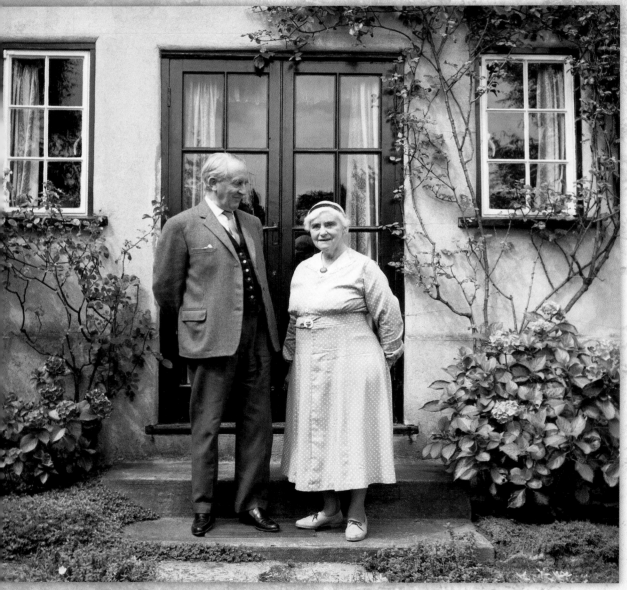

*Above: J.R.R. Tolkien in the garden with his wife, Edith, in Oxford, 1961. Edith Tolkien passed away in 1971, and J.R.R. Tolkien passed away two short years later on September 2, 1973.*

had not been convinced of the book's saleability, and agreed to a profit-sharing deal with Tolkien. This was enough to boost the author's bank account balance considerably over the remaining

*The Silmarillion*, edited by Tolkien's son Christopher, finally saw print in 1977, at last added to the works that, as his publisher Sir Stanley Unwin once commented, will last for many years to come.

## The Story of The Hobbit

Hobbit Bilbo Baggins leaves his home in the Shire to join a group of Dwarves, who want to reclaim the Lonely Mountain and its treasure from the dragon Smaug. Bilbo will be their "burglar" to enter a secret door into the Mountain, as shown on a map provided by Gandalf. While fleeing some Goblins, Bilbo is separated from the others, and finds a mysterious Ring, guarded by Gollum. Wearing the Ring makes him invisible, allowing him to escape and rejoin the Dwarves. After evading pursuing Goblins and Wargs, and encountering Giant Spiders and Wood Elves, the party reaches Lake-town. From there they travel to the Mountain where they find the door. Bilbo steals a great cup from Smaug, and discovers a weakness in his armor. Smaug heads to Lake-town to destroy it, but its defender, Bard, learns of the dragon's vulnerability and kills it.

Bilbo finds the Arkenstone, an heirloom belonging to the Dwarves' leader Thorin, which he hides, eventually trying to ransom it to prevent a war between the Dwarves and various others who have a claim on the treasure. When an army of Goblins and Wargs approach, the Dwarves, Men, and Elves team up, and eventually win the Battle of Five Armies. Thorin dies after making peace with Bilbo, and the Hobbit returns home with a small portion of the treasure, enough to make him very wealthy.

*Above: "Three is Company" by Anke Eissman.*

## The Story of The Fellowship of the Ring

On his eleventy-first birthday, Bilbo leaves the Shire, giving his possessions to his nephew Frodo. These include the Ring he took from Gollum, which Gandalf warns Frodo to keep hidden. Seventeen years later, Gandalf tells Frodo that the ring belonged to the Dark Lord Sauron, who has now risen again and seeks it. He tells Frodo to travel to the Elf-haven, Rivendell, where he believes Frodo will be safe. Frodo's friend and gardener, Samwise Gamgee, eavesdrops and agrees to accompany Frodo.

When they eventually leave, Frodo's friends Peregrin Took (Pippin) and Meriadoc Brandybuck (Merry) also come along. Pursued by Ringwraiths searching for the Ring, they eventually reach the village of Bree, where they meet Gandalf's friend, the ranger Aragorn. Frodo is stabbed with a cursed blade, and as they try to get him to Rivendell for treatment, the party is attacked once more by the Ringwraiths, but they are swept away by a giant wave, commanded by Elrond.

Frodo is healed in Rivendell, where he meets Bilbo again. They attend the Council of Elrond, with Gandalf, and others, including Boromir, the son of Denethor, the Steward of Gondor. Many forces are aligning against them: Gollum is looking for the Ring, as are the Ringwraiths. Even the chief wizard Saruman wants the Ring for himself and is gathering a force of Orcs.

The Council decides to destroy the Ring in the fires of Mount Doom in Mordor, and Frodo offers to be the Ring-bearer. A Fellowship of nine set out: Frodo, Sam, Merry, Pippin, Aragorn, Boromir, the Elf Prince Legolas, Gandalf, and Gimli the Dwarf. Forced to travel through the mines of Moria, the party is attacked by Orcs, and Gandalf falls into an abyss battling a Balrog of Morgoth. The other eight reach the Elf-haven of Lothlórien, where the rulers Celeborn and Galadriel give them gifts that may prove useful. After Boromir tries to take the Ring for himself, Frodo decides to break the Fellowship and head for Mordor on his own—although Sam insists on joining him.

## The Story of The Two Towers

Boromir is mortally wounded by Saruman's Uruk-hai (advanced Orcs) who have kidnapped Merry and Pippin. The remnant of the Fellowship follows them, not realizing that the two hobbits were able to escape after the Riders of Rohan attacked the Uruk-hai. In the Fangorn Forest, the pair is able to make allies of the giant treelike Ents, after their leader Treebeard persuades their council that Saruman is a threat to their existence.

Aragon, Gimli, and Legolas meet the Riders, led by Éomer, nephew of King Théoden, then are reunited with Gandalf, who has been resurrected with increased power. The quartet enlists King Théoden's help, and expose Saruman's spy in Rohan, the king's adviser Gríma Wormtongue. Théoden's troops accompany them to Helm's Deep where a huge battle takes place against Saruman's army. The day is won when Gandalf brings along the remains of another army that had been defeated by Saruman. The orcs are killed; Gandalf, Aragorn, Gimli, Legolas, Théoden, and Éomer head for Saruman's base at Isengard, where they find Merry and Pippin. The Ents have taken Isengard, leaving Saruman and Wormtongue trapped in a tower. During the confrontation, Wormtongue throws a seeing-stone out of the tower, which Pippin looks into and sees the Eye of Sauron. Gandalf and Pippin set out for Gondor; the others begin to muster the troops of Rohan.

Meanwhile, Sam and Frodo capture Gollum who promises to show them the way to the Black Gate of Mordor but then stops them from entering, saying they'd be captured. He takes them toward a secret entrance, which is accessed through the Gondorian province of Ithilien. They meet Boromir's brother, Faramir, and learn of Boromir's death. Sam accidentally reveals that Frodo has the Ring, so Frodo tells Faramir he plans to destroy it. Faramir warns Frodo that Gollum is not to be trusted—as proves to be the case when he leads Frodo and Sam into the lair of the giant spider Shelob, hoping to take the Ring from their dead bodies. Frodo is stung and collapses, and Sam believes he is dead. Deciding to complete the quest himself, Sam takes the Ring but follows the Orcs who take Frodo's body—and is amazed to learn that Frodo is alive, but taken by the enemy.

## The Story of The Return of the King

Sauron's armies assault Gondor, besieging Minas Tirith. The Steward, Denethor, is tricked by the Dark Lord into committing suicide, and nearly takes Faramir with him, although he is prevented from doing so. Aragorn, Legolas, Gimli and the Rangers take the Paths of the Dead, and are able to raise an army of undead oath-breakers, who help defeat Sauron's fleet, the Corsairs of Umbar. They take control of the Corsairs' ships and sail to the rescue of Minas Tirith. Sauron's army is routed at the battle of the Pelennor Fields.

After rescuing Frodo, Sam accompanies his friend across Mordor, while Aragorn attempts to keep Sauron distracted from Frodo's mission by leading the armies of Gondor and Rohan toward the Black Gate of Mordor, where they engage Sauron's forces. However, when Frodo and Sam reach the Cracks of Doom the Ring exerts its malevolent influence on Frodo who then claims it for himself. Gollum reappears, biting off Frodo's finger to get the Ring, but as he wildly celebrates he falls into the fires, taking the Ring with him. Once it has been destroyed, Sauron is vanquished, the Ringwraiths die, and Aragorn's army defeats his forces. Aragorn is crowned King of Arnor and Gondor, and marries Elrond's daughter Arwen.

When the Hobbits return to the Shire, they discover that it has been enslaved by Saruman, who escaped from Isengard. Grima Wormtongue turns on Saruman and kills him, before being killed by Hobbit archers. Merry and Pippin are hailed as heroes; Sam marries Rosie Cotton, and uses Galadriel's gift to heal the Shire. Only Frodo is still suffering, after carrying the Ring for so long. Years later, he, Bilbo, and Gandalf set sail west to the Undying Lands so he can find peace.

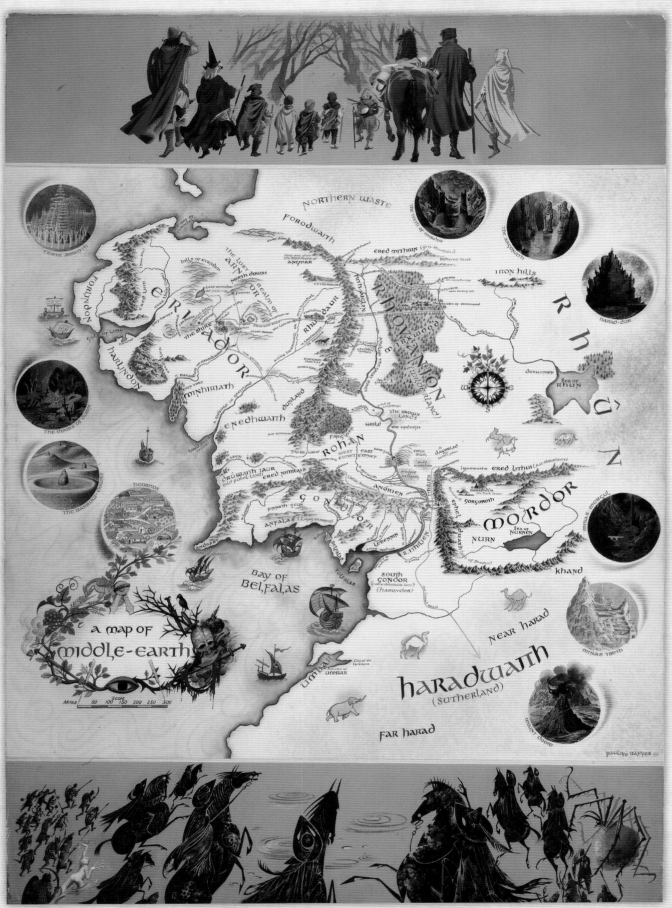

**Above: Map of Middle-earth painted by Pauline Baynes in 1969.**

ARLINDON

R. BARANO

CIRN VORA

MINHIRIATH

DUNLAND

ENEDHWAITH

NIN CURUNIR

The Doors of Dur

R. ISEN

RUWAITH IAUR
ENEDH DUNLAND

ERED NIMRAIS

HOBBITON

The BARROW-DOWNS

PINNATH GELIN

ANFALAS

ANDRAST

Bay of
BELFALAS

a map of

MIDDLE-EARTH

# Part I
# the hobbit

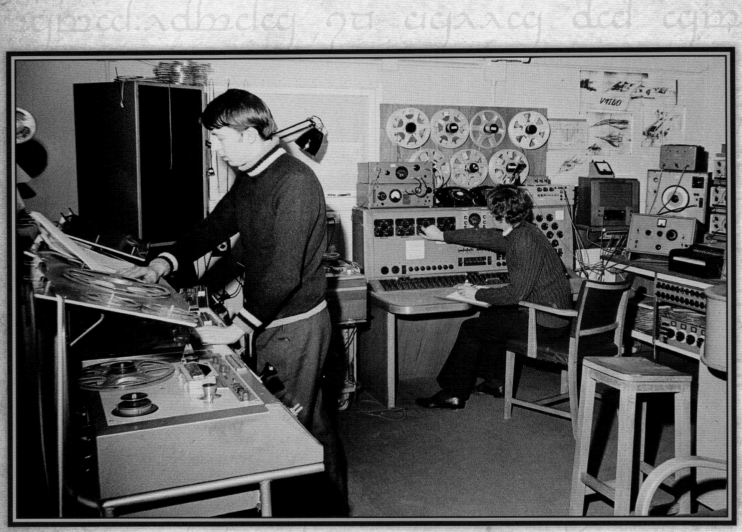

*Above: Composers and sound engineers Malcolm Clarke and Brian Hodgson at work in the BBC Radiophonic Workshop at the BBC's Maida Vale studios in London on March 22, 1969.*

# CHAPTER 1
## Audio Adaptations

While J.R.R. Tolkien's tales of Middle-earth are most widely known thanks to the two trilogies of movies directed by Peter Jackson, the best adaptations can be found in the audio medium, especially in the case of *The Hobbit*.

The earliest radio broadcast appears to be a Canadian version in 1953 that had been licensed through Tolkien's Canadian publishers Thomas Nelson & Sons without reference to either the author or Allen & Unwin. The broadcast only consisted of brief extracts from the book, and no fee had been charged by the publishers.

The first BBC Radio adaptation of *The Hobbit* was a 13-week serial read by David Davis beginning January 4, 1961, as part of the *Children's Hour* program. Later that same year, *The Hobbit* was also dramatized in four installments for the BBC's School's Department program *Adventures in English*. Tolkien was offered the opportunity to approve the scripts used in both projects, and he was used to the way the BBC worked having previously delivered several radio talks on the Third Program. However, an approach by the University of Illinois, Chicago, for another radio version gave Tolkien "the horrors" and he left it to Allen & Unwin to refuse. In January 1967 the Canadian Broadcasting Corporation enquired about the audio

rights to produce readings from the book without success.

The first properly dramatized version of *The Hobbit* was produced by the BBC in 1968 and broadcast in eight 30-minute episodes on Radio 4 between September 29 and November 17. Adapted by actor Michael Kilgarriff and produced by John Powell, it was faithful to Tolkien's 1951 revised version. The one major addition is the role of "The Tale Bearer" (Anthony Jackson), a narrator, who is frequently interrupted by Bilbo Baggins (Paul Daneman).

Kilgarriff had approached the BBC with the idea of adapting *The Hobbit* as a radio serial, although it took a couple of years for his script to come to fruition. As Kilgarriff had never written for radio before, head of the BBC Radio Script Unit Richard Imison asked him to produce a sample episode, and a breakdown of all planned eight installments. The majority of the episodes were scripted in Kilgarriff's Kilburn flat, but as a working actor he was often away on location, so some of the serial was written during breaks when he was on location in Segovia, Spain for a month working on *Camelot* (1967) with Richard Harris and Vanessa Redgrave. When it came time to record *The Hobbit*, Kilgarriff unfortunately missed out on the chance of featuring in it as he was working elsewhere on another project. "I was fortunate to have John Powell as my producer," recalled Kilgarriff, looking

**Above: Script for** The Hobbit **adapted for radio by Michael Kilgarriff (opposite) in 1968.**

back on the production, "for he was not only a fan of the books but had been a pupil of Professor Tolkien at Oxford. The music by David Cain was a great asset, and the cast was a sumptuous gathering of wonderful radio voices, some going back to the pre-television days of the 1930s. The production was fraught with technical difficulties, so John asked for twice the usual amount of studio time. Normally a 30-minute drama would be rehearsed and recorded in one day, but John negotiated two days for each episode. I think the crisp, subtle, and truly magical quality of the entire production shows he was right."

The episodes were largely recorded "as live," so sound effects and other audio enhancements had to be performed live or played in from tape during the performances. The BBC Radiophonic Workshop (a cutting-edge electronic music department largely concerned with *Doctor Who* in the 1960s) provided distortion for voices, as well as specially devised sound effects. Characters whose voices were augmented included Gandalf (Heron Carvic) when imitating the Trolls, the Trolls themselves, and creatures such as the Wargs, Eagles, and Goblins. Wolfe Morris played Gollum, while John Justin voiced Thorin Oakenshield. Francis de Wolfe played Smaug the dragon.

As Jackson would later do, Kilgarriff expanded his sources to take in material from and references to events in *The Lord of the Rings*. The alterations ranged from simple things, like changing *The Hobbit's* "elephants" to "oliphaunts" as used in *The Lord of the Rings*, to expanding the stakes considerably, as when Gandalf declares at the commencement of the battle of five armies that "upon victory depends not just the treasure, nor only our lives, but the whole future and well-being of Middle-earth"—the term "Middle-earth" does not occur in Tolkien's works until *The Lord of the Rings*. Battle cries from the Elves and the Dwarves also referred to conventions used in the trilogy ("Tharnduil" and "Baruk Khazâd! Khazâd aimênu!" respectively). Kilgarriff believed his non-*Hobbit* additions must have been subconscious from having read *The Lord of the Rings*, but he felt he had been faithful enough to Tolkien's original. Despite these small embellishments, the story still had to be abridged to fit the running time of four hours. Tolkien fans criticized the adaptation, mainly for occasional mispronunciations of character names.

As with much of the BBC's output, the original master tapes of the 1968 version of *The Hobbit* were wiped some time in the 1970s. However, the shows were recovered thanks to fans that retained off-air copies. These domestic tape recordings were from FM transmissions and had been recorded as either 60-minute or 90-minute compilations, edited together from the original 30-minute installments. These recordings were re-edited by the BBC back to the 30-minutes episodic format of the original transmission. Various home releases followed, including a 1997 CD version that also included series producer John Powell's recollections of the making of the program, as well as

**Above: Portrait of actor Michael Kilgarriff in 1968. Kilgarriff had approached the BBC with the idea of adapting The Hobbit as a radio serial.**

of the Baskervilles by Sir Arthur Conan Doyle. When adapting the work of American authors, the largely American-accented players did not seem out of place, but when it came to British-created or -set drama, even fantasy worlds such as that of The Hobbit, the American voices sound less suitable. Additionally, the cast worked separately (a process abandoned for their later version of The Lord of the Rings, which they recorded together), leading to a sometimes stilted and isolated feel to some of the exchanges. Later CD releases were somewhat abridged from the original versions in an attempt at condensing the drama.

There have been many recordings of direct readings of Tolkien's work, but the most authentic are those made by the author himself. Where others sometimes mispronounced the names of the peoples and places of Tolkien's imagination, it can be trusted that the author would get such things correct!

In August 1952 Tolkien visited Malvern with George Sayer, a friend of C.S. Lewis and an associate of the Inklings. During his stay, Sayer recorded Tolkien reading and singing from The Hobbit and the then-unpublished typescript of The Lord of the Rings. Listening back to these amateur recordings, Tolkien admitted he was "much surprised to discover their effectiveness as recitations, and (if I may say so) my own effectiveness as a narrator . . . ."

selected tracks of the series' music by David Cain, performed by David Munrow with The Early Music Consort. A 2008 reissue featured an audio interview with Professor Tolkien discussing many aspects of his work, from The Hobbit to The Lord of the Rings, including critical reactions.

American radio theater company The Mind's Eye produced an audio adaptation of The Hobbit in 1979, initially released as a set of six one-hour audio cassettes. Adapted and directed by Bob Lewis, the series featured Gail Chugg as narrator and Gollum; Ray Reinhardt as Bilbo; and Bernard Mayes as Gandalf (roles all three also played in the same company's 1979 audio version of The Lord of the Rings). Adapter Lewis took the role of Thranduil himself. The series was aired in the United States on National Public Radio. Since the early 1970s The Mind's Eye had been adapting much-loved literary works, beginning with Lewis Carroll's Alice in Wonderland in 1972. Other books tackled included works by Edgar Allan Poe, Mark Twain, and Charles Dickens, as well as the Sherlock Holmes story The Hound

**Above: The audio adaptation of The Hobbit from The Mind's Eye released in 1979 as a set of six one-hour cassettes. The adaptation also aired on National Public Radio.**

**Above:** *A reel-to-reel recorder from the late 1950s. Though Tolkien was jokingly suspicious of recorders, he did buy one of his own and recorded his own recitations from both* The Hobbit *and* The Lord of the Rings.

According to Tolkien's first biographer Humphrey Carpenter, the author had never encountered a tape recorder before and jokingly regarded it with great suspicion, going so far as to recite the Lord's Prayer into the microphone in the hope of exorcising any electronic demons lurking there. Despite this Hobbitlike suspicion of technology, Tolkien was so impressed with the recordings that he soon acquired a machine of his own, which he used to make further very effective tapes of his readings.

The first of these tapes to be released commercially by Caedmon Audio (later via Harper Audio) as a single 50-minute cassette was entitled *J.R.R. Tolkien Reads Excerpts from The Hobbit and The Lord of the Rings*. The highlight is undoubtedly Tolkien's reading of much of Chapter 5 of *The Hobbit*, "Riddles in the Dark" (totaling almost 30 minutes).

Notable in the reading are Tolkien's rolling "r"s, especially evident on his pronunciation of "Mordor" when reciting the Ring Verse (from *The Lord of the Rings*). Bizarrely, he also seems capable of rolling his "l"s, giving an odd but not unsuitable cadence to some of his recital. It is clear from his readings from *The Hobbit* that Tolkien had much sympathy for Gollum, and took great care over the way he voiced the character (with an occasional Welsh lilt), something that may have influenced Andy Serkis.

In his *Recollections of J.R.R. Tolkien,* Sayer noted that Tolkien talked ". . . in a curious fluttering way . . . It was striking how

much better his voice sounded when recorded and amplified. He asked to record the great riddle scene from *The Hobbit*. He read it magnificently and was especially pleased with his impersonation of Gollum . . . He went on recording until I ran out of tape."

The rest of the material from the 1952 recording was collected and later released as *The J.R.R. Tolkien Audio Collection,* including his recitations from *The Hobbit* and readings of excerpts from *The Lord of the Rings*, and the poem "The Mirror of Galadriel." As well as bringing great character to Gollum, Tolkien also brought imaginative vocal life to Tom Bombadil in his reading from *The Adventures of Tom Bombadil*.

The tracks were remastered and digitally "cleaned up" for release on CD. This made Tolkien's voice somewhat clearer but removed or reduced some of the ambient noise that came through on the earlier cassettes. Background sounds, like Tolkien's chair creaking, his shuffling of papers on his desk, or even the noises of passing cars, added to the experience of listening to the author reciting his own work (much of it pre-publication) in the autumn days of 1952, sitting in his book-lined study in Holywell, Oxford. It brings the listener closer to that place and time, just as Tolkien's own voice brings the listener closer to the fantasy worlds of Middle-earth.

\*\*\*

An early non-Tolkien reading of *The Hobbit* that's worth noting is the authorized Argo Records LP version, released in 1974 featuring a solo performance by Nicol Williamson. As an acclaimed character actor, Williamson had been hailed by playwrights John Osborne and Samuel Beckett as one of the greatest actors of his generation. Born in 1936, he played in many productions of Shakespeare (including Hamlet), and in various films. Williamson is best known for his idiosyncratic depiction of the wizard Merlin in John Boorman's retelling of Arthurian myth *Excalibur* (1981). Williamson's Merlin may contain a hint of how he may have played Gandalf in Boorman's abandoned movie of *The Lord of the Rings*.

Demi Demetriou—who brought in Williamson as reader—adapted *The Hobbit* to fit across both sides of four vinyl "long-

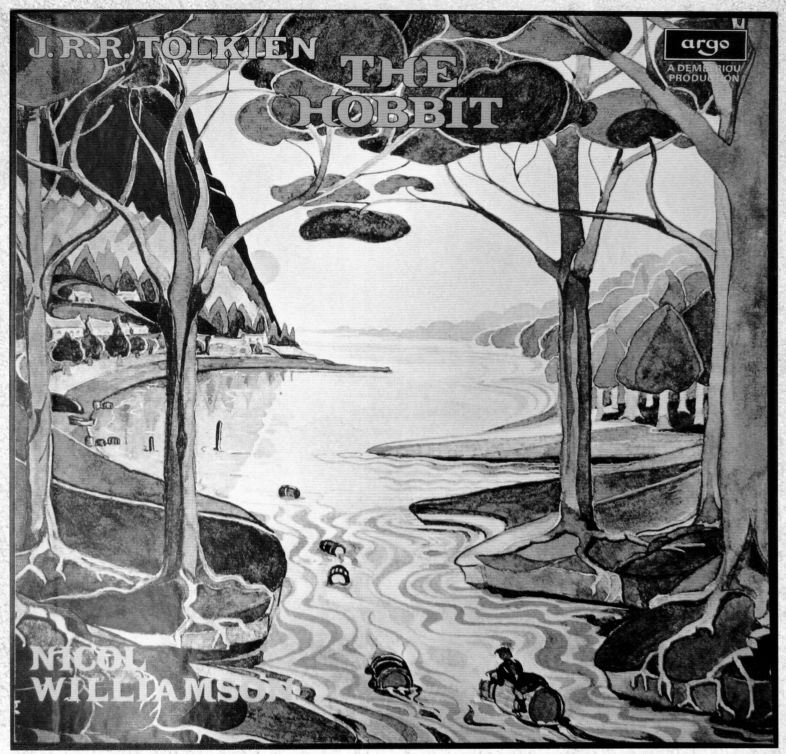

*Above: The authorized Argo Records LP version of **The Hobbit** that was released in 1974 and featured a solo performance by acclaimed actor Nicol Williamson.*

playing" records (lasting around three-and-a-half hours), with audio director Harely Usill guiding Williamson's performance. Usill was the founder and joint-MD of Argo, a label established in 1951 for releasing spoken word material, and later absorbed by Decca in 1957.

The credit for the success of this version of *The Hobbit*, however, belongs solely to Williamson. He was an avowed Tolkien fan and, according to his son, Luke, relished the opportunity "to work on such a challenging solo project." Working with Usill, Williamson abridged the draft script further by deleting all use of storytelling

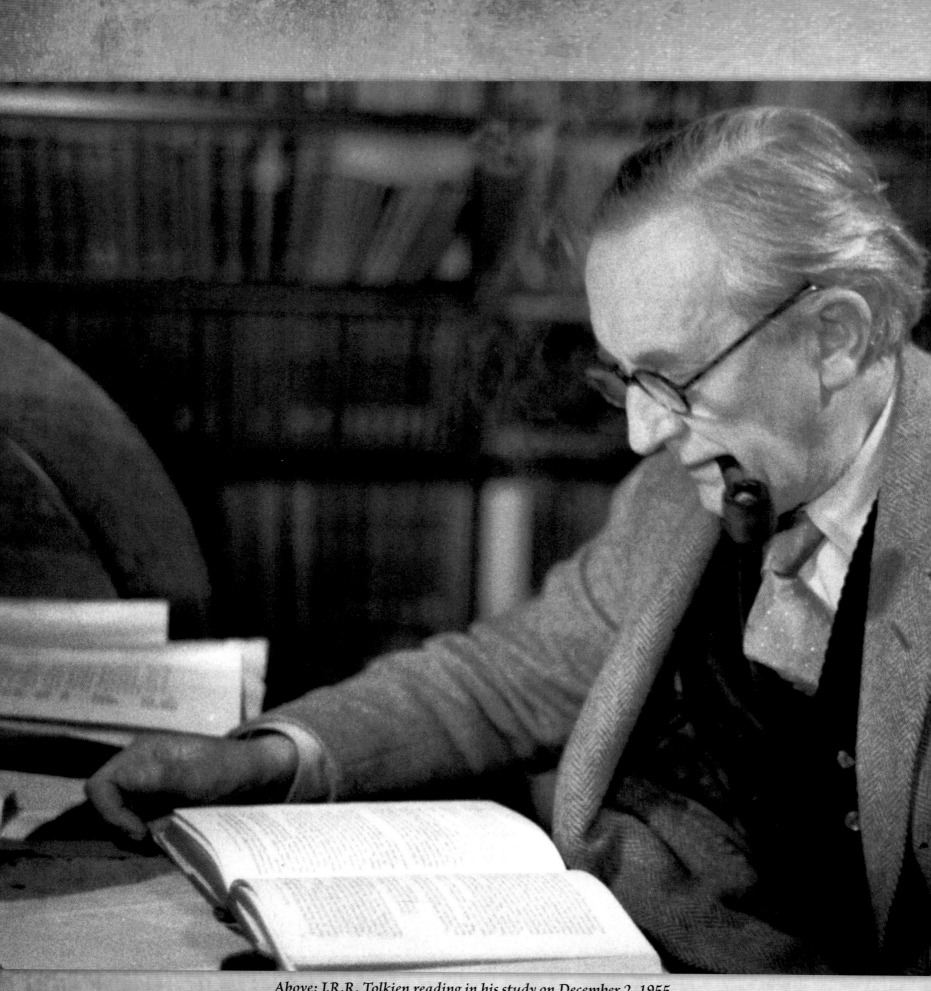

Above: J.R.R. Tolkien reading in his study on December 2, 1955.

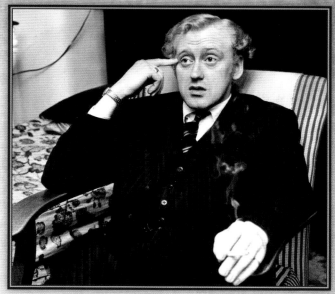

*Above: Actor Nicol Williamson in his dressing room at Wyndham's Theatre after a show on May 6, 1965. Williamson was an avowed Tolkien fan, and he gave a solo performance for Argo's recording of* The Hobbit.

conventions such as "he said." Instead, the actor decided to rely on his own facility for voices to indicate which character was speaking. According to Luke, "Nicol really preferred that to an overall reliance on descriptive narrative, feeling it kept you more in the story."

Although a one-man performance, Williamson brings each individual character to unique life (giving Bilbo a light West Country accent), making it easy for the listener to be sucked in by Tolkien's simple story. Despite featuring only one actor, Nicol Williamson's abridged reading of *The Hobbit* is one of the best audio realizations of Tolkien's younger-skewed story of Middle-earth. A few years before Williamson's death in 2011 at the age of 73, there had been plans for him to create a companion piece solo reading of *The Lord of the Rings*, but unfortunately it never came to pass.

Other narrators—prime among them Rob Inglis (unabridged, 2002—he also tackled *The Lord of the Rings*) and Martin Shaw (abridged, 2007)—have given audio readings of *The Hobbit*, but few have been as characterful as that by Williamson, or those tantalizing extracts read by Professor Tolkien himself.

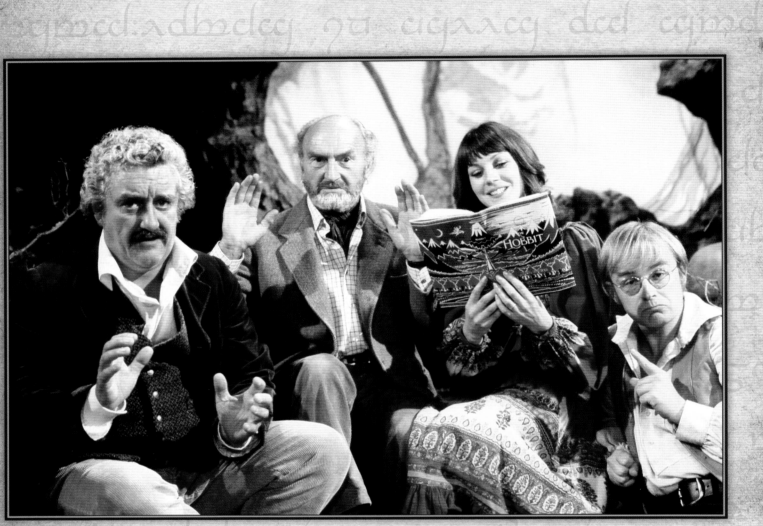

*Above: Still from BBC TV's children's storytelling show* **Jackanory**. *The reading of* **The Hobbit** *utilized four narrators across ten unabridged 14-minute installments in 1979.*

# CHAPTER 2
# Television Adaptations

Perhaps the most faithful version of *The Hobbit* ever to appear on television was the 1979 reading for the 3,000th installment of BBC TV's children's storytelling show *Jackanory* (1965–1995, with occasional revivals). This consisted of an episodic reading of a children's book or story by a single narrator over several weekday afternoons. However, *The Hobbit* employed four narrators to tell Tolkien's tale in ten unabridged 14-minute installments aired between October 1 and 12th, 1979, at 4:25 P.M. The choice of *The Hobbit* followed a poll of *Jackanory* viewers to discover which book they'd like featured, and Tolkien's story beat Roald Dahl's *Charlie and the Chocolate Factory*.

The story was sensitively adapted and directed by Roger Singleton-Turner, with Anna Home and Angela Beeching as producers. The narrators were Bernard Cribbins playing Bilbo, but best known to younger viewers as the voice of children's puppet series *The Wombles*, and a frequent reader on *Jackanory*; Maurice Denham as Gandalf; David Wood as Thorin Oakenshield and Gollum; and Jan Francis (seen holding the book as the main narrator). They all appeared together in each episode and took turns narrating parts of the story directly to camera, as if talking to each individual child viewer, with frequent musical accompaniment composed by Alan Roper.

Unusually for *Jackanory, The Hobbit* reading featured a fairly elaborate set designed like a forest clearing. The closing credits ran over a deep green version of the map found in the novel.

Each episode was introduced by an animated graphic in which various children's literary characters—including Alice from *Alice in Wonderland*, Babar the elephant, and John Grant's cave boy hero Littlenose—pushed or pulled the individual numbers that make up the number "3,000" onto the screen. According to David Wood, the Tolkien estate vetoed any repeat broadcast or subsequent release of the *Jackanory Hobbit* episodes on videotape or DVD, so they have never been seen since original transmission.

An unauthorized television version of *The Hobbit* aired on a Russian TV channel (now Petersburg Channel 5) in Leningrad in 1985. At just over 70 minutes, this version of Tolkien's tale is a lot shorter than Peter Jackson's epic movie trilogy, and it is also less faithful to the source material.

With a title that literally translates to *The Fantastic* (sometimes rendered as *Fabulous* or *Fairytale*) *Journey of the Hobbit, Mr. Bilbo Baggins*, the Russian adaptation was narrated by a mustachioed, cane-waving substitute for Tolkien, played by

Zinovy Gerdt. The character was never identified as "Tolkien," simply a rocking-chair-based "Professor," complete with bowler hat and umbrella (perhaps the Russian idea of an English storyteller?). An acclaimed theater and cinema actor, Gerdt was recognized with the title "People's Artist of the USSR" and was an accomplished puppeteer, having worked for almost 40 years as part of the Obraztsov Central Puppet Theatre in Moscow.

Shot in 1984, this Soviet-era take on *The Hobbit* was produced as an installment of the children's storytelling television series *Tale After Tale* (a variation on *Jackanory*), and was rescreened sporadically on the Leningrad TV Channel until the 1990s. Mikhail Danilov played a wool-hatted and pink-shirted Bilbo, with Anatoly Ravikovich as an orange-clad Thorin Oakenshield, Ivan Krasko as a rather camp Gandalf, and Igor Dmitriev as an angry, fishnet clad Gollum. Ravikovich was better known for comedy movies, such as *The Pokrovsky Gate* (1982), and was a prolific stage actor. Dmitriev was similarly largely a comedic actor, working as part of the Nikolay Akimov Theatre of Comedy. He had an international career, appearing in over 120 movies, as well as performing many radio versions of classic Russian literature.

All the actors playing Hobbits were normal-sized, with only a limited number of attempts made to have them appear smaller through the use of perspective and camera angles. Many scenes saw the actors fuzzily imposed over artwork backgrounds representing the various environments of Middle-earth. Despite these visual liberties, the text used in the Russian dialogue appeared true to Tolkien's original. The story begins with Bilbo in his garden (the wider world of Hobbiton or the Shire is not evoked), where he is visited by the playful wizard Gandalf. Gandalf is then followed by the 13 Dwarves, whose introductions are accompanied with crazy cartoon-style music, as are their antics at Bilbo's dining table. While not as lengthy as Jackson's take on the same introductory material, these opening sequences do fill the first 20 minutes, just under a third of the total running time!

Throughout, Bilbo is depicted as a rather more confident figure than the standard interpretation, while Gandalf seems more of a trickster, willing to play with Bilbo rather than be straightforward about their quest and the dangers involved. Director Vladimir Latshev—who also adapted *The Hobbit*—seems to have called on Gerdt's puppeteering skills for his realization of the fantastic world of Middle-earth. While the majority of the roles were played by live actors, puppets were used to portray the dragon Smaug and the spiders of Mirkwood (rather poorly, looking more like something from 1970s *Doctor Who* than Jackson's twenty-first century special effects–filled film). The Goblins were reimagined as humanlike figures with minimal makeup and performed by dancers from the Leningrad State Academic Opera and Ballet Theatre (who also doubled up as the lantern-wielding inhabitants of Lake-town). The Goblins are introduced in the style of a 1980s music video, complete with video effects and a proto-rock soundtrack! Not included in this version were Bilbo's encounter with the Trolls, the characters of Elrond or Beorn, and the Wood Elves. Rivendell, the Eagles, and the escape from Lake-town in barrels were also omitted. However, the frequent use of the professorial narrator made it easy to skip sections of the story, while keeping the overall drive of the narrative intact.

The story moves through the Goblin caverns, the encounter with Gollum, the spiders of Mirkwood, the visit to Lake-town, and the desolation of Smaug. As with many versions of the story, Bilbo's meeting with Gollum is a highlight—and comes halfway through the television special's running time—even if this bizarre Russian Gollum is rather threadbare, wearing a torn green hood and what appears to be a fisherman's net, with red-and-yellow gardening gloves. Given the limitations of mid-1980s Soviet television, Smaug's attack on Lake-town and the climactic battle of the five armies—simply artwork with actors milling around in front in a distinctly abstract take on the story's major set-piece—are all somewhat reduced in spectacle. This fascinating, colorful curiosity may not be cinematic Tolkien as it is now perceived, but it is far more concise than the epic movies!

Above: Ivan Krasko as Gandalf in the Russian TV adaption of The Hobbit.

Above: The Hobbits trapped in a spider's web. (The spiders of Mirkwood were portrayed with puppets).

Above: Bilbo (played by Mikhail Danilov) discovering the Ring.

Above: Igor Dmitriev portraying Gollum.

Above: Smaug was depicted in the adaptation with a puppet.

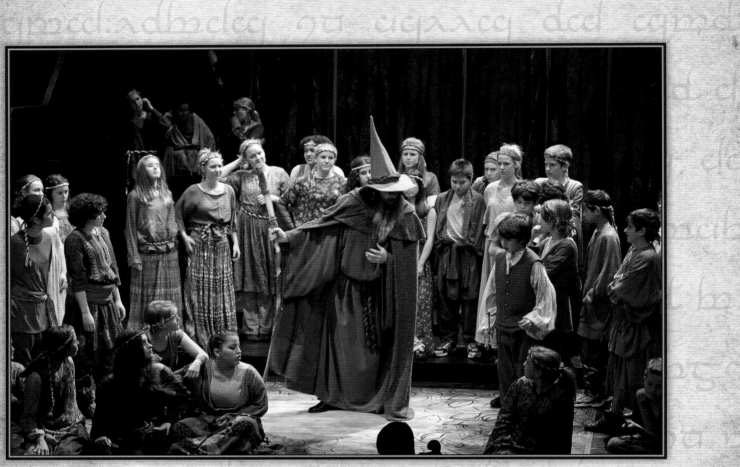

**Above: The Canadian Children's Opera Company performing** The Hobbit.
**Gandalf and Bilbo are in the center.**

# CHAPTER 3
# The Hobbit *on Stage*

Unlike the Peter Jackson adaptation—which has taken J.R.R. Tolkien's short novel for children and created a prequel to *The Lord of the Rings* that matches the earlier trilogy in style and scope—most versions of *The Hobbit* have retained the child-friendly qualities of the text.

Even before *The Lord of the Rings* was published and interest in Middle-earth intensified, schools looked to Tolkien's story as inspiration for a stage show. Although the creators of the 1967 musical version have subsequently claimed that their production was the first time the author had approved of a staging of Bilbo's adventures, there had, in fact, been many others that had received his consent, if not his approval.

St. Margaret's School in Edinburgh put on a production in 1953, for which Miss L.M.D. Patrick requested permission from Tolkien's publisher, George Allen and Unwin. They were allowed to give a limited run of performances, unlike the producers of a version in 1959, whose script seemed to Tolkien to be "a mistaken attempt to turn certain episodes . . . into a sub-Disney farce for rather silly children. . . . At the same time it is entirely derivative." Composer David H. Jones's plans to write an operetta for children, in 1960, also apparently did not proceed.

From his correspondence, it seems clear that Tolkien would prefer that the book wasn't adapted, but he would consent if the adaptation was "good of its kind" or part of the normal education process at a drama school. Yale Drama School was given permission to perform a version in 1959, as was a school in Wallingford, Pennsylvania, in 1967. When Tolkien was contacted by a woman in Nairobi, Kenya, who wanted to produce an adaptation for puppets, he passed the letter to Allen & Unwin noting that he had no objection so long as she didn't alter or add to the original story. However, Tolkien would not give permission for any of these performances to be produced in large public venues, or for the scripts to be published.

In 1967 Paul Drayton and Humphrey Carpenter gained Tolkien's permission to produce a musical version of *The Hobbit* to be performed by prep school boys from New College School in Oxford. Writing a few years later, Drayton and Carpenter recalled that Drayton established the musical structure of the play and wrote the songs, while Carpenter adapted the text, trying both "to retain the style and character of the book" but also "to impose dramatic shape upon it." To that end, various edits were made—elements Carpenter deemed "trimmings" and "not absolutely vital to the plot" such as the Trolls, the Wolves, the Eagles, and Beorn were removed. He also introduced the

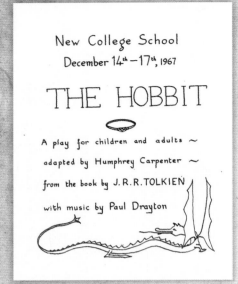

*Above: Poster advertising the New College School's production of* The Hobbit *in Oxford, 1967.*

21.11.67.

Dear Professor Tolkien,
    I am very glad to learn that you hope to be able to attend the final performance of "The Hobbit".
    Humphrey Carpenter will arrange to call on you before then for you to autograph four copies of the book.
    We do appreciate very much your kind co-operation in this venture.

                Yours sincerely,

Professor J.R.R.Tolkien
76 Sandfield Road
Oxford

*Above: Letter from New College School to J.R.R. Tolkien who attended the final performance of* The Hobbit *at the school in 1967.*

character of Bard earlier, and set Smaug's demise "in the center of the action" at Lonely Mountain. Tolkien himself attended the final performance, and while he approved of some of the production, he was not happy with the plot changes that Carpenter imposed on the ending of the play.

The Dramatic Publishing Company (DPC) of Chicago, Illinois, released two versions of *The Hobbit* in 1968 and 1972, bearing the inscription "This adaptation of 'The Hobbit' is authorized by Professor J.R.R. Tolkien." The first, by Patricia Gray, is now marketed by the company as a "comedy"; the other, with book by Ruth Perry, music by Allan Jay Friedman, and lyrics by David Rogers starts with Gandalf singing, "I, Gandalf, Best wizard that you'll see, Bid the darkling spirits, Send the band of Dwarves to me." (The website description of the play suggests they are "darling spirits" which would change the tone even more.)

The inscription is rather misleading: It resulted from a compromise between Tolkien's publishers and DPC, since at the time of publication there was a question over the copyright position on *The Hobbit* in the United States. Tolkien had little

option but to agree to the publication, although he did request some changes in Gray's text, and made it clear that "the publication is with his authorization . . . [but] he would not wish it to be said that the dramatization has his *approval* [sic]."

When a Chicago company staged a production of Gray's script in 2004, director Susan Holgersson realized that the script "actually distorted Tolkien's whole value system," particularly since in this version, it's Thorin who kills Smaug. When even the children she was directing queried the changes from the book, Holgersson penned her own adaptation of Gray's play, adding a prologue, an interim scene, and an epilogue. To her surprise, DPC told her she was the first person to complain about Gray's work, but they gave her permission to make the alterations.

One of the more peculiar versions was produced in California in the spring of 1969. *Down in Middle Earth* was a musical recounting of the tale written by Don and Fred Bluth and "inspired by the J.J. [sic] Tolkien book." According to a report at the time, Gandaulf [sic] is accompanied by three

*Above: Act 1, Scene 1 of* The Dramatic Publishing Company's adaptation of The Hobbit *directed by Susan Holgersson.*

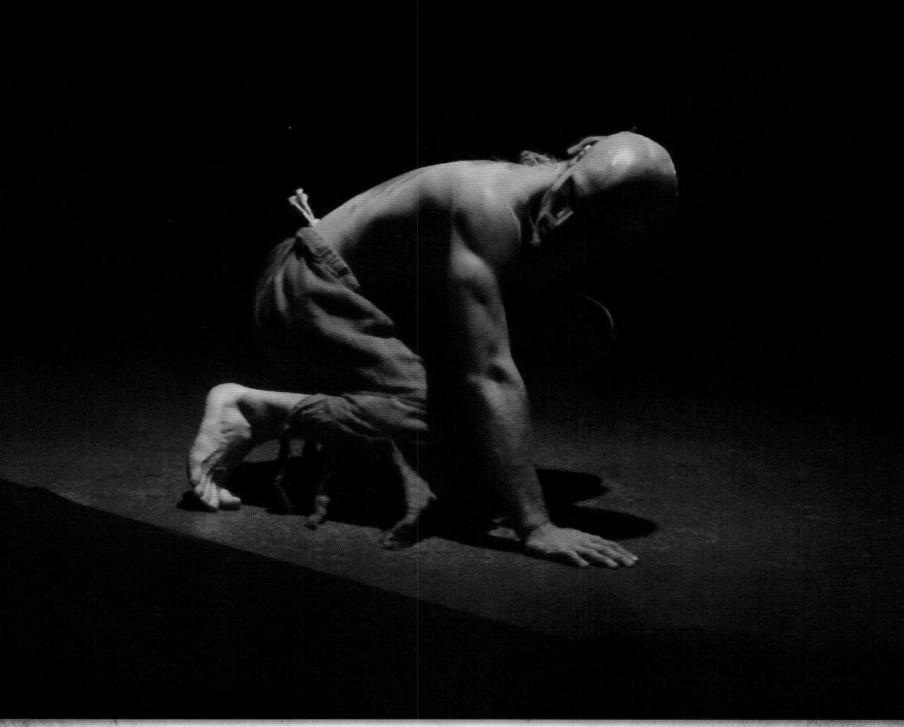

**Above: Gollum in Act 1, Scene 4 of The Dramatic Publishing Company's adaptation of**
The Hobbit **directed by Susan Holgersson.**

singing hobbits—Poke, Put, and Scratch—who are in love with Phoebe, who is in love with Bilbo. The plot deals with this "love pentangle and the theft of the Ring from the hobbit palace;" Bilbo regains the Ring and gives it to Phoebe, thereby receiving her love and becoming the "Lord of the Ring." Perhaps luckily, it appears that no script of this travesty still exists.

At least three other musical versions have been composed: Graham Devlin scripted one with music by Michael Hinton

for the Oxford University Experimental Theatre Club in 1971; Stephanie Nunn provided the music for Rony Robinson and Graham Watkins' adaptation at the Phoenix Arts in Leicester, England in 1984; while Thomas W. Olson wrote the book for the Children's Theatre Company of Minneapolis's production with music by Alan Shorter in 1990.

Markland Taylor wrote a small-cast version published by DPC in 1992. Needing only six actors for the 23 characters, this

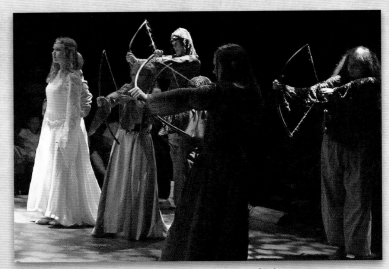

Above: The Elves Appear in Act 2 of The Dramatic Publishing Company's adaptation of **The Hobbit** directed by Susan Holgersson.

reduces the text almost to a shadow of Tolkien's original. In this version, there's only one dwarf (Thorin), and the battle of the five armies is mentioned in an aside to the audience. A 60-minute adaptation written by Edward Mast and published in 1996 loses the Elves, Trolls, and the Giant Spiders, and only features Gandalf at the start and end of the story. According to reviews, by centering on the riddle scene between Gollum and Bilbo it does retain the core themes.

Some adaptations can only be performed in specific territories, such as Kim Selody's eight-actor version written in 1999 for the Manitoba Theatre for Young People, which can only be performed in Canada. The adaptation was nominated for the 2001 Chalmers Award for Outstanding New Play in the Theater for Young Audiences (TYA) category. The performance uses masks, puppetry, and shadow play to tell the story across 90 minutes, although more than one reviewer comments that the rapidity of the action leads to a loss of some of the characterization and story detail.

In 2001 *The Hobbit* became the core of the 56-minute ballet *Hobitti* (Finnish for "Hobbit") mounted using preexisting music by Aullis Sallinen by the Finnish National Opera. Available now to hire under the title *The Dragon Mountain*, its opening "convincingly vindicates the perseverance with which the production was pursued despite copyright difficulties. The fantasy world of Tolkien's children's book is abundantly rich, with Hobbits, Dwarves, Elves, Wolves, and Goblins amid fantastically beautiful sets. Sallinen's music fits the work admirably; it is effective, rhythmically vivid, and lucid in its idiom," according to Mikael Kosk writing in the newspaper, *Hufvudstadsbladet*.

The most recent version was an opera written by Dean Burry, commissioned by the Canadian Children's Opera Chorus in Toronto in 2004. Further performances were initially "locked up" by the Tolkien estate, because of the rights issues surrounding the Peter Jackson films, but a further production was put on in Saratoga, Florida, in 2008, with newly written orchestration. It has subsequently been translated into German.

Writing prior to the first performance, Burry summed up the

Above: Carl Knif as Bilbo in **Hobitti**, a 56-minute ballet by the Finnish National Opera.

Above: A cast marketing photo for **Hobitti**, launched by the Finnish National Opera in 2001.

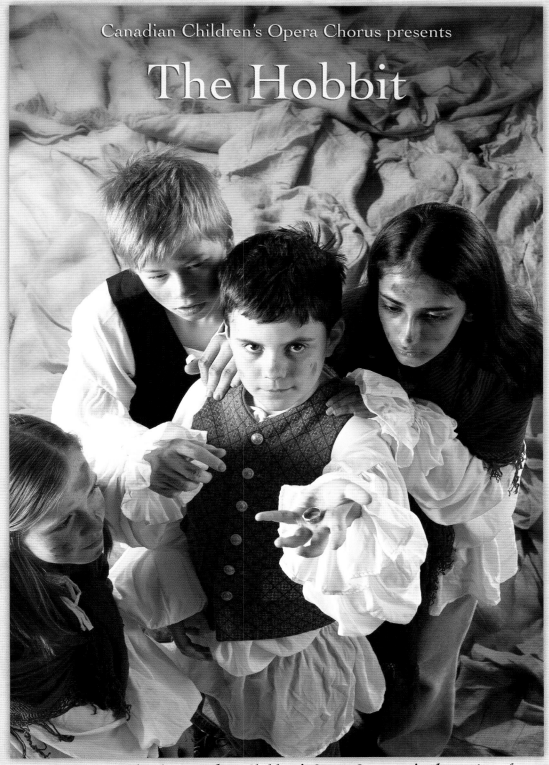

*Above: Poster for the Canadian Children's Opera Company's adaptation of*
**The Hobbit** *in 2004 (they were known as the Canadian Children's Opera Chorus*
*when the production took place).*

appeal of *The Hobbit* for composers: "The music of my opera was inspired by the many races found in the book. Of course, the music must reflect the epic plot, but it must also portray the simple quaintness of the Hobbits, the earthy fortitude of the Dwarves, the pastoral lightness of the Elves, the mischievous wickedness of the Goblins, and the arrogance of Smaug the Magnificent." With such a rich text to draw from, it is not surprising that so many different stage versions have appeared over the years.

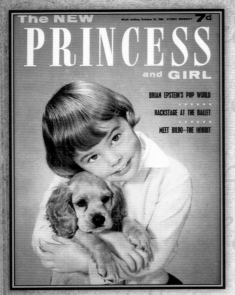

*Above: Cover of The New Princess and Girl on October 24, 1964. The magazine featured a serial of The Hobbit during the 1960s.*

*Above: Bilbo and Gollum illustration by Ferguson Dewar in The Hobbit serial from The New Princess and Girl magazine on November 7, 1964.*

**Above: Bilbo smoking his pipe illustration by Ferguson Dewar in The Hobbit serial from The New Princess and Girl magazine on October 10, 1964.**

# CHAPTER 4
## Comics and Games

There have been several attempts to adapt *The Hobbit* to comic books, whether as part of an ongoing regular title or as a stand-alone graphic novel. It has also been a jumping-off point for a variety of video and board games.

One of the earliest graphic adaptations of Tolkien's work ran between September 1964 and 1965 in a British magazine for young girls, although it had been planned as much as five years earlier. A 15-part version of *The Hobbit* featured as a "visual serial" in UK Fleetway Publications' girls' comic magazine *Girl* (1951–1964, originally a sister comic to *The Eagle*), and was then continued in *Princess* (1960–1967) following a merge of the titles.

Fleetway had contacted Tolkien in December 1963 to request permission to adapt his novel as a "visual serial," essentially a heavily abridged text, featuring seven or eight pictures with each installment. Tolkien replied, indicating he was "agreeable in principle," provided he could see the illustrations and that on no account should "Gollum be made a monster."

By 1964 Fleetway had negotiated with Joy Hill at Allen & Unwin, outlining a plan for ten or 12 installments of around 3,500 words each, with four or five illustrations by artist Ferguson Dewar. Tolkien had to approve the illustrative material.

In August 1964, he responded to some of the artwork. Tolkien wrote: "[Although] criticism of the drawings is probably not in this case useful . . . I should myself wish at least that Gandalf were less fussy and over-clad and had some dignity. He should not be styled 'magician' but 'wizard.'"

Tolkien did concede one change to his text, suggesting that Fleetway's version should use the plural "Dwarfs" rather than his unique "Dwarves," as he'd been told of a case of a confused schoolmaster who'd corrected a pupil's work, only to be presented with a copy of *The Hobbit* as justification for the error. "I am all in favor of spelling being taught, and don't wish a master's authority to be damaged by the quirks of a professor," wrote Tolkien.

The serial ran for 15 weekly installments across pages five and six of each issue, with Dewar's illustrations inflicting an extremely bushy haircut on Bilbo and making Smaug more rabbitlike than dragon. Some elements of the story were rewritten, although most of the reduction was achieved through cutting parts of the original that were not germane to the main thrust. A complete set of the relevant magazine issues were sent to Tolkien by Allen & Unwin, but there's no further record of his opinion of the adaptation.

The Hobbit was later adapted in 1989 as a three-issue comic book miniseries by Chuck Dixon (now best known for his 1990s *Batman* and *The Punisher*), with lettering by Sean Deming, and art by David Wenzel (who'd previously worked with Dixon on *Savage Sword of Conan*, and had been recognized for his work on *The Avengers*). It was released through Eclipse Comics. Wenzel had previously tackled Tolkien in a very different style in Centaur Books' *Middle Earth [sic]: The Work of Tolkien Illustrated* (1977), a collection of illustrated scenes annotated by fantasy author Lin Carter.

According to Wenzel, "[*The Hobbit*] was the first book I'd really read that I wanted to create drawings for . . . And in doing so, I found myself in a new artistic position of thinking of creating other worlds. [The comic book] is an almost complete visualization of *The Hobbit*. The movie is not . . . ."

The first issue of *The Hobbit* comic book (called *Book One* on the spine) contained 44 pages of art, taking the story up to "Riddles in the Dark"—almost mirroring Jackson's first movie. *Book Two* takes the story to 88 pages, concluding with the rafts of the Lake-men (in "Barrels Out of Bond"). *Book Three* concluded the adventure, bringing the whole collection to 133 pages.

Perhaps in keeping with the younger audience, this comic book is fond of bright pastel colors, while the figures of the Dwarves, and in particular Bilbo, look very cartoonlike, almost in keeping with the 1970s' animated films. That served, perhaps, to reduce the emotional impact of the tale, while the reliance on Tolkien's writing (which, arguably, might be too reverential for an illustrative medium) resulted in some very text-heavy panels. A more ruthless approach may have resulted in a comic book that flowed better with more appeal to the target age. Twenty-five years on, *The Hobbit* comic book appeals to die-hard Tolkien fans and dedicated comic book collectors.

The three-issue series was republished as a single volume "graphic novel" in 1990 by Unwin in the UK. In 1999 the book was

**Right: David Wenzel's "Riddles in the Dark" published by Eclipse Comics in 1989 featuring Gollum and Bilbo.**

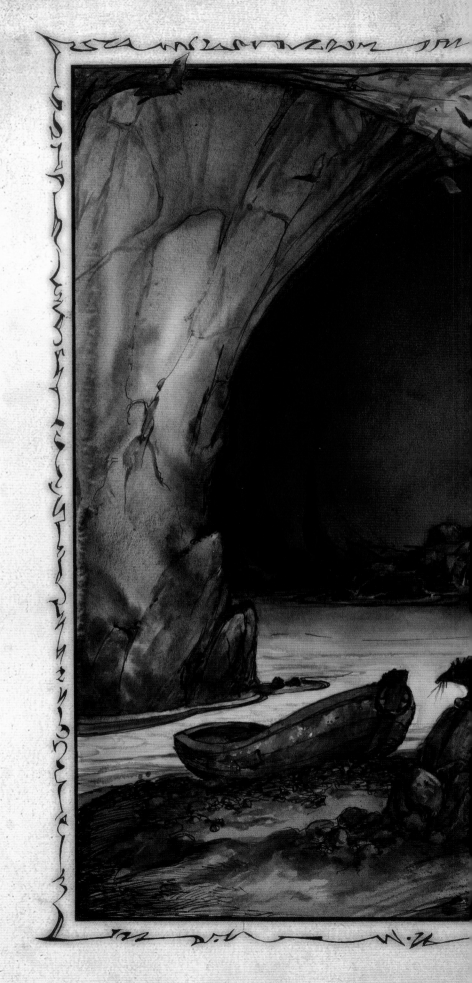

nominated in the Eisner Awards—the comic book Oscar—as Best Finite Series. It was once again collected in a single volume by Del Rey/Ballantine in 2001 to tie in with the release of Jackson's *Rings* films, featuring new cover art by *Magic: The Gathering* illustrator Donato Giancola—who had also done covers for the Science Fiction Book Club editions of Tolkien's main works—and 32 pages of additional art. The new cover won Best Cover Illustration at the Association of Science Fiction Artists Awards for 2002. A new edition was released toward the end of 2012 to tie in with the first of Jackson's movies of *The Hobbit*, featuring an additional six pages of new artwork.

*The Hobbit* was featured on a set of five Royal Mail commemorative stamps in 1998. As part of Presentation Pack #289 entitled *Magical Worlds: Fantasy Books for Children*, illustrator Peter Malone created an image of Smaug the dragon and Bilbo for the 20-pence stamp (the cheapest in the set). The other featured works of acclaimed children's literature were Tolkien's fellow Inkling C.S. Lewis's *The Lion, the Witch and the Wardrobe*; E. Nesbit's *The Phoenix and the Carpet* and *The Borrowers*; and Lewis Carroll's *Alice Through the Looking Glass*.

\*\*\*

As the 1970s craze for *Dungeons and Dragons* role-playing games was taking hold (*see Chapter 8*), TSR Inc. returned to the source of many of their fantasy games and created a board game based directly upon *The Hobbit*. Released in 1976, the Larry Smith–designed game drew upon the battle of the five armies that climaxes *The Hobbit*. The TSR game featured color maps and counters, with a board made up of hexagons depicting the terrain (including the river) across which the battle raged. Each of the 170 game pieces represented a participant in the conflict

**Left: David Wenzel's "The Hobbit" published by Eclipse Comics in 1989 and featuring both Gandalf and Bilbo.**

and carried data, including defense, strength, and movement statistics, used in determining the outcome of each encounter. Although simple by modern standards, this game was many fans' introduction to the world of tabletop fantasy game playing.

The battle of the five armies was a popular choice for *Hobbit*-based board games. There was a 1982 version—most widely available from an Italian reprint included in *KAOS* magazine #50 in 1997—a 1984 game from Iron Crown Enterprises, and a 2005 Miniatures Wargame from Games Workshop.

There were a host of other traditional board games based upon *The Hobbit* released between the Ralph Bakshi animated film and the Jackson trilogy. They ranged in quality from the fan-produced *Riddle of the Ring* in 1977 from Fellowship Games, to a Tolkien variation of the card game Solitaire from West Coast Games (also 1977) called *There and Back Again*, to a widely-

played 3-D *The Hobbit* board game from Milton Bradley (also in 1977. All anticipated the Bakshi movie).

The Milton Bradley game featured a three-quarter wraparound card background containing scenes from Middle-earth using art from the Bakshi movie, and a split-level playing area around which players moved their pieces. The first to get their Hobbit figure to the finish line wins. Obstacles encountered included journeys around the Troll Circle, the Gollum Circle, and the Goblin Circle, as well as encounters with Spiders and Elves.

There was a previous children's board game based on the book from 1976 called *The Hobbit Game* from American Publishing Corp. Played across a two-part playing board, the player had to accumulate 200 pieces of gold while journeying to the Lonely Mountain. Hazards involved landing on squares that instructed players to select Adventure or Creature cards that affected

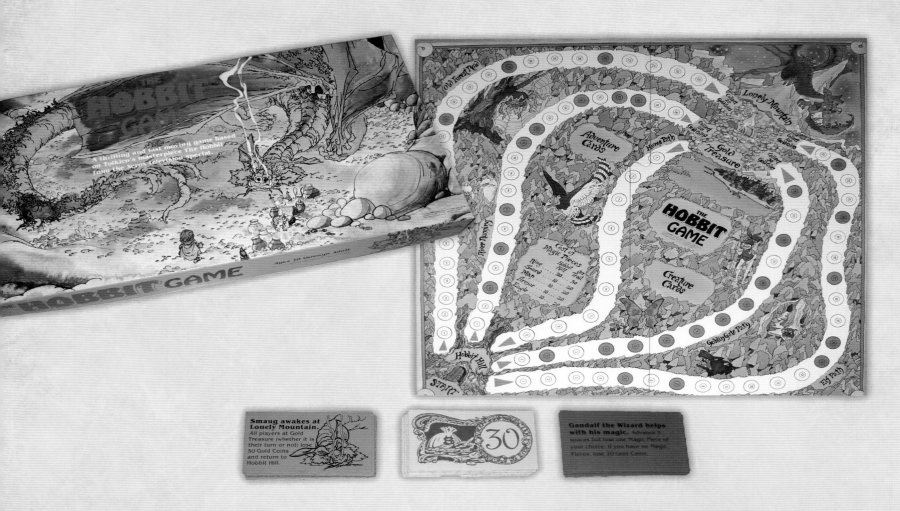

***Above:** The Hobbit Game produced in 1976 by American Publishing Corp. and designed by Larry Smith.*

the outcome of the game. Magic Pieces could be collected and invoked to help a player on their journey.

*The Lonely Mountain: Lair of Smaug the Dragon* was released in 1983 by Iron Crown Enterprises (ICE), based around the traditional adventure game hexagonal board layout. Design and game play had advanced by 1997 when the same company released *The Hobbit Adventure Boardgame*, featuring an illustrated geographical map of Middle-earth. Similar game play mechanics applied, but this game culminated in a confrontation with Smaug. After collecting enough tokens by journeying across the lands of Middle-earth, the player fought the dragon using dice and a variation on *Dungeons and Dragons* rules.

Smaug was unsurprisingly the focus of the 2001 game *The Hobbit: The Defeat of the Evil Dragon Smaug* from Fantasy Flight Games. Created by Michael Stern and Keith Meyers, and with illustrations by Tolkien artist Ted Nasmith, this game featured a circular playing area split into six segments, with the Lonely Mountain—topped by a triumphant figure of the dragon—in the center. Each of the two-to-six players had to safely navigate their way to the mountain, reclaim the treasure, and not fall victim to the dragon's breath.

A worthy successor was the 2010 *The Hobbit Board Game* (see page 46) , again from Fantasy Flight Games, this time featuring art from John Howe. The board consisted of a magnificent widescreen profile painting of the Lonely Mountain, across which the players moved their pieces. Designed by German games guru Reiner Knizia, it featured the use of strategic cards mixed with the unpredictability of dice throws. There was a ticking clock threat, as each player defeat saw Smaug move closer to Lake-town. If he arrived, the game ended! Unlike in Tolkien's work, the winner of the game accumulated the most treasure rather than the one who learns something from the experience, as Bilbo does in the novel. The game came with two attractive sculpted figures, one of Bilbo and one of Smaug.

*The Hobbit: An Unexpected Journey Adventure Board Game* movie tie-in from Pressman Toy (released in 2012) used character likenesses from the Jackson films to illustrate the character cards, game pieces, and multiple hexagonal boards. Several boards fitted together to create a playing space that could easily occupy a good-sized rug, encompassing 12 different Middle-earth locations. Although the game looked great, it was criticized for some complicated game play and inadequate instructions. However, the game was designed to be expandable with new installments

*Below: The widely-played 3-D **The Hobbit** game from Milton Bradley distributed in 1977 in anticipation of the upcoming Ralph Bakshi animated film.*

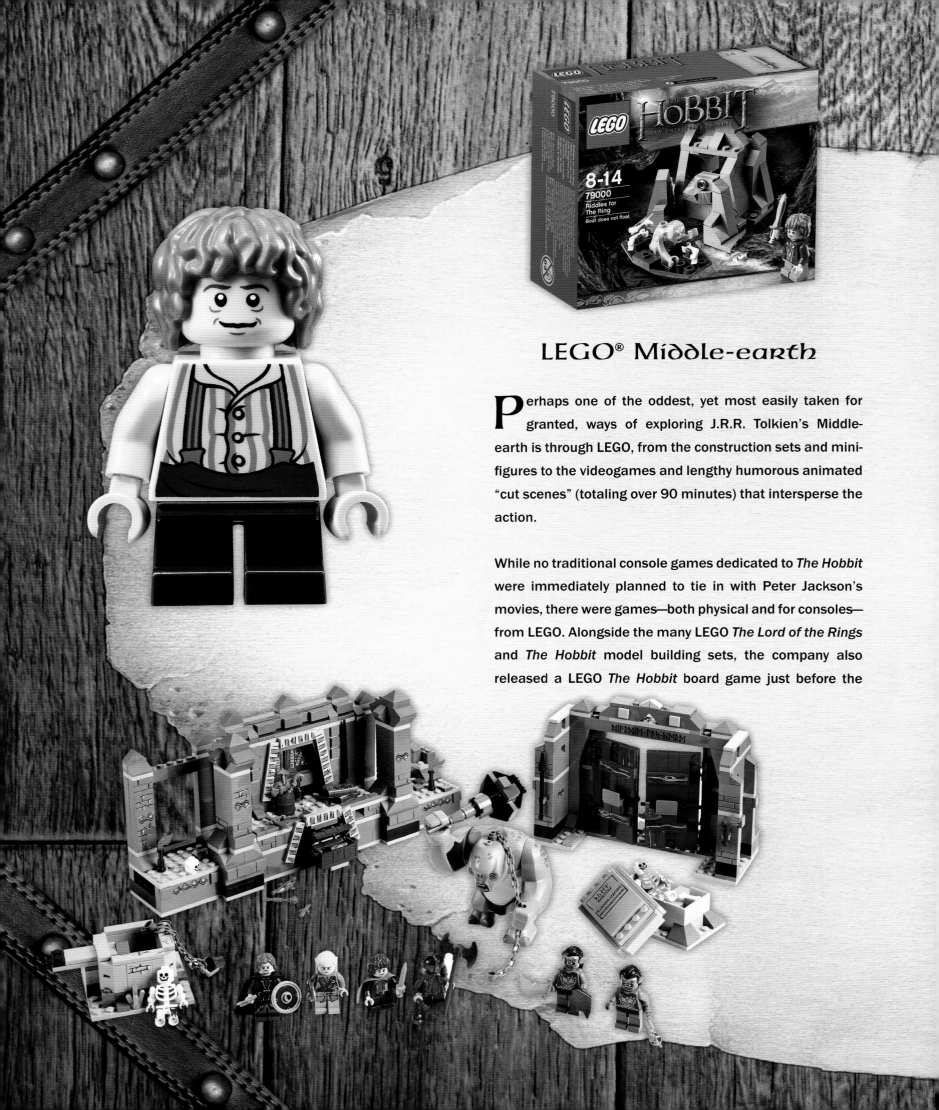

## LEGO® Middle-earth

**P**erhaps one of the oddest, yet most easily taken for granted, ways of exploring J.R.R. Tolkien's Middle-earth is through LEGO, from the construction sets and mini-figures to the videogames and lengthy humorous animated "cut scenes" (totaling over 90 minutes) that intersperse the action.

While no traditional console games dedicated to *The Hobbit* were immediately planned to tie in with Peter Jackson's movies, there were games—both physical and for consoles—from LEGO. Alongside the many LEGO *The Lord of the Rings* and *The Hobbit* model building sets, the company also released a LEGO *The Hobbit* board game just before the

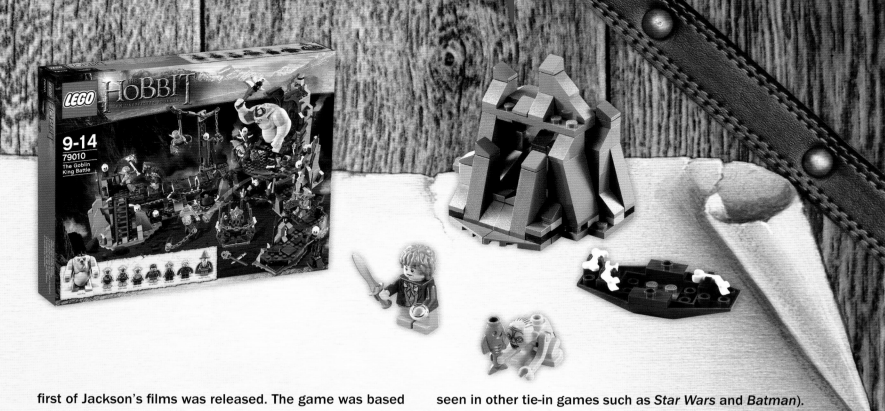

first of Jackson's films was released. The game was based around the unique versatility of LEGO pieces, allowing the board to be built by the players in a different configuration each time it was played. Set within Hobbiton (which players must build from LEGO pieces before starting), the game sets Bilbo, Gandalf, Dwalin, Kili, and Fili in search of the other missing ten Dwarves who are lost in the Hobbit holes of Hobbiton. Aimed at younger players, the game introduces not only Tolkien's stories, but also game play and the skills of LEGO building combined in one.

Older fans had long adapted various traditional LEGO sets to create Tolkien-inspired characters and settings, long before the company itself got around to creating bespoke licensed products. After years of speculation by LEGO fans, *The Hobbit* movie was the opportunity for the company to release a LEGO *The Lord of the Rings* videogame for major consoles, encompassing the entire Tolkien epic. Although focused almost exclusively on the later trilogy, the game does include the younger Bilbo Baggins (from the period of his adventures in *The Hobbit*) as a playable character. Scenes from the films and Tolkien's originals have been altered to make them more family friendly or more humorous, the LEGO approach to videogaming (as

seen in other tie-in games such as *Star Wars* and *Batman*). There is more of a traditional role-playing game feel to LEGO *The Lord of the Rings*, though, with players building up an inventory of items that can be used much later in the action. Free Roam mode also allows players to freely explore Middle-earth, albeit in LEGO form, while a variety of side-quests allow the player to go "off-story" if they like. There are more than 80 playable characters, including a bonus unlockable Tom Bombadil.

Since May 2012, a variety of *The Lord of the Rings* LEGO building sets and mini-figures have been on sale, encompassing all areas of the story from dramatic set-pieces such as "The Mines of Moria" or "The Battle for Helm's Deep" (from *The Fellowship of the Ring*), to "The Goblin King Battle," and "Gandalf at Dol Guldur" (both from *The Hobbit* movies).

The 15 sets currently available at the time of publication offer a host of possibilities to imaginative junior Tolkien fans, who could combine and recombine the bespoke LEGO sets in innumerable inventive ways to build just as diverse and imaginative a world of their own as the version of Middle-earth created by Tolkien himself.

released with each of the following episodes of *The Hobbit* movie trilogy, thus ensuring long-running and adaptable game play. Writing on the Kotaku videogame Web site, critic Alex Kidman noted " . . . the sheer quantity of *Hobbit*-centric videogames. It's a pity, then, that such a classic setting has seen so many terrible games." While many of the games have been mediocre, many more are of their time—some from the earliest days of home computing—so have to be appreciated in that context.

The first widely available videogame based upon *The Hobbit* was released during the first flush of home computing as an entertainment hobby. Developed by Beam Software and published by Melbourne House, the game is now considered a classic by those who grew up playing it and those who have rediscovered it online as a "retro" gaming experience.

Released in 1982, the game was available to play on most home computers and came with a copy of the novel that players were encouraged to read in order to find clues that might help them. Rather than a straight retelling of the story in a limited text adventure format, the narrative used elements from *The Hobbit* in an imaginative way, with creative graphics given the limited computing power available. The game was cowritten by Philip Mitchell and Veronika Megler, who set out to offer a more immersive experience described as "interactive fiction."

As well as the colorful images—if simplistic, and very slow to draw on screen— designed by Kent Rees, the game innovated in its use of a text parsing system dubbed "Inglish." Rather than using the simple verb-noun compounds of traditional text computer adventure games (commands such as "Go West" or "Get Sword"), Megler created a game engine that allowed players to enter commands in complete sentences, thus helping children in their language skills. "I wrote the game to be very general and to not restrict people from doing things," Megler recalled in an interview with IT Web site The Register. "Everything was an object. If you killed a Dwarf you could use it as a weapon—it was no different to other large heavy objects. That was something you could not do with other games of the time, they had fixed possibilities."

Megler had been challenged by Melbourne House to write the greatest adventure game ever, so she brought her experience of the rapidly developing computer science of the 1970s and early-1980s to the project. Following the release and success of the game—it won the 1983 Golden Joystick Award for Best Strategy Game and sold over 100,000 copies in two years—Megler moved on in her career

*Above:* **The Hobbit Board Game** *is a strategy game by Reiner Knizia featuring the spectacular art of John Howe. Players compete to win as much treasure as they can, while threatened by Smaug the Dragon.*

without realizing she'd been part of something many games players would fondly remember. Some still recall encountering the phrases "You wait—time passes" and the iconic "Thorin sits down and starts singing about gold."

Apart from a spoof game in 1986 called *The Boggit: Bored Too* (a sequel to the game *Bored of the Rings*, based on the comic novel) and an obscure Soviet 64kb ZX Spectrum game sold in the UK in 1990, there was little on *The Hobbit* video gaming front until the Jackson films of *The Lord of the Rings* brought renewed interest.

Vivendi Universal released *The Hobbit: The Prelude to The Lord of the Rings* in November 2003. The platform version of the game for the hand held console Game Boy Advance featured puzzles to solve and enemies to battle,

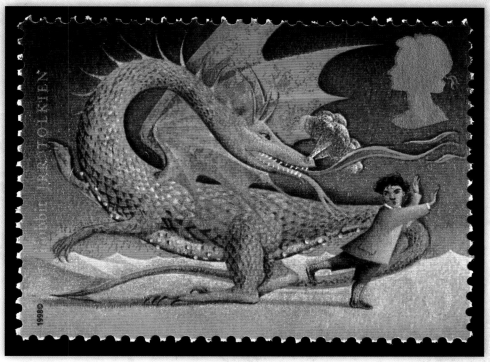

*Above: The UK's Royal Mail "Hobbit" stamp. It is a 20p stamp featuring* **The Hobbit** *illustration by Peter Malone and was part of the 1998 Presentation Pack #289 entitled* **Magical Worlds: Fantasy Books for Children.**

while closely following the course of the novel. The player had to negotiate a variety of levels that required jumping skills, as well as rope swinging and ladder climbing. On other consoles—including Windows PCs, GameCube, PlayStation 2, and Xbox—the game was a 3-D role-playing adventure. Each version included the ability to use the One Ring to escape or sneak up on enemies. Optional quests could prolong playing time. Among the voice talent featured were future stars of the *Star Wars* animated TV series *The Clone Wars*, including Dee Bradley Baker, Tom Kane, and James Arnold Taylor. The music—composed by Rod Abernethy and Dave Adams, and performed by the Northwest Sinfonia in Seattle—won Best Original Soundtrack of the Year at the Game Audio Network Guild Awards in 2004. Reviews of the game were mixed, with the PS2 version scoring only 59 out of 100 and the PC version scoring 62 out of 100 on ratings aggregator Metacritic.

Peter Jackson's *The Hobbit* movies provoked a flurry of new videogames activity. Reflecting the 21st-century shift from consoles and computers to social media sites, such as Facebook, Warner Bros. Interactive and game creator Kabam released two

free-to-play games for tablets and mobile devices. Launched in advance of the first movie, *The Hobbit: Kingdoms of Middle-earth* (mobile devices) and *The Hobbit: Armies of the Third Age* (Web browsers) heralded a new age in Middle-earth gaming.

*Kingdoms of Middle-earth* challenged the player to build and maintain their own kingdom in Tolkien's world, while joining with other players to explore the environment and engage in epic battles. *Armies of the Third Age* put the player in charge of an army of Elves, Dwarves, or Orcs, and offered the chance to control key characters such as Bilbo Baggins and Gandalf the Grey in a game of fast-moving strategic combat. Both were designed for fast-and-immersive play in short bursts.

A multi-online battle arena (MOBA) game—*Guardians of Middle-Earth* [sic] also made its debut in connection with the first movie of *The Hobbit*, although its online multi-player team battles drew upon a wide range of Tolkien environments and characters. Along with the LEGO-based spin-off videogames, it seems likely that as technology continues to evolve Middle-earth will always be a top destination for game players.

LINDON

MINHIRIATH

ENEDHWAITH

DUNLAND

CRN. VORN

R. GWATHLO OR GREYFLOOD

LONG

R. ISEN

SWANFLEET

ENEDWAITH JAUR
(OLD PUKEL-LAND)

ERED NIMRAIS

PINNATH GELIN

9

ANFALAS

ANDRAST

CAPE OF ANDRAST

THE DOORS OF DURIN

THE BARROW-DOWNS

BAY OF
BELFALAS

A MAP OF
MIDDLE-EARTH

Miles    50   100   150   200   250   300

Scale

# Part II

# the lord of the rings

*Above: BBC Broadcasting House in London during the 1950s. This is where many of the legendary Tolkien audio adaptations were recorded.*

Ask Tolkien fans about the best adaptation of *The Lord of the Rings* prior to the Peter Jackson movies, and chances are that they will talk about the major 26-part version that was produced by BBC Radio and first broadcast in 1981. However, this was by no means the first time that the BBC had tackled Tolkien's magnum opus, with two very different versions of the trilogy appearing shortly after its publication.

The more prestigious of these was broadcast on the Third Program in 12 episodes split over two years. At the time the BBC had only three radio channels: the Home Service, dedicated to news and drama, which became Radio 4; the Light Program, for light entertainment and music (its remit was split between Radios 1 and 2 in 1967); and the Third Program, whose purpose was to disseminate the arts and promote the classics. It was therefore quite a coup for a new book—particularly one of such a fantastical nature—to be considered for adaptation and broadcast on the Third.

Unfortunately, none of the episodes now exists—it was very rare in those days for either radio or television broadcasts to be recorded, and those that do survive from the period are ones of great historical value, such as the coronation, or experiments with the technology. However, because Tolkien corresponded at length with the producer, Terence Tiller, we have considerable insight into the alterations that were required. Tiller, a published and respected poet in his own right, approached Tolkien directly on January 25, 1955, seeking permission to adapt *The Fellowship of the Ring* into six 45-minute episodes, promising to show the author the scripts for his approval.

Tolkien replied the next day, finding the idea "most interesting and gratifying" although he wondered how the book could be condensed into such a short time, and he wanted to know how Tiller proposed to proceed. His publishers, in whom the rights were vested, were happy with the idea, and were formally approached a couple of days later; at that point, Tiller hoped to broadcast between April and June 1955. Tolkien's ambivalence toward the project was clear from the start. Despite his apparent pleasure, he told Philip Unwin: "I view the project with deep misgivings and do not expect to derive anything but pain and irritation from the result." However, he was prepared to be guided by his publishers if they were certain it would be a "good thing" for promoting the book. In a letter written after *The Fellowship of the Ring* had been broadcast, Tolkien noted that "'Broadcasting' is . . . at least temporary, and one is pitied rather than blamed for its defects."

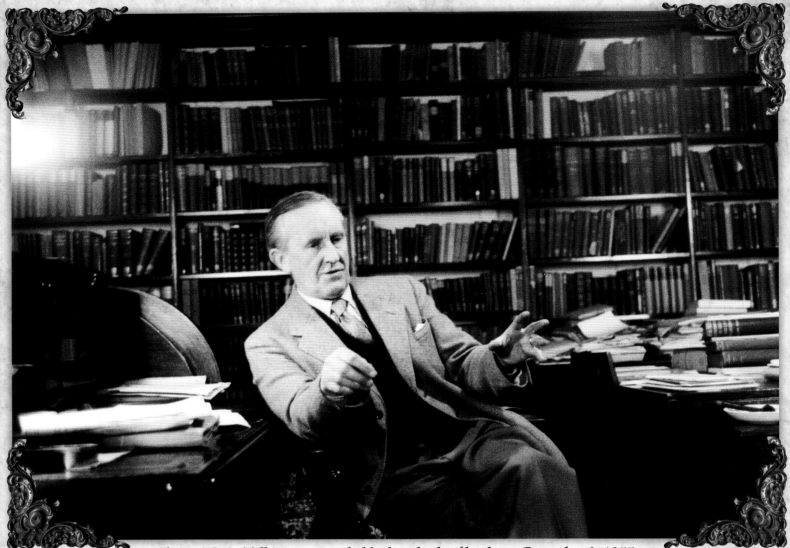

*Above: J.R.R. Tolkien surrounded by hundreds of books on December 2, 1955.*

Tiller decided to use a narrator to link dramatized scenes, with as much of the original dialogue preserved as possible, albeit in his own words, "substantially reduced," with most of the songs and poems lost in the process. Tolkien agreed, and offered his own ideas for the Troll-song and Galadriel's lament. The adaptation took Tiller longer than he first thought. By early June, he had only completed drafts of the first three episodes, which, for reasons that are unclear, now lasted only 30 minutes each. These were presented to Tolkien at a meeting on June 24. The author had a number of comments on them that, it seems, Tiller incorporated into the final versions. These were completed in early October. The first rehearsals and recording were set for November 12 and 13, to which the author was invited, although due to ill health he was unable to attend.

To ensure fidelity to Tolkien's vision, Tiller asked him about the accents that the various characters should adopt. Tolkien replied at great length, although he accepted that the necessities of ensuring that the actors sounded sufficiently different to the listener might override his opinion. He didn't want the higher-born hobbits, such as Merry and Pippin to have "anything more than the merest tinge of 'country' (if any) in their speech," although Sam and Butterbur "may well be characterized by speaking with a 'country accent' of some kind—fairly but not too strongly marked." He accepted that an accent deriving from England's West Country area was most commonly used as a form of audio shorthand to signify "the country," but he was keen not to misuse the "h" sound or "have any supposedly 'Zummerset' z/v for s/f initially."

The first episode was broadcast on November 14 at 10:10 p.m. and repeated the next day at 6:40 P.M. The others followed weekly, although the repeats were not always on the same day of the week. The BBC proudly announced that this was the first modern novel to be serialized on the Third Program, and it was popular with listeners. Tolkien, however, still thought the book was "quite unsuitable for 'dramatization,'" although he did accept that the later episodes were better than the earlier ones. He particularly disliked the portrayal of Tom Bombadil, perhaps because Goldberry was presented as his daughter. In a letter to Tiller, he found the cutting of the Council of Elrond "masterly" but queried some of the descriptions used by the continuity announcer introducing the episodes. In a later letter, written after the penultimate episode aired, Tolkien admitted, "I should like to have the thing continued—if you are the producer."

While the six-part drama found favor with audiences, it wasn't as well received by the hierarchy at the BBC, as Tiller discovered on January 20, a month after the final episode. Instead of two further series to present the other books in the same depth, a simple six-part 30-minute version was proposed. The Chief Assistant to the Third Program suggested that this could partly be achieved by "ending it with the victory and restoration of Gondor" and everything else "being treated as an epilogue and either omitted altogether or disposed of in a few lines of narration." Given that he had received letters complaining at the cuts required to *The Fellowship of the Ring*, Tiller was understandably appalled at the idea of such butchery to the text, but he preferred to have something broadcast, rather than leave the story unfinished.

Tiller didn't inform Tolkien of the plans until the following September, and the author agreed. When Tiller sent the scripts of the first three episodes for Tolkien's comments at the start of November, the producer acknowledged that "any listener who knows the books themselves will, I fear, be somewhat disappointed in the broadcasts," but hoped that other listeners "will at least obtain the gist of the story and of its excitements." Once again, Tiller asked Tolkien's advice about accents, to which the author sent an immediate reply. Tolkien was more considered about providing his general comments, waiting for

*Above: Norman Shelley, the BBC radio broadcaster and storyteller. Shelley voiced Gandalf in the Third Program's audio adaptation of* The Lord of the Rings.

*Above: Actress Prunella Scales filming* Lacksdale Hall *in 1952. She also had a small role in the Third Program's audio adaptation of* The Lord of the Rings.

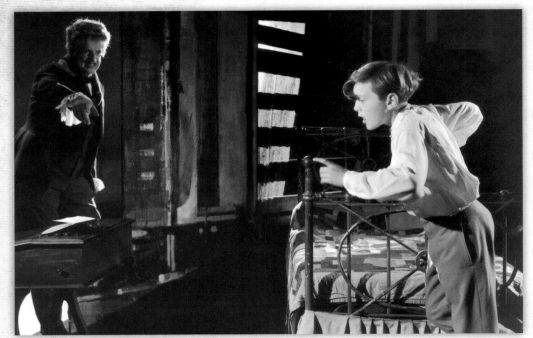

*Above: A young David Hemmings (right) as Miles in the English Opera Group's production of "The Turn of the Screw" on October 13, 1954. Hemmings also had a small role in the Third Program's audio adaptation of* The Lord of the Rings.

four days before writing back. It was clear that he was not at all happy. While he was "flattered and pleased" that the book was receiving attention from the BBC, and felt that Tiller couldn't have done a better job given the circumstances, he couldn't understand what benefit it would be to the Third Program to broadcast it in such a truncated form. "[T]he text is (necessarily in the space) reduced to such simple, even simple-minded terms," he noted. Unfortunately none of the further correspondence between the two men is preserved, either by the Tolkien estate or the BBC Written Archive.

The six half-hour episodes—simply entitled *The Lord of the Rings*—were broadcast on the Third Program between November 19 and December 23, 1956. Across the two series, Oliver Burt played Frodo, with Norman Shelley as Gandalf and Tom Bombadil, Derek Prentice playing both Boromir and Faramir, Michael Collins as Merry, Basil Jones as Pippin, and Victor Platt as Sam. A young David Hemmings and Prunella Scales had small roles, while the narration was provided by Derek Hart.

The second BBC radio version was prepared as part of the Schools Broadcast series *Adventures in English*, between January and March

1956. It is probable that this was simply a reading of an abridged version of the text, like the later reading of *The Hobbit*.

According to some sources, there was a short adaptation of the entire trilogy broadcast by New York radio station WBAI-FM in 1961 organized by its Drama and Literature Director William Baird Searles, which was suppressed by Tolkien's legal representatives. Some years later, after discussions with Tolkien to authenticate pronunciations of the characters' names and the language, Searles narrated "The Council of Elrond" from *The Fellowship of the Ring*, which is repeated annually as part of the radio program *Hour of the Wolf*.

Straightforward audio readings of the books have been available for a long time. The Library of Congress recorded three unabridged versions, with Livingston Gilbert in 1967, Norman Barrs in 1978, and then David Palmer in 1999. Rob Inglis read the entire trilogy in 1990 for Recorded Books, creating music for all of the songs, which he performed over a six-week period. As discussed in Chapter 1, there are also recordings of Tolkien himself reading excerpts from both *The Hobbit* and *The Lord of the Rings*.

A dramatization written and produced by Bernard Mayes was broadcast in America by National Public Radio in 1979, and then released on cassette and CD. Although it was praised at the time, it is now generally regarded as inferior to the BBC version from two years later. It seemed to try to copy the style of radio drama prevalent in America from the 1930s to 1950s, with dialogue taking precedence over description, and was performed by local actors, mostly friends of the producer, who had difficulties with the names of the characters and places. It gains plaudits from some fans for including scenes that other versions remove—notably the Tom Bombadil scenes—but even its 11-hour running time required many elisions and excisions.

The cast included Ray Reinhardt and Gail Chugg reprising their roles as Bilbo and the narrator from the company's version of *The Hobbit*, with James Arrington as Frodo, Pat Franklyn as Merry, Mac McCaddon as Pippin, Lou Bliss as Sam, Mayes himself as Bombadil (as well as playing Gandalf once more), and Tom Luce as Strider/Aragorn. The most widely available version of this on CD is heavily edited and cuts the text back even further. Those who want to experience the full benefit of its squeaky-voiced Elves should seek it out on audio cassette.

In 1981 came the version that was described by one reviewer as "the unsung hero of all the dramatizations of Tolkien" and by another as "an embarrassment." The third BBC radio adaptation of *The Lord of the Rings* has polarized audiences over the years. It was certainly one of the most ambitious undertakings carried out by the Corporation. Star Ian Holm wrote in his 2004 autobiography: "It was made, I suppose, at a time when the BBC took risks and there used to be more opportunity for unconventional work."

Unlike in Tolkien's original books, adapters Brian Sibley and Michael Bakewell took a chronological approach, following the timeline given as one of the appendices to *The Lord of the Rings*. This was to ensure that each of the 26 half-hour episodes involved all the central characters, instead of following one plotline for a considerable period as in the book—even if this went against Tolkien's wishes. Tolkien had insisted in April 1958 that his structure should be maintained, as "in the author's opinion, this arrangement cannot be altered without serious damage" to the effect of the story.

In 1980 the BBC was in the midst of one of its periodic love affairs with science fiction and fantasy. Tom Baker was approaching the end of his highly successful fourth incarnation of the Doctor in *Doctor Who*; space opera *Blake's 7* was in the middle of a four-year run on television; and Douglas Adams's science-fiction comedy *The Hitchhiker's Guide to the Galaxy* had been a major hit on Radio 4—the news and drama station that would be the home for *The Lord of the Rings*. The head of the BBC's Script Unit, Richard Imison, was keen to bring Tolkien's masterwork to radio,

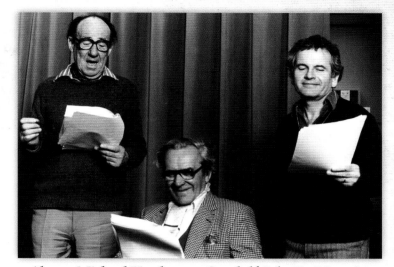

*Above: Michael Hordern as Gandalf, John Le Mesurier as Bilbo, and Ian Holm as Frodo in the Radio 4 dramatization of J.R.R. Tolkien's* **The Lord of the Rings,** *which began broadcasting on March 8, 1981. All three actors are reading scripts in the studio.*

no doubt feeling that the medium's ability to allow listeners to build pictures in their imaginations would work in the project's favor, as it had with *The Hobbit* a few years earlier.

This was Brian Sibley's first professional involvement with the world of Tolkien—he would later write the official books charting the making of Peter Jackson's movies, as well as an authorized biography of the director. When another project he was working on was turned down by the BBC, he was asked what he would like to adapt for them and he mentioned *The Lord of the Rings*, not realizing that negotiations were already under way. Once the rights were obtained from the Tolkien estate, Sibley's enthusiasm for the project meant that he was assigned to the adaptation. As he was a relatively novice writer, he was teamed with the highly-experienced Michael Bakewell, who had recently adapted Leo Tolstoy's *War and Peace*, another saga told on an epic canvas. Sibley wrote the synopsis for each of the 26 episodes, and the two men took 13 apiece to script, with Bakewell using his experience on the Tolstoy book to tackle those featuring complex battle sequences.

Inevitably, certain cuts and compressions had to be made while other explanatory material was inserted from *The Hobbit* and Tolkien's *Unfinished Tales*. Most controversially, as far as fans were concerned, the Hobbits' adventures with Tom Bombadil

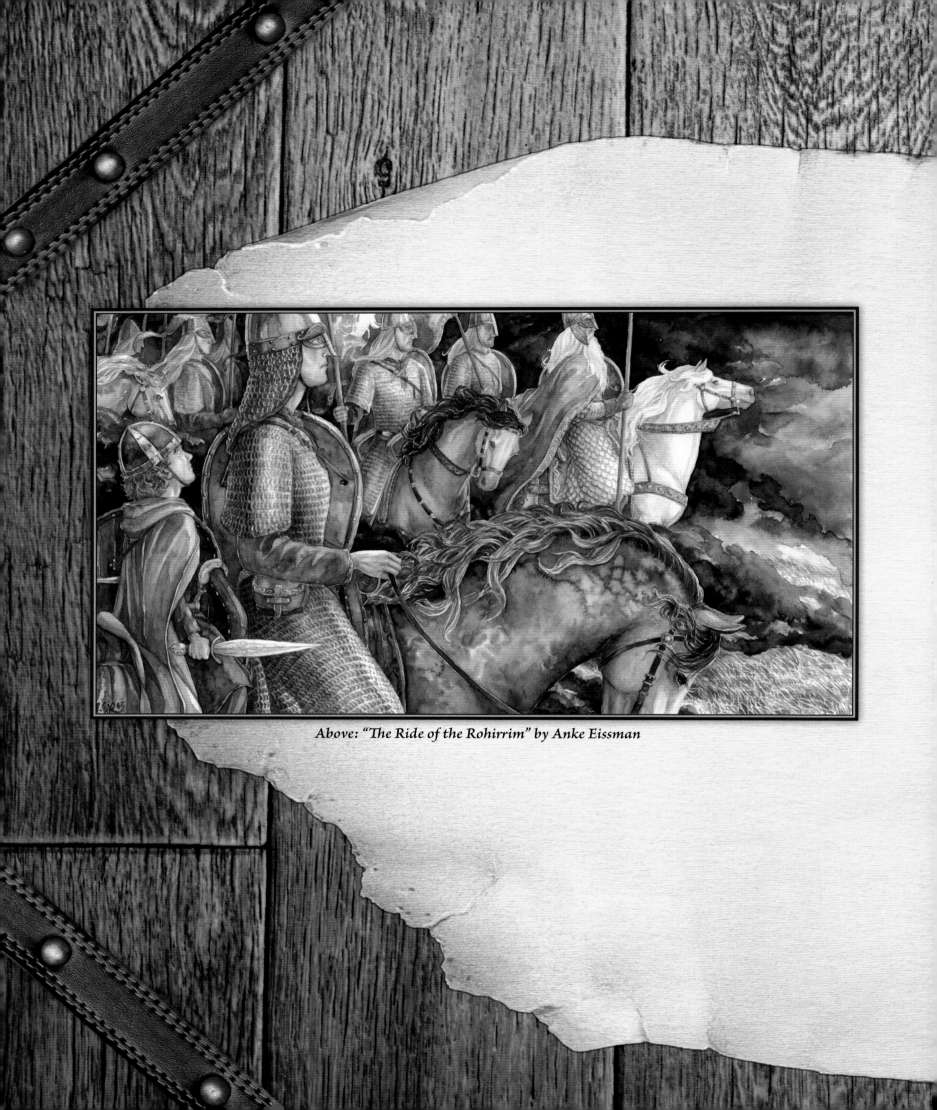

*Above: "The Ride of the Rohirrim" by Anke Eissman*

# "Men of the Twilight;" The Stewards of Gondor in Book, Film, and Audio

## by Dr. Una McCormack

Tolkien's modern epic *The Lord of the Rings* seems almost to have been conceived to disprove contemporary conceptions of what makes a good novel, not least in the way that his characters eschew the extensive introspection that is a distinctive marker of modern fiction. You do not turn to Tolkien for the lengthy streams-of-consciousness and complex motivations of a Stephen Daedalus or a Clarissa Dalloway. Tender and simple loyalties motivate the Hobbits on their various quests, while the Men are driven by high ideals: winning or defending a kingdom, defeating evil. Tolkien's own conception of the Men in *The Lord of the Rings* is as "Men of the Twilight;" "loftier" than the heroes of epic but still from cultures "less corrupt and nobler" than our own (Letter 244). The Gondorian characters of the novel—the Steward of Gondor, Denethor, and his two sons, Boromir and Faramir—inhabit a liminal state between epic hero and modern protagonist. Their characters, sketched by Tolkien in *The Lord of the Rings* in compressed but evocative descriptions and supported by brief analyses in ancillary materials such as the appendices and the letters, have been fertile ground for adaptors and actors looking to portray psychological depth.

## "Maybe you discern from far away the air of Númenor"

Boromir's appearances in the novel, almost entirely contained within Book II of *The Fellowship of the Ring*, emphasizes his pride, physical strength, and heroic aspects, beginning with the description of him at the Council of Elrond: "a tall man with a fair and noble face . . . proud and stern of glance." His mistrust of the Elves is surely to be read as a point against him, in the same way that his brother Faramir's reverence is a point in his favor. Faramir sketches his brother's character to Frodo as proud and bold, and hints too at Boromir's resentment that he cannot be king, and the possibility of rivalry with Aragorn. Pippin, in Minas Tirith, nevertheless reflects upon the man's "lordly but kindly manner" and Appendix A of *The Lord of the Rings* describes him as "ever the helper and protector of Faramir." We are shown none of this kindness in the main action of the book (although this is in all likelihood the source of the film adaptation's brief and charming scene of Boromir's encouraging tutoring of the Hobbits in swordplay). Faramir, the younger brother, is, according to both himself and the appendices, valued less by his father and the people of Gondor than his brother, on account of his less warlike demeanor and his scholarly inclinations. (Tolkien, in Letter 180, writes: "As far as any character is 'like me' is it Faramir—except that I lack what all my characters possess [let the psychoanalysts note!] *Courage*.") In Ithilien, he presents himself as grave, but "wise and fair," he is the source of much as what we learn about Gondorian history, and he is a skillful interrogator of Frodo (and, later, of Éowyn).

The father of these men, Denethor, the Steward of Gondor, is one of Tolkien's most psychologically interesting creations. Both he and his second son, Faramir, according to Appendix A, are blessed with the gift of insight, able to "read the hearts of men," but whereas Faramir is moved to pity, Denethor is

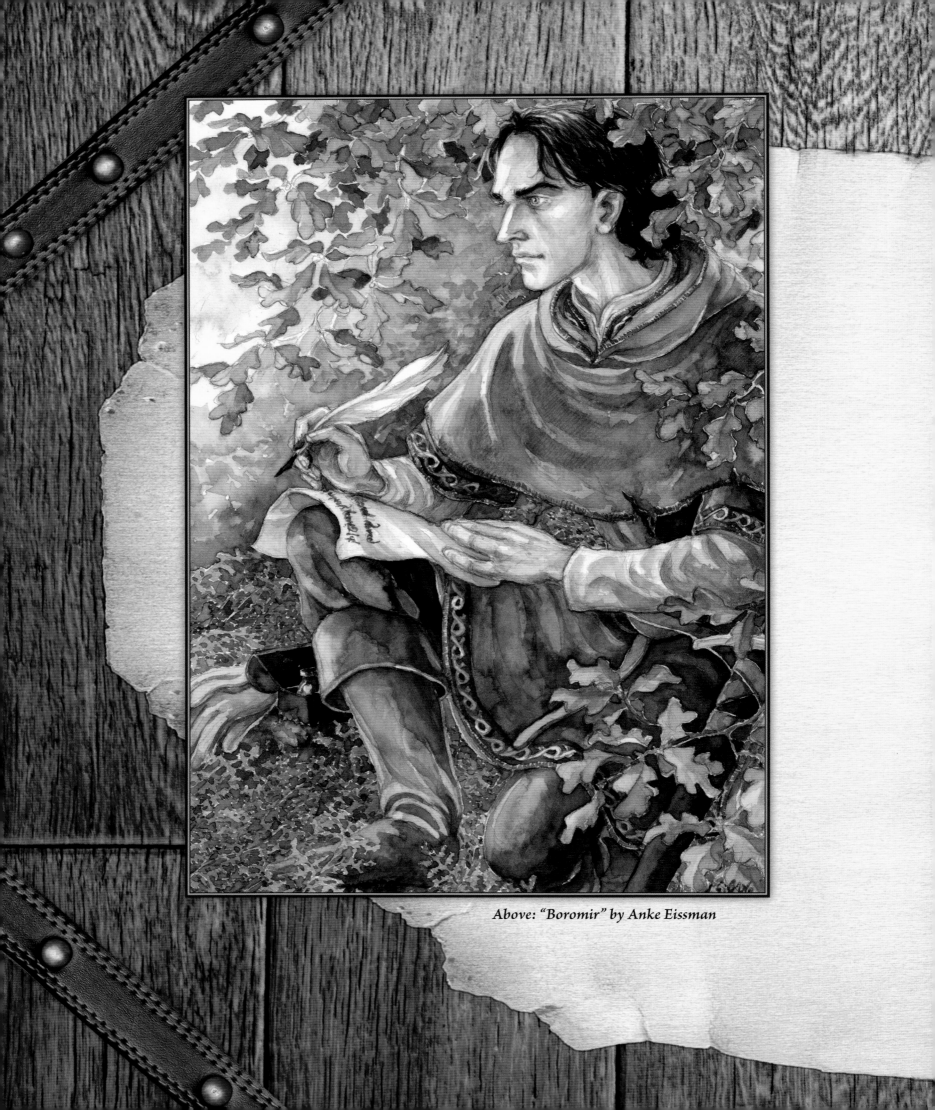

*Above: "Boromir" by Anke Eissman*

moved to scorn. The early death of his wife Finduilas is suggested in *Unfinished Tales* as a possible source of his "grimness," and his struggle with Sauron for control of the palantír as the cause of premature aging and later despair. (One wonders if there are echoes of Tolkien's own childhood after the death of his mother, left with his younger brother in the care of the daunting and elderly Father Francis.) Denethor is a master strategist, whom you feel could give even Gandalf the White a run for his money. His hopes for Gondor are pinned on the valor of his older son, and he mistrusts the romantic ideals of his younger son. The relationship between Denethor and Faramir is deftly laid out in two understated scenes in *The Return of the King*, where Denethor firstly grasps the extent to which Faramir is the "wizard's pupil" (Faramir having sent Frodo on his way with the Ring to Mordor), and a second devastating exchange in which Denethor manipulates Faramir, against his better judgment, to take command of the defense of Osgiliath. (Faramir's own manipulative skills are later shown directed toward better ends in his gentle but relentless courtship of Éowyn.) The drafts of these scenes in *The History of Middle-earth*, Volume 9, show how Tolkien moves steadily toward harsher versions of these encounters. These suggestively but minimally sketched characters have provided the gaps necessary for adaptors and actors to create their own interpretations.

## "We are become Middle Men"

One of the great successes of Peter Jackson's film of *The Fellowship of the Ring* is the narrative trajectory given to Boromir (Sean Bean). The potential rivalry with Aragorn (Viggo Mortensen) for leadership of Gondor is transformed into a subtle comparison of how both men respond to the ever-present temptation of the Ring, and what this means for their fitness for the kingship. Boromir's desire for the Ring is deftly explicated in two new scenes: the iconic image of him holding the Ring aloft on a snowy mountainside, and a quiet conversation with Aragorn in Lothlórien in which he speaks despairingly about his city's fortunes. Aragorn's (also added) appearance at Amon Hen is a logical conclusion of this thread: his refusal of Frodo's offer of the Ring contrasts with Boromir's attempt to seize it. Boromir's subsequent redemption is achieved in part through his defense of Merry and Pippin (as in the book), but also through his recognition of Aragorn not only as the better man, but as a worthy king (not present in the book, where Boromir "did not speak again," but perhaps a gesture toward Faramir's awakening in the Houses of Healing, where he acknowledges Aragorn as king). This is a skillful interpretation of Boromir's story, satisfying a modern desire for psychologically-driven characterization while operating within the constraints of screen time.

Screenwriters Philippa Boyens and Fran Walsh, speaking on DVD commentaries, persuasively argue that, having set up the Ring as such a powerfully tempting force in *The Fellowship of the Ring*, they were now presented with a narrative difficulty: Faramir's lack of reaction to the Ring—a mere "strange smile" and a glint of the eyes in the book— would undermine their efforts to make the Ring a present and plausible danger. Faramir's momentary reaction is therefore transformed into a moral struggle lasting most of the second half of *The Two Towers* as he tries to carry through his decision that the Ring should be taken to Minas Tirith, rather than letting Frodo and Sam go on their way. However, other choices made in adaptation critically undermine Faramir's character.

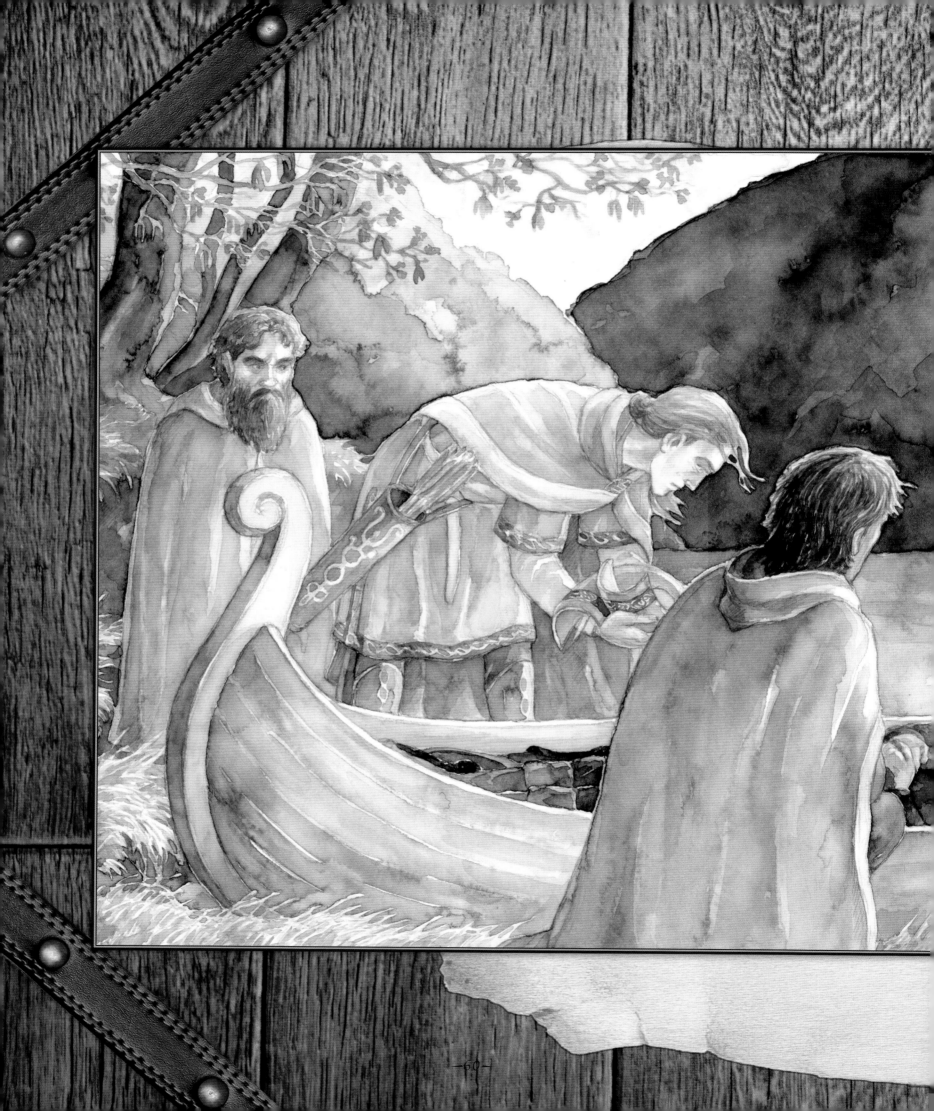

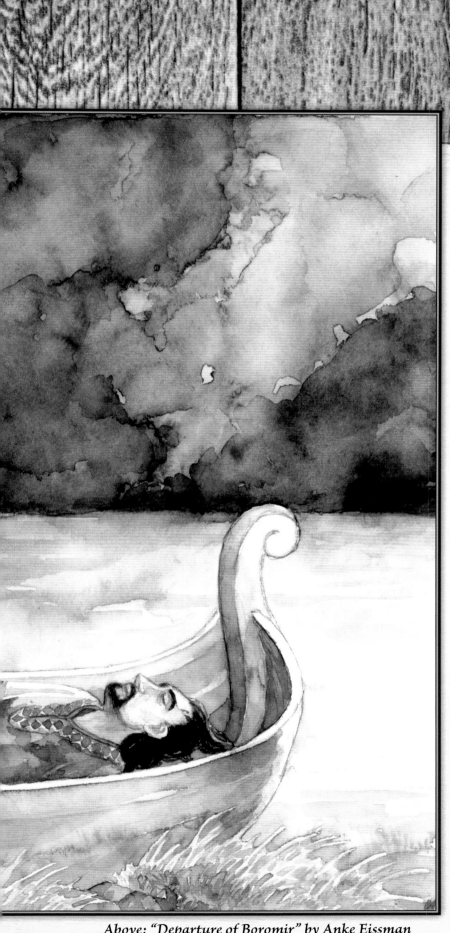

*Above: "Departure of Boromir" by Anke Eissman*

During the physical mistreatment of Gollum by the Ithilien Rangers, Faramir (David Wenham) turns his back, therefore simultaneously allowing these actions by his men while not acknowledging responsibility. The problems are compounded when Denethor (John Noble) finally makes his appearance in a bafflingly cartoonish performance that is not helped by a reductionist depiction of Faramir's mission to Osgiliath. The dogged defense of Gondor is transformed into an insanely reckless order. Faramir's continued obedience to this lord's commands is senseless. He is a poor prize for Éowyn.

## "Tears more unbearable than wrath"

The BBC's 1981 radio adaptation, without opportunity for spectacle, makes a virtue of small spaces and spare soundscapes to portray the complexities of the relationship between Denethor and Faramir. The quarrel over Faramir's decision to let Frodo go, the barbed debate over the defense of Osgiliath and, later, Denethor's crumbling into insanity after his son's return from the battlefield, near to death, are played out in bare echoing halls with the faint crackle of a burning city under siege to be heard in the background. Faramir (Andrew Seear), in scenes with Frodo, Denethor, and Éowyn, is a man who is, as Tolkien writes in Letter 244, despite a "bossy brother" and a "stern proud father," "evidently personally courageous and decisive." The two pivotal scenes with Denethor (Peter Vaughan) smolder with overt resentment on the part of the bereaved father and barely-checked restraint on the part of his grieving son.

were excised, although Sibley carefully included a line that hints that other adventures happened which weren't being dramatized, and indeed he would feature the sequence in a later radio series that focused on Bombadil. Sibley fought to include the Battle of Bywater, albeit in reduced form, as he felt that Tolkien wanted the events of the War of the Ring to be reflected in the Shire.

As with the earlier BBC version, the series used a narrator. "We primarily wanted to use that voice to get us as quickly as possible from A to B or to set a scene without having too many lines like, 'Look at those huge stone figures standing on either side of the river,'" Sibley later recalled. If one of the characters narrated the story, audiences would guess that he or she survived, so a narrator was created who occasionally reacted to events, but more typically was a step apart from them. The CD reissue of the serial in 2002 included some extra narration by Ian Holm in character as Frodo, but it was presumably felt by this time that audiences were aware enough of the story to know that the Hobbit returned to the Shire safely. The scripts were read through by Christopher Tolkien, who queried potential errors and provided the production with audio-cassette tapes with "authorized" pronunciations of key names. After four months of work, they were ready for recording.

Producer Jane Morgan was assisted by director Penny Lancaster on the epic project, with Sibley and Bakewell joining them in long discussions about the production, often held around Morgan's kitchen table. According to the liner notes from the 2002 CD release, Morgan "didn't want it to sound like science fiction" and was determined to choose actors "who sounded right and whose voices wouldn't need treatment."

Holm was cast as Frodo, an inspired and ideal choice, according to Sibley, with veteran actor Michael Hordern as Gandalf. The latter apparently never really understood what was going on, querying

**"It was made, I suppose, at a time when the BBC took risks and there used to be more opportunity for unconventional work."**
**—Ian Holm (on the third BBC _The Lord of the Rings_ audio adaption)**

why he had been hired for so many episodes when his character seemed to die earlier in the story! They were joined by a wealth of talented British actors, including Peter Woodthorpe—who revisited the role of Gollum that he had played in Ralph Bakshi's 1978 animated movie version of _The Lord of the Rings_—and similarly, Michael Graham Cox, portraying Boromir for a second time.

Music is an essential element of any Tolkien adaptation, and after revered English composer Sir Malcolm Arnold declined to be involved, the up-and-coming Stephen Oliver came aboard and adapted Tolkien's lyrics where necessary. He created a score that was so successful in its own right that it was rerecorded and released commercially.

The 26 episodes were recorded rapidly, usually over the space of a day and a half, and the first was broadcast at lunchtime on Sunday, March 8, 1981. The program was promoted with a cover feature in the _Radio Times_, the official BBC listings magazine for television and radio programs, with a badge given away proclaiming that "Radio is Hobbit-4-ming" to publicize the start of the run. This was the only time that it was transmitted in this format—it was subsequently re-edited into 13 one-hour editions, which were released on audio cassette and later on CD. For the 21st anniversary of the first broadcast, and to tie in with the Peter Jackson movies, the BBC revisited the recordings, removing the episode breaks and adding new material by Holm to introduce each of the three volumes.

Looking back in 2002, Jane Morgan recalled "a feeling of trepidation" before the first broadcast, "and it wasn't until the letters came flooding in that I knew we had got it right . . . As one listener wrote, 'Preparing the Sunday lunch will never be the same again.'" Thirty years later, Sibley and Bakewell's epic adaptation, which proved the old adage that "the pictures are better on radio," still remains the benchmark by which other versions of _The Lord of the Rings_ are judged.

*Above:* Radio Times *cover featuring Radio 4's serial dramatization of* The Lord of the Rings.

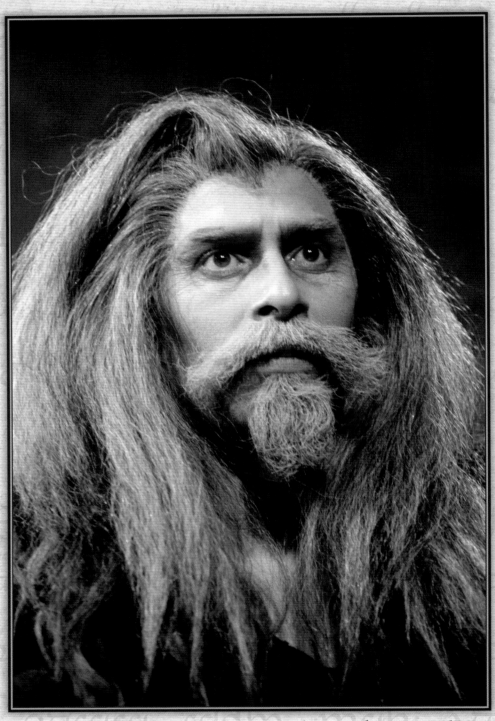

*Above: Gandalf as depicted in the Finnish television adaptation Hobitit ("The Hobbit") which drew on source material from both* The Hobbit *and* The Lord of the Rings.

# CHAPTER 6
# Television Adaptations

If it was a daunting task for Peter Jackson to think of adapting J.R.R. Tolkien's *The Lord of the Rings* as three lengthy but well-funded blockbuster movies, imagine the sheer foolhardiness of attempting to bring this complex trilogy of books to television, with all its limitations of scale and budget.

Foolhardy or brave would-be adapters were not discouraged, however, with freelance writer Carole Ward suggesting a BBC2 adaptation of *The Lord of the Rings* in a letter to the author in August 1964, just five months after the launch of the BBC's second television station. Tolkien noted he was "very skeptical about the whole idea," pointing out that a television version could damage or destroy a "complicated but closely woven story." Yet the approaches kept coming, with one from Britain's commercial television broadcaster ITV during the same period, and another suggesting *The Lord of the Rings* be done using puppets in the style of then-current *Thunderbirds* show. Of that proposal, Tolkien wrote that he hoped "we never hear any more about them." There was also an approach about producing an adult animated television version of *The Lord of the Rings* in 1968, the same year that Tolkien was interviewed for a BBC Television program on him and his work.

Alongside the Rankin/Bass television animation of *The Hobbit* (1977) and *The Return of the King: A Tale of the Hobbits* (1980) [covered in detail in *Chapter 10*], the most expansive television version of Tolkien's work is the 1993 nine-episode would-be epic created for Finnish television, with a total running time of 270 minutes (each episode is about 30 minutes).

*Above: A scene from the Finnish television adaptation of* **The Hobbit** *directed by Timo Torikka.*

The director was veteran Finnish actor Timo Torikka—whose previous directorial experience was on short films—with a screenplay from Toni Edelmann and Torikka. Edelmann, a prolific composer for documentaries and TV series, also supplied the music for *Hobitit* (meaning "The Hobbit") using a kind of

**Above: Blue-screen technology was used in the shooting of Hobitit, a technology that was not widely available in Finland at that time.**

(although Krohn is simply a reflection in a pool). Unlike Jackson's original trilogy, they even found room to include "Tom Bombadillo" (Esko Hukkanen). In an interesting departure from most versions, Boromir (Kristian Rundman) approximates a Samurai warrior in hairstyle and dress, with a bizarre snake tattoo on his forehead. Costumes, including Boromir's, were by Riitta Anttonen and Tiina Kupias.

Despite including much of the story, budget limitations obviously affected the producers' ambitions, with events in Gondor and Rohan simply mentioned in passing, crucially taking place off-screen. This allowed for the traditional focus on Frodo's journey that is the centerpiece of most successful adaptations. Edelmann's Hobbit-heavy television version drew upon the successful Finnish stage play of 1988–1989, and used many of the same actors. The play ran for around six hours and was performed for two summers running in an open-air amphitheater to many full houses.

The Hobbits most heavily featured were Frodo (Taneli Mäkelä) and Bilbo (Martti Suosalo), alongside Merry (here as "Merri," played by Jarmo Hyttinen) and Pippin (Jari Pehkonen). Vesa Vierikko channeled a more mystical and more mad-eyed Gandalf than is traditional.

Much of the shooting involved the blue-screen technology not widely used in Finland previously. Scale models of various environments (including the Shire and Bree) and artwork filled-in the backgrounds, making for a largely dialogue-driven, low-key version of Tolkien's work. This ambitious, but flawed, production was designed by Pablo Sikow.

The first episode—entitled "Bilbo"—has an elderly Sam Gamgee (Pertti Sveholm) relating the tale of his adventures (from the Red Book of Westmarch) to younger Hobbits who have not heard the story before (he describes it as a long story that he will summarize, thus explaining away some of the omissions and alterations). This episode encompasses most of the key points from *The Hobbit*, including Bilbo's crucial role in recovering the One Ring from Gollum, whose back story is explained and dramatized here. Sam pops up throughout the series to fill in

Middle-earth take on Finnish folk music. The series aired twice—between March 29 and May 24, 1993, and again in 1997–1998—on Finnish TV channel YLE TV1 and was shot in their studios in Helsinki and at the city's Rhymäteatteri theater.

The TV series drew freely on material from both *The Hobbit* and *The Lord of the Rings*, and featured a stylish animated opening depicting the forging of the One Ring. Aragorn—played by Kari Vaananen, who also doubles up as Gollum, dubbed "Klonkku" in Finnish—and Galadriel—played by Heidi Krohn—appear

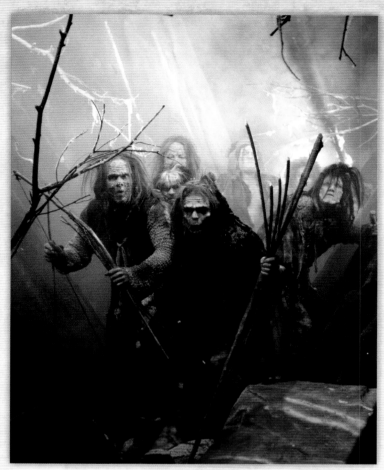

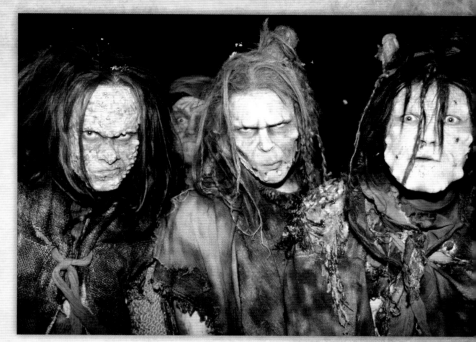

Above: Costumes for the 1993 Finnish television adaptation **Hobitit** were designed by Tiitta Anttonen and Tiina Kupias.

*Above: The Finnish television adaptation of* The Hobbit *and* The Lord of the Rings *drew heavily upon the successful stage production in Finland in the late 1980s.*

gaps where this television version cannot encompass major battle scenes or much in the way of action-driven adventure.

The second episode—entitled "Tie," or "The Road"—jumps to the beginning of *The Fellowship of the Ring*, with the return of Gandalf and the start of the Hobbits' quest. The third installment, entitled "Vanha metsä," or "Old Forest," features appearances by Tom Bombadil and Saruman in Isengard. Episodes four ("Pomppiva pony," or "The Prancing Pony") and five ("Konkari," or "Strider") feature Aragorn, while six ("Lorien") and seven ("Mordor") rush the Hobbits through the Mines of Moria to their destiny in Mordor. Much of *The Two Towers* is dispensed with, referred to only in dialogue (the Balrog and Shelob are mentioned, but not actually seen, while the Nazgûl is little more than a threatening shadow), and the final two episodes ("Tuomiovuori," meaning "Mount Doom" or "Judgment Mountain," and "Vapautus," meaning "Liberation" or even "Release") cram in the events of

*The Return of the King,* heavily abridged.

In a 2004 edition of The Tolkien Society's magazine *Legolas*, Juho Gröndahl described *Hobitit* as capturing "the atmosphere and the spirit of the books," despite the obvious budgetary limitations and poor background scenery, something Peter Jackson was not lacking in his use of New Zealand's natural landscapes. He described the actors' performances as "thoughtful" and believed they had captured the "look and feel" of Tolkien's characters. The focus on telling the story almost entirely from the point-of-view of the Hobbits made this Finnish take on the novels a suitable way of tackling the material for the smaller scope of television compared to the open-ended imagination of radio, or epic, big-budget widescreen cinema.

Displaying its stage origins a bit too obviously, this Finnish version of *The Hobbit* and *The Lord of the Rings* has been compared to the BBC's special-effects challenged adaptation of Tolkien's fellow Inkling C.S. Lewis's *The Chronicles of Narnia* from 1988–1990. Overall the piece is lacking in humor, which when combined with the low production values give it the feel of an earnest, well-meant high school play, rather than dramatic television.

## "It Was the Dawn of the Third Age . . ."

*by Jill Sherwin*

Once there was a world-builder.

He dreamed of a universe filled with magical beings, dark creatures, safe havens, and hope for the future.

He told his story in multiple adventures, with various appended material added on throughout the writing, and Lost Tales explored afterward, which told of further adventures that occurred while the main action was happening.

It was a story of good and evil, light and darkness and which paths people followed in their journeys. An overriding question was: Who would inherit the world and help unify it in the wake of the old races'

passing on? Who would take power and who would wield it justly?

As in our own world, there were various races of peoples with their own cultures and agendas. None seemed to get along well with or trust the others.

The main races included a quiet, spiritual, long-lived elder race whose power was starting to wane. A wise Council led them, guided them and determined their long-term goals.

There was also a fiercely proud warrior race, oppressed and driven from their homeland vowing to one day return and re-conquer.

And then there were those trained to guard and protect the world once the elder race passed from it. They swore to walk in the dark places that no one else would enter and stand on the bridge, so that none may pass.

There were also rarely seen almost mythical, larger-than-life mystical beings that periodically interfered with the course of other races' destinies.

The first adventure seemed to start out simply, with a lighthearted tone, much humor, and a mystery. At the dawn of the Third Age, an unlikely hero was drawn into events and a battle against powers he could not yet imagine. And his successor would rise to rid the worlds of a dangerous threat aided by a coalition of beings magical, mystical, and lethal. This unlikely team would come together for the sake of their future—rangers, warriors, mages, and elder beings.

Both protagonists would be marked and pulled into their

journeys by the same sagacious mysterious powerful figure that seemingly died but returned anew. And both protagonists would encounter among others a creature dwelling underground in a warren of tunnels that talked to himself and whom no one else took seriously but who would have a great impact on both their destinies.

Later stories grew much darker and focused on the successor to the original protagonist, as he fought the dark servants of the enemy.

There were tales of great battles and tales of great romances. One man would fall in love with a member of the elder race and their marriage would change the course of both races' futures.

There were politics and intrigues, trusts and loyalties given along with unexpected betrayals. Over the course of fighting the enemy, the homeland of the protagonists was attacked and devastated.

There were warnings given to not upset Wizards for they were subtle and quick to anger. Other characters would disappear into the unknown with the simple caveat to expect them . . . when they saw them.

The enemy used a Great Eye to guard their location. And one man was warned that he would die in the shadows of a dreaded place called Z'ha'dum. And in the end, the successor would be taken beyond with the oldest races, who left the known worlds after the Great War.

And so it was that a beautiful homage/love letter to J.R.R. Tolkien's Middle-earth was created by J. Michael Straczynski.

And it was a science fiction television series called *Babylon 5*.

Before shows such as *Farscape* or *Game of Thrones*, *Babylon 5* was an epic tale told on a scale no science fiction or fantasy series had dared to attempt. A series of novels for television, each season was a volume in the multi-year tale written almost entirely by one writer, something that hadn't been attempted previously to this extent on American television.

*Babylon 5*'s main storyline—that of the last days of the grand experiment of the Babylon space stations—was supplemented by TV movies, spin-off attempts, and the brief but filled-with-potential sequel series *Crusade*, which would feature other wizards and dragons and the search for a seemingly magical solution to their quest. These were Straczynski's appendices and Lost Tales.

His heroes Jeffrey Sinclair and John Sheridan were the inheritors of Bilbo and Frodo Baggins' spiritual mantels. That angel of the First Ones, Kosh, may as well have been a certain gray-bearded Maia. Marcus Cole the Ranger seemed Aragorn's noble, space-faring brother. The wormtongued Mr. Morden who whispered evil into the ears of those gullible enough to believe him, helped corrupt entire races. And a magical being named Lorien kept alive a dying hero in a sacred place by using his own brand of magic.

*Babylon 5* was not a direct retelling of *The Lord of the Rings*, but Straczynski's clear love and respect for that material were a strong influence in both the way the *Babylon 5* story unfolded and in the archetypes and nods found within.

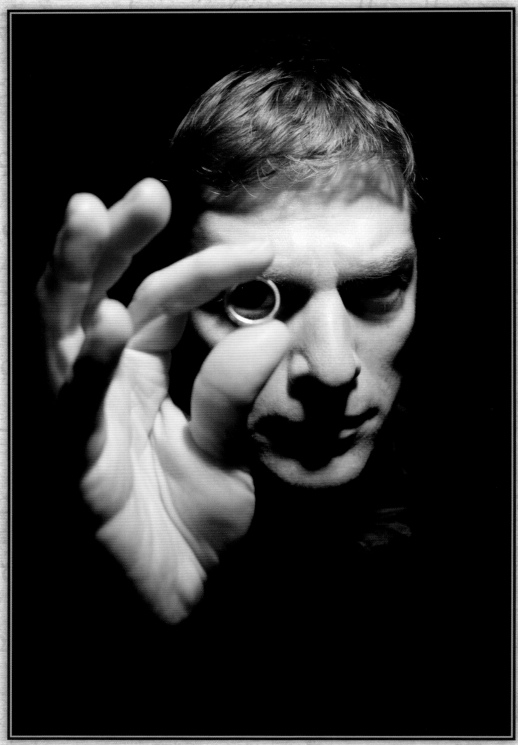

*Above: Charles Ross, known for his high-velocity, one-hour performance of*
*The Lord of the Rings, is peering through the One Ring.*

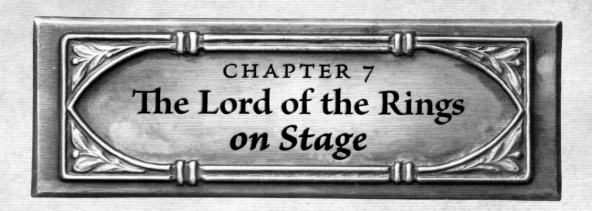

# CHAPTER 7
## The Lord of the Rings
## *on Stage*

J.R.R. Tolkien was very clear: "Here is a book very unsuitable for dramatic or semi-dramatic representation," he wrote Terence Tiller, who had the unenviable task of producing a highly-condensed version of *The Lord of the Rings* for BBC radio in 1956. "If that is attempted it needs . . . a lot of space." Unfortunately the constraints of live theater have meant that no production would ever be likely to meet his stringent parameters.

In the same way that he allowed school performances of *The Hobbit*, Tolkien gave permission for such versions of *The Lord of the Rings*. A pageant play in December 1959 is the first known adaptation. The following year saw at least two stagings, one by Joyce Biddell of Maidstone, Kent, and the other by a schoolteacher who was allowed to give only one performance of her version. In July 1966, Tolkien was invited to Pate's Junior School in Cheltenham by the adapter, Mrs. Webster, but he was unable to attend. As he pointed out at various times, he might be "personally averse to any dramatization of my works, especially *The Lord of the Rings*," but he wasn't going to be "so bigoted" to prevent a project that schoolteachers and children would enjoy.

Rob Inglis performed a live one-man version of the entire trilogy, which was heavily abbreviated, prior to recording both it and

*The Hobbit* in 1990. Canadian actor, playwright, and—by his own admission—"professional geek" Charles Ross has performed his own one-hour version around the world since 2009, which "careers at breakneck speed" through the novels while still adding in the odd sardonic comment about inconsistencies in the books. Perhaps not surprisingly, Sir Ian McKellen's comment that "If you liked *Lord of the Rings*, you'll love Charlie Ross's version" is prominently displayed on his posters.

The producers at Chicago's Lifeline Theatre didn't try to condense everything into one show—they followed the structure imposed on *The Lord of the Rings* by Tolkien's publishers, and divided it into three separate plays, premiering in 1997, 2000, and 2001 respectively. Kevin McCoy's adaptation of *The Fellowship of the Ring* was hailed by the *Chicago Reader* as an "exceedingly well acted and sumptuously-designed production." However, it pointed out the frequent discussions that people needed a scorecard or an atlas to understand them, "creating stagnant, talky sections in between the gleeful, thrilling action sequences"—a criticism that would also be leveled at the multimillion dollar production in Toronto and London's West End a few years later.

The same paper was more enthusiastic about James Sie and Karen Tarjan's two-hour long follow-up, *The Two Towers*. (McCoy had

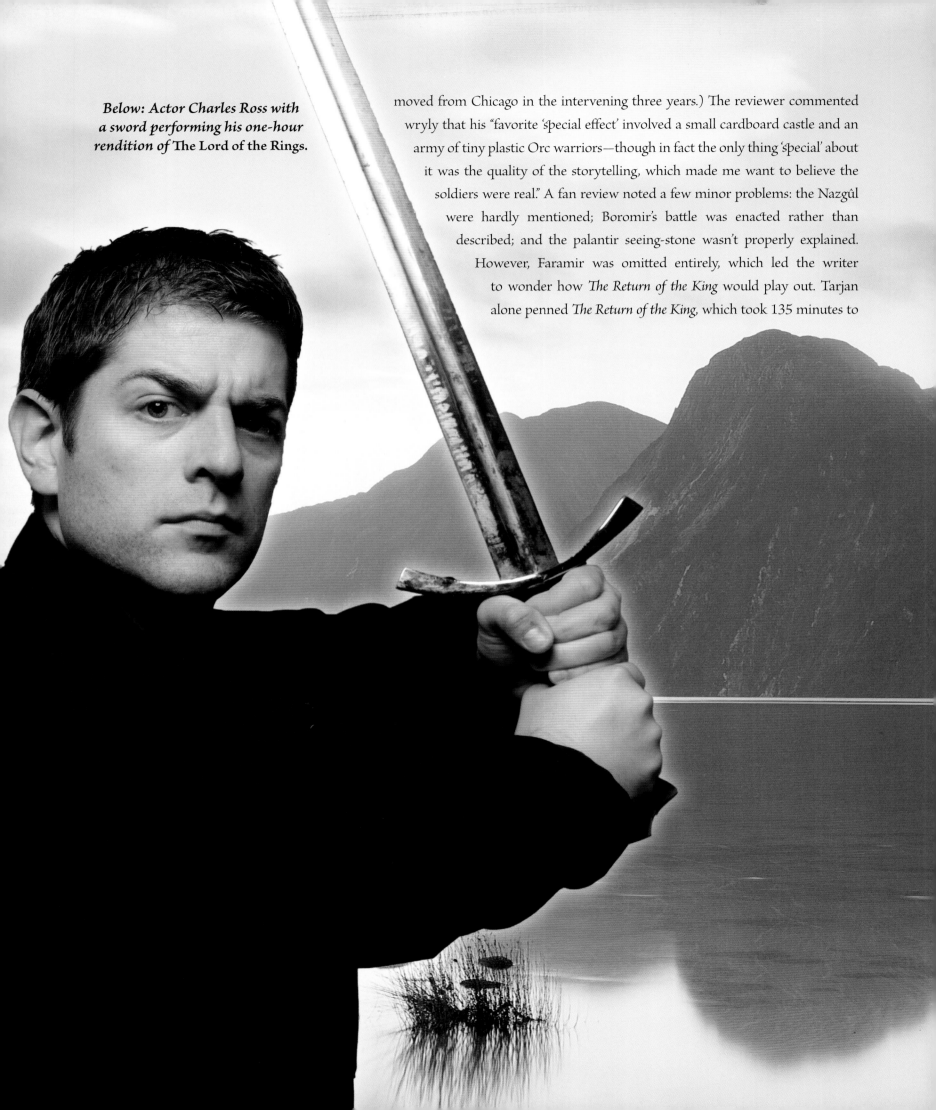

**Below: Actor Charles Ross with a sword performing his one-hour rendition of The Lord of the Rings.**

moved from Chicago in the intervening three years.) The reviewer commented wryly that his "favorite 'special effect' involved a small cardboard castle and an army of tiny plastic Orc warriors—though in fact the only thing 'special' about it was the quality of the storytelling, which made me want to believe the soldiers were real." A fan review noted a few minor problems: the Nazgûl were hardly mentioned; Boromir's battle was enacted rather than described; and the palantir seeing-stone wasn't properly explained. However, Faramir was omitted entirely, which led the writer to wonder how *The Return of the King* would play out. Tarjan alone penned *The Return of the King*, which took 135 minutes to

bring the story to a close in a version which the *Chicago Reader* noted was "faithful down to the commas," although the *Chicago Tribune* did notice "a few more uneven passages than was the case with its predecessors."

As the Chicago productions were winding down, the Ovation Theatre Company of Cincinnati began its trilogy of adaptations with *The Fellowship of the Ring* in September 2001. Eventually advertised as the first time that one person had been responsible for dramatizing all three plays for the stage, it featured musical versions of Tolkien's songs, which were sung by the gender-blind cast—Gandalf, Merry, Pippin, Gollum, and Gimli were all played by women, with Gandalf's beard created with flowing scarves. Like the Sibley/Bakewell radio adaptation and the Jackson movies, writer Blake Bowden drew inspiration from all of Tolkien's writings about Middle-earth, with

elements such as Elrond and Aragorn's talk before he leaves Rivendell, where Aragorn is warned that he must ascend his throne before Arwen can be his bride, as delineated in Tolkien's appendices.

*The Two Towers* followed in October 2002, and played to larger audiences than its predecessor. By then, Peter Jackson's movie of *The Fellowship of the Ring* had opened, and while that certainly helped to attract people, it meant that some elements of the production, notably the costuming, were influenced by the look of the film. However, both Treebeard and Shelob demonstrated the originality seen in the first play, with what were described as "Edward Scissorhands-type appendages" for the former, and the use of glowing red eyes approaching the audience particularly effective for the latter.

A new company, Clear Stage Cincinnati, completed the trilogy in October 2003. Bowden finished his version in style, to provide "the most successful and polished of the three stage productions [which] should please Tolkien fans," according to the *Cincinnati Enquirer*.

"When I saw [a] theater-workshop of *The Odyssey*, I knew that Tolkien should be on the stage as well," Bowden said, explaining that he had understood the power of myth while working with terminally ill children during his residency as a child psychologist in Boston. "My bag of tricks didn't work with kids who were dying. But spending the time to read a compelling story of a hero's journey seemed to help them come to terms with their lives and where they were going."

By this stage, preparations were well underway for the major production that would premiere in Toronto, Canada, before transferring to London's West End. However, before that opened in 2006, a much smaller production made its debut on January 25, 2005, in the El Portal Theatre in North Hollywood, California. Greeted with considerably more acclaim than the big-budget version, *Fellowship!* did for *The Lord of the Rings*—or at least, the first book of it—what the 1980s musical *Little Shop of Horrors* did for the original 1960 Roger Corman film.

*Fellowship!* was devised by Los Angeles writers Kelly Holden-Bashar and Joel McCrary in 2004. "We were laughing about movies that should never been turned into musicals, but when we got to *The Lord of the Rings: The Musical*, we realized it wasn't such a bad idea," McCrary recalled in an interview for this book. "We sat down and hit some bullet points from what we remembered of the story, and before we knew it, we were in the middle of writing the show. Within a few months we had the first draft, and knew the placement of the songs. It stayed surprisingly close to that original draft; we tightened a few things but it remained close to that blueprint."

At that point they brought in composer Allen Simpson to pen songs that cross various genres (and are a long way from Tolkien's intentions), and then, in concert with the cast of improv

> ## "We weren't making fun of the genre—at various levels, we all loved the source material. We wanted to tell the story in a funny way."
> —Joel McCrary, co-writer of *Fellowship!*

comedians they assembled, they developed the book and songs. "Allen was a big *Lord of the Rings* fan, and called us on a couple of things in the script," McCrary noted. "When we went back and found he was right, we knew he was the right guy." What resulted was a parody of not just Tolkien's original story, but also Jackson's films. ("History became legend, legend became myth, myth became a book, the book became a movie, and tonight the movie becomes a musical!" Galadriel explains at the start of the show.) The cast of nine plays the Fellowship and all the other roles, so Merry doubles Elrond, and Sam is the Balrog.

"We didn't want to be mean-spirited," McCrary explained. "We weren't making fun of the genre—at various levels, we all loved the source material. We wanted to tell the story in a funny way." The hardest song to write was a pastiche of 1980s power ballads called "One Moment With You." "We looked at the originals, and

it was hard to write lyrics that were that bad. Once we got the first verse and a chorus, we realized we needed another verse of the song. So we said, 'What if the second verse was just Elvish gibberish? That way we don't have to write another verse.' " Although the Elvish sounds authentic to begin with, astute listeners will notice some words Tolkien would never use.

*Fellowship!* was put on "as a lark for a three-week run in Los Angeles in a small theatre. After we extended our run several times, I looked out and saw there wasn't a single person in the audience I knew—that's a rare thing in Los Angeles theater. Our first week, we had 75 people in our 99-seat house; but the *L.A. Times* gave us a tremendous review, and then we just sold out."

*Fellowship!* won various awards, including Best Comedy Ensemble and Musical of the Year at the 2006 LA Weekly Theater Awards, and a 2009 revival at the Falcon Theatre in Burbank, California, was hailed as Best Local Stage Production: Small Theatre by the Saturn Awards, which reward excellence in science fiction, fantasy, and horror.

In years to come, it's possible that the 2006 musical version of *The Lord of the Rings* may become best known for its use in the 2007 David Schwimmer movie *Run Fatboy Run*, in which a visit

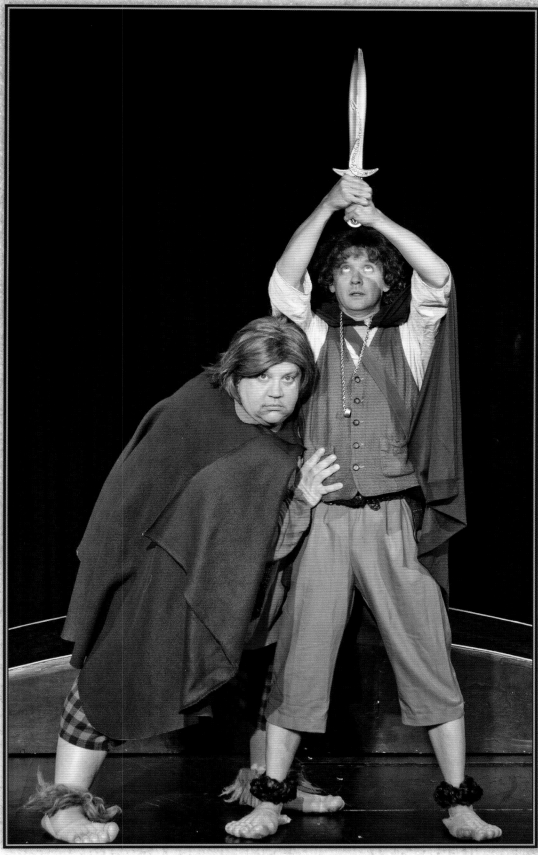

*Above: Frodo and Sam strike a Star Wars pose in the award-winning musical parody* **Fellowship!** *written by Joel McCrary and Kelly Holden-Bashar and featuring music by Allen Simpson.*

to the London production is a key battleground between Simon Pegg and Thandie Newton's characters. That may be preferable to its current reputation as one of the biggest failures in West End stage history. Many articles have been written trying to work out what went wrong, but the *National Geographic* documentary about its creation certainly highlights some of its inherent flaws.

The genesis of the show was in a German adaptation of Tolkien's work by Bernd Stromberger that was advertised as being *The Lord of the Rings*, but was, in fact, a retelling of *The Hobbit*. This version had played in a tent in Berlin, and British director Stuart Wood was invited to help salvage the show, which was experiencing problems. When that proved impossible, a new version was started, with a script by veteran adapter Shaun McKenna, which producer Kevin Wallace used in 2002 to request a license from Tolkien Enterprises and Saul Zaentz, who owned rights as a result of earlier attempts to film the trilogy (see *Chapter 10* for more details). Wallace was envisioning a major show that would start in London, and, assuming that was successful, open around the world, in the same way that *The Phantom of the Opera* and *The Lion King* had done. A license couldn't be granted until early 2003, after the film of *The Two Towers* had opened in theaters.

Before then, work continued to refine the script, with a great deal of assistance from Laurie Battle, the Creative Consultant for Tolkien Enterprises, and a demo CD was produced with music by Stromberger and British composer Stephen Keeling. Wallace pitched the production in February 2003 and received the green

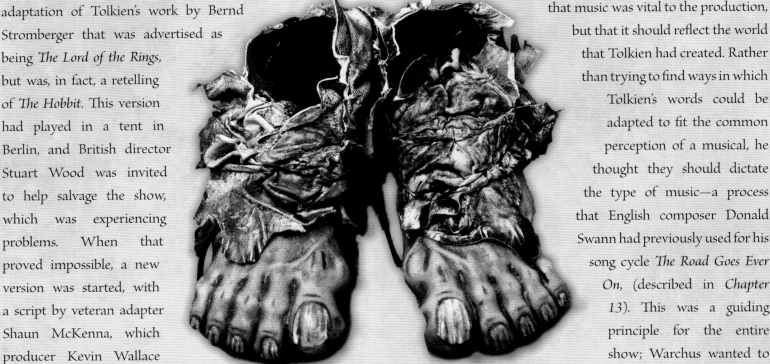

*Above: **Hobbit feet** from London's*
**The Lord of the Rings** *musical*.

light, based on the involvement of director Matthew Warchus.

Warchus, who had a strong track record as a director with the Royal Shakespeare Company and other major companies, was keen that the production didn't obey any of the conventions of the musical theater genre. After much debate, this eventually led to his jettisoning the music already written for the show and finding new composers. He was convinced that music was vital to the production, but that it should reflect the world that Tolkien had created. Rather than trying to find ways in which Tolkien's words could be adapted to fit the common perception of a musical, he thought they should dictate the type of music—a process that English composer Donald Swann had previously used for his song cycle *The Road Goes Ever On*, (described in *Chapter 13*). This was a guiding principle for the entire show; Warchus wanted to create a "very holistic" piece, where all the elements—dialogue, music, design, choreography, and even the casting—formed part of the same world.

Long before a theater was booked, the production team workshopped the script, as revised by Warchus and McKenna, with ten actors; after two days of discussions, the entire first act was rewritten overnight by McKenna, and two weeks later, they felt that they had solid drafts of the entire three acts. This workshopping process was repeated at various points during pre-production of the show to ensure that there were no inherent faults that might become apparent when it was too late to correct them. The workshopping sessions were not intended as casting sessions, but a few of the actors involved went on to play the roles in Toronto.

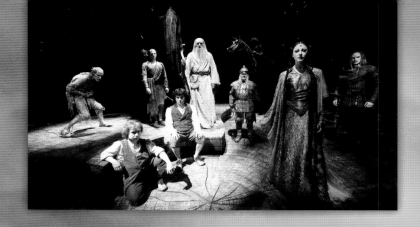

Left: The Lord of the Rings musical at Drury Lane Theatre Royal in London.

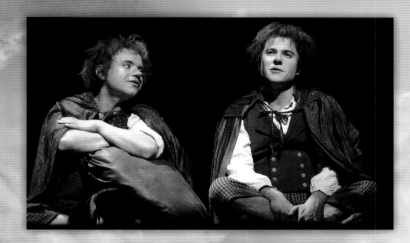

Left: Hobbit characters Frodo and Sam at the preview of the The Lord of the Rings musical in September 2006 at the Drury Lane Theatre Royal.

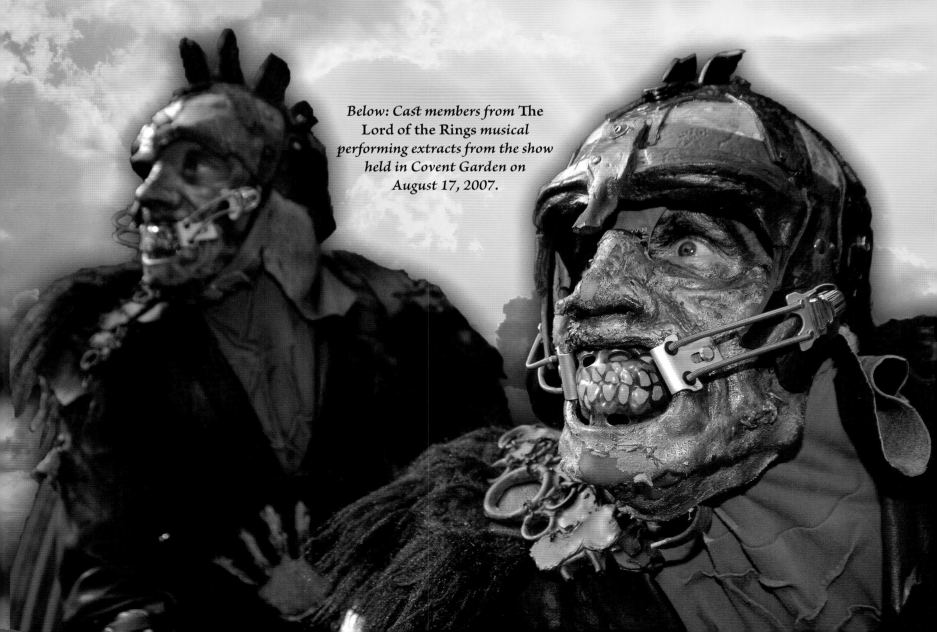

Below: Cast members from The Lord of the Rings musical performing extracts from the show held in Covent Garden on August 17, 2007.

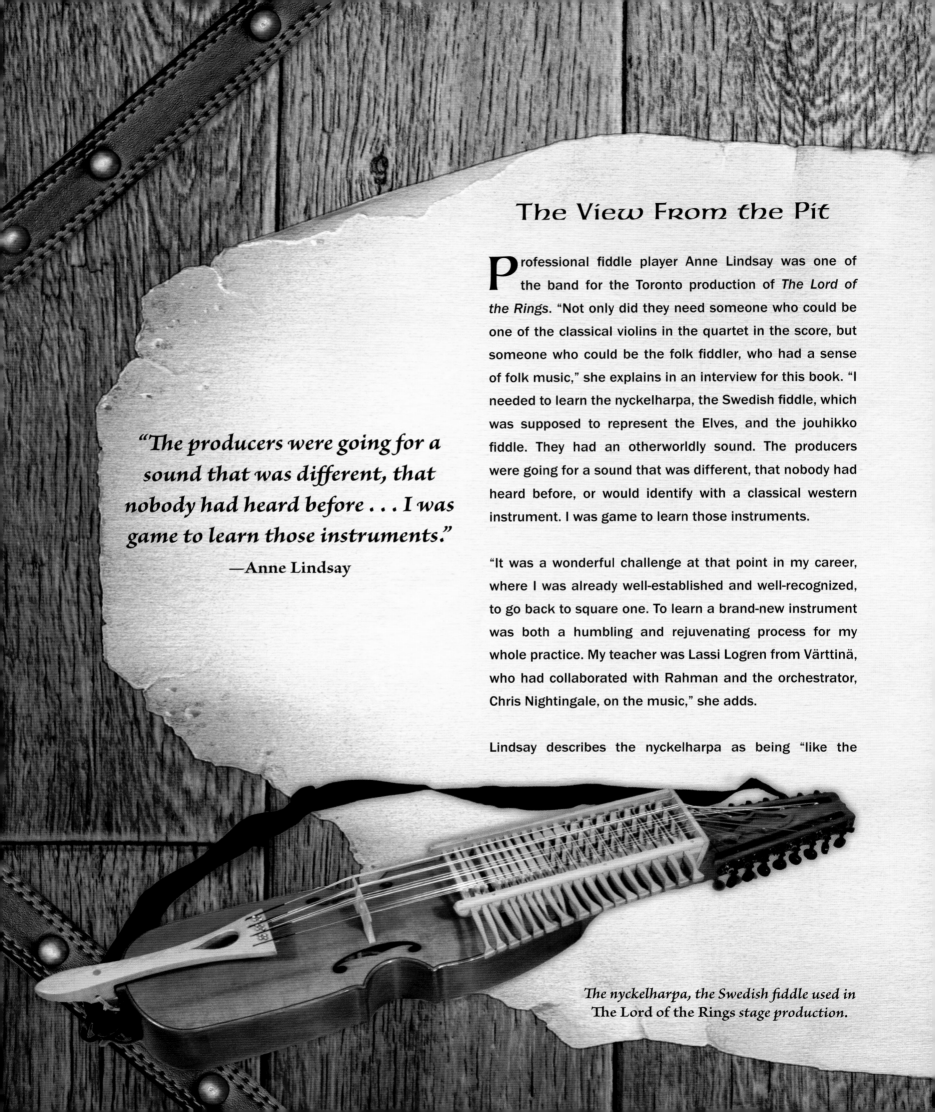

# The View From the Pit

Professional fiddle player Anne Lindsay was one of the band for the Toronto production of *The Lord of the Rings*. "Not only did they need someone who could be one of the classical violins in the quartet in the score, but someone who could be the folk fiddler, who had a sense of folk music," she explains in an interview for this book. "I needed to learn the nyckelharpa, the Swedish fiddle, which was supposed to represent the Elves, and the jouhikko fiddle. They had an otherworldly sound. The producers were going for a sound that was different, that nobody had heard before, or would identify with a classical western instrument. I was game to learn those instruments.

"It was a wonderful challenge at that point in my career, where I was already well-established and well-recognized, to go back to square one. To learn a brand-new instrument was both a humbling and rejuvenating process for my whole practice. My teacher was Lassi Logren from Värttinä, who had collaborated with Rahman and the orchestrator, Chris Nightingale, on the music," she adds.

Lindsay describes the nyckelharpa as being "like the

> *"The producers were going for a sound that was different, that nobody had heard before . . . I was game to learn those instruments."*
>
> —Anne Lindsay

*The nyckelharpa, the Swedish fiddle used in* The Lord of the Rings *stage production.*

accordion of the fiddle family. It's got keys that you press which stop the four strings with wooden ties." It's bowed—although it uses a technique that is counterintuitive for a regular violinist—and has a similar range to a viola, except the strings are tuned to C, G, C, and A. "It sounds quite a bit like a cello, without the low range of the cello. It has a deeper sound than a viola. But what makes it sound so otherworldly are the sympathetic strings underneath those four strings: there are 12 of them, tuned chromatically from G, which just resonate. They pick up on all the harmonics of the bowed strings."

The jouhikko hails from Finland. "It's a wooden box that's hollowed out, with strings made from ice-fishing line. It's like a bowed lyre, and is played sitting down. It had almost died out in Finland by the 1950s, but the whole folk music revival got people asking about the instruments their elders were playing," Lindsay explains. "They're very hard to play, because the finger placement is very random. It's very scratchy and very simple. It's very difficult to tune; we used to kid in the orchestra pit that when you were talking about the jouhikko, 'tuning' was an oxymoron."

In the show, the jouhikko was used for the Hobbit fiddle. "In one of the early versions of the prologue, they had me on stage dressed as a Hobbit playing the jouhikko, which was very fun. The strangeness of the instrument gave the audience something else to think about. In later versions, during the prologue it was just the folk band playing—accordion, bouzouki, jouhikko, and percussion—and we would take off and improvise on a theme."

Lindsay was involved throughout the Toronto run, playing six different instruments. "I had to switch back and forth in the show between my classical violin, my folk fiddle (which has a different, woodier sound), the nyckelharpa, two alto jouhikkos, and one treble."

And no two days were the same. "When we first went into rehearsals, the show was five hours long, and they kept cutting. It's not unusual to have things changing before the premiere of a show, but these were dramatic cuts—I'm still using music that got cut or rewritten. It was a great job for the music copyists; they were up all night doing the reruns, and handing new parts to the orchestra as we came in."

Lindsay volunteered to come to London, but realized it wasn't practical. "I was involved in a little bit of the preparation for London, because they were thinking about what to cut. They would ask me if I thought it would work if they cut the nyckelharpa from the show, and in the end, I think they did and just used samples on the synthesizer.

The end of the run came at a perfect time for Lindsay, who had been concerned about the restriction of playing the same music every day for eight shows a week. "I wasn't sure creatively if I could handle it," she admits. "I was starting to go nuts, and training sub[stitute]s for me was very difficult, because they had to learn the instruments. When it finished, I was needing a change. But I loved the score; it was a perfect fit for me, and I admired so many of the people I got to work with."

As a result of her experiences with *The Lord of the Rings*, Lindsay has incorporated both the nyckelharpa and the jouhikko into her own performing repertoire, and has even composed new music for both instruments.

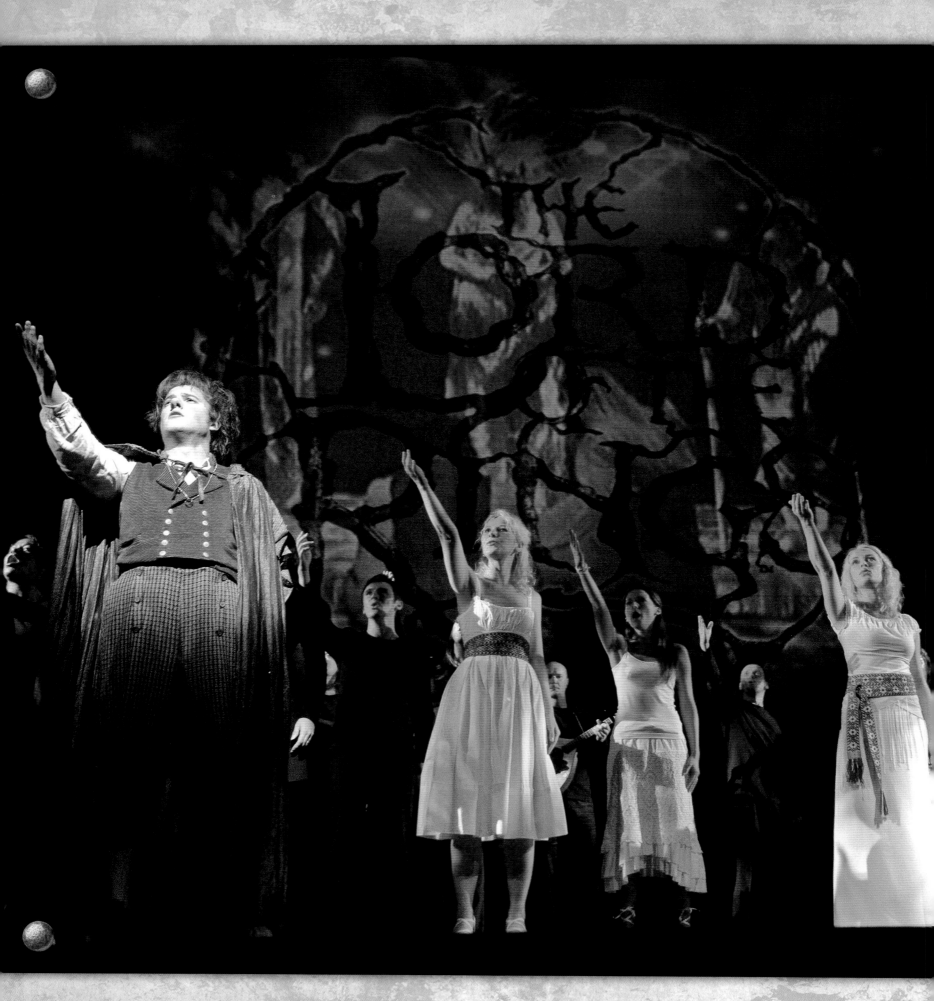

Some of the changes that the writers made to the script were a direct result of watching Peter Jackson's movies, in particular the treatment of the character of Arwen, who was fleshed out considerably. Faramir was removed entirely, because McKenna didn't feel his character worked within the parameters of their production. Translating over 1,000 pages into three-and-a-half hours meant that many such decisions had to be taken, and McKenna freely admitted that he wasn't a complete Tolkien fan, so could look at the material more objectively than others. These decisions continued right up to the opening—at one stage, the Ents were lost completely, and the character of Wormtongue was in some drafts but not others.

The music was supervised by Christopher Nightingale, who brought two very different composers on board in an effort to encapsulate the wide-ranging world Tolkien created in *The Lord of the Rings*. Indian musician A. R. Rahman, best known for his Bollywood scores, and Finnish folk group Värttinä were the eventual selections—the music of the latter was already influenced by the same roots that Tolkien had used to create the Elvish languages, such as the *Kalevala*, the Finnish national epic of myths, songs, and spells. Värttinä started off composing based on the script, not realizing that their work would be amalgamated with Rahman's music, as well as McKenna's lyrics (which were based on Tolkien's, but quite consciously did not use his originals). The eventual collaboration was smoothed over musically by Nightingale, who wanted to ensure that the audience wouldn't be able to link specific sequences to the different composers, but instead had its own unique style. Some of the lyrics were written in Anglo-Saxon as well as the Elvish languages Quenya and Sindarin, with technical assistance for these provided by various linguistic scholars. Every theatrical trick in the book was used to bring the story to life on stage in Toronto and London. Computer effects, on-stage magic, dance, circus performers bringing the Ents to life, puppeteers manipulating the giant Shelob—the production turned to whatever they felt would make the show

*Left: The production for **The Lord of the Rings** musical featured a cast of over 50 actors and cost over 25 million pounds to produce. The official premiere date was June 19, 2007 at the Theatre Royal on Drury Lane.*

work. "We haven't set out to create a musical of *The Lord of the Rings*, a play of *The Lord of the Rings*, or a spectacle of *The Lord of the Rings*," Wallace announced. "It is a hybrid production, because this is not any of those things singularly—it is all of those things."

Although Wallace had hoped to open the show in London, he was unable to find the right venue; he didn't want to launch it in New York, since he felt Broadway was "such a fickle place" where it was impossible to tell what tone would strike home with an audience. They considered Chicago, but eventually decided to go to Toronto. Local producers helped finance the show, as did the city and provincial governments, who were hoping to use it as a publicity tool for tourism. Even Air Canada became involved. In February 2006, *The Lord of the Rings* began previews at the Princess of Wales Theatre in Toronto, with a running time of about three hours and forty minutes. During previews this was reduced by twenty minutes, losing a minute here or there from some sequences, and cutting out the Paths of the Dead. When the show transferred to London after its seven-month run in Canada, an additional 20 minutes were removed, including the excision of the show's prologue.

The show had to perform well to make its money back. Before it opened in Toronto, *Time* magazine hailed what they described

*Above: The cast gets ready in the makeup room backstage at the Drury Lane Theatre for* The Lord of the Rings *musical.*

as "the thinking man's *Cats*" as the most expensive show on or off Broadway, at a cost, they estimated, of 28.2 million Canadian dollars. Reviews were mixed. The *Toronto Star* said the audience was left "bored of the Rings" with the actors like "pawns in a giant rapid-fire chess game." In a review that didn't bode well for the eventual transfer to the West End, the London *Daily Telegraph*'s Charles Spencer felt that there was "nothing here to rival the imaginative visual coups and heart-tugging emotion of such great family shows as *Billy Elliot*, *The Lion King*, and *Mary Poppins*." However the *Boston Globe* was more positive. The team had "created a stage epic that is surprisingly smart and visually stunning, and does not feature Frodo singing about a few of his favorite rings" although the reviewer concluded that it was "a spectacle-filled evening that will win over droves of *Lord of the Rings* fans, but may leave the unconvinced unconvinced."

*The Lord of the Rings* played to over 400,000 "guests" during its Toronto run, which came to an end in September 2006, much earlier than originally anticipated and without repaying its investors. Major revisions were undertaken before the show was previewed in London the following May. The script went through further rewrites, reducing the cast from 65 to 50. The orchestrations were redone, and the use of some of the more eclectic instruments featured in the original were removed (see pages 78-79). What the producers perhaps failed to address was the show's lack of identity. They still tried to include as many characters and situations from the book as possible, which led to multiple cameos which were simply confusing to any audience member who wasn't as conversant with the original books—or even the films—as the authors.

It needed to recoup £350,000 a week during its British run; it did not do so. During school vacations, houses were full, but outside those times, it lost money. It was clear to most of the cast that it was not going to achieve the success it required, and a number of the lead actors did not renew their contracts in the summer of 2008. Ironically, just before the long summer school vacation began in July 2008, and after 492 performances, including previews, the London production closed. Although there was talk of a smaller-sized version touring Europe and Australia, there has been no sign of such a tour.

Many of the team, including Warchus, Nightingale, and key members of the cast went on to create the highly successful West End adaptation of Roald Dahl's story *Matilda* in 2011, which opened on Broadway in March 2013. Following the failure in the West End, the only live performances of *The Lord of the Rings* have been screenings of the Peter Jackson movies, with a live orchestra playing the score.

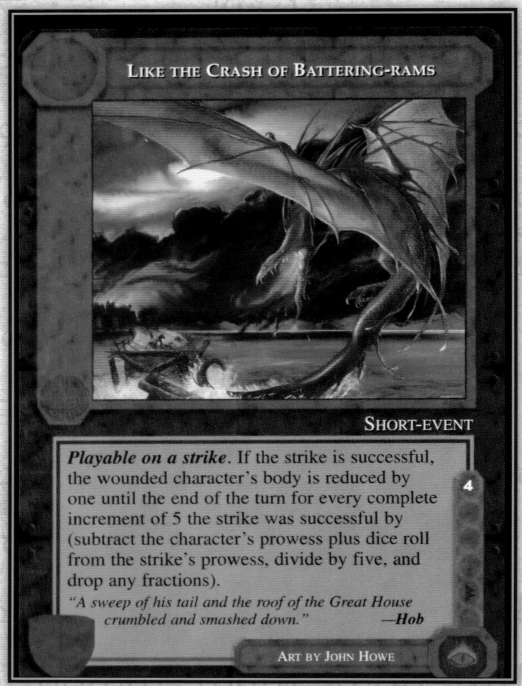

## LIKE THE CRASH OF BATTERING-RAMS

SHORT-EVENT

4

*Playable on a strike*. If the strike is successful, the wounded character's body is reduced by one until the end of the turn for every complete increment of 5 the strike was successful by (subtract the character's prowess plus dice roll from the strike's prowess, divide by five, and drop any fractions).

*"A sweep of his tail and the roof of the Great House crumbled and smashed down."* —Hob

ART BY JOHN HOWE

Above: *"Like the Crash of Battering Rams"* game card featuring the art of John Howe from Iron Crown Enterprises' **Middle-earth Collectible Card Game.**

# Comics and Games

**T**he 1978 Ralph Bakshi film (*The Lord of the Rings*) based on the first two books in the Tolkien series appears to have been the inspiration for the first comic book versions of Tolkien's epic, although they were never published in English.

Appearing in Italy in 1979, 1980, and 1981, the comic book *Il Signore degli Anelli* was written and illustrated by Spanish artist Luis Bermejo, who also created the cover art. The comics were translated and made available in Spain, Finland, the Netherlands, Germany, Denmark, Sweden, and Iceland, but never in the UK or the United States. Bermejo had begun his career on children's comics in Britain in the 1950s, and worked on war comics in the 1960s. In the 1970s he worked largely on U.S. horror comics from Warren Publishing, such as *Creepy*. Bermejo's Middle-earth comic books were created under license from the California-based Tolkien Enterprises, the trading name for The Saul Zaentz Company who owned the movie rights to Tolkien's work.

The Bakshi movie also gave rise to a "Fotonovel" of the film, essentially a graphic novel where the images were film frame enlargements. Published in 1979, in the days before home video or DVD were commonplace, this was the closest fans could come to reliving the film. That same year Warren Publishing (publishers of *Famous Monsters of Filmland*) released an "official magazine" of Ralph Bakshi's *The Lord of the Rings*. It told the story of the movie through 120 full-color illustrations within a Luis Bermejo cover of Gandalf towering over Frodo and Sam. The magazine also featured profiles of the filmmakers and biographies of the stars.

While *The Hobbit* had been adapted as a three-issue comic book by Eclipse Comics in the late-1980s, *The Lord of the Rings* failed to be fully adapted into comic book or graphic novel form in English. This may be due to the fact that the daunting length makes it difficult to adapt economically. It might be possible to release the story as an ongoing series across several years, and later possibly collect it into graphic novels, but no comic book publisher has yet risen to the challenge.

The closest attempt has been Northlanders writer Brian Wood's very limited sixteen-page digital comic inspired by characters and settings of Tolkien's *The Lord of the Rings*, released as an exclusive bonus with preorders of *The Lord of the Rings: The War in the North* role-playing videogame through Amazon or Toys "Я" Us. The comic acts as a prequel to the game, and Wood regarded the project as " . . . a fun job. I wish I could have written more than sixteen pages . . . I love *The*

THE BOARDGAME
*of* J.R.R.Tolkien's

# LORD of the RINGS

For **2** to **5** players
Age **12** to adult

*Game by* **Reiner Knizia**

*with illustrations by* **John Howe**

*Above:* The Lord of the Rings *boardgame released in 2000 by Kosmos/Fantasy Flight Games. Designed by Reiner Knizia, the game also featured illustrations from popular Tolkien illustrator, John Howe.*

Lord of the Rings, and nothing would make me happier than to write a regular comic [based on it] for general release."

Tolkien's fantasy epic was a huge driving force in the development of the fantasy role-playing gaming system known as *Dungeons and*

*Dragons* (D&D). Designed by Gary Gygax and Dave Arneson in the early 1970s, the game assigns characters to players—drawn from a series of "classes" or type—including Wizard, Human, Elf, or Halfling. The game is run by a Dungeon Master (DM) who drives the narrative forward by offering players a variety of

actions and puts obstacles in their way. While it doesn't require a board—just character creation sheets, several dice and a lot of imagination—the game is often enhanced with miniature character figures and an adaptable board representing the fantasy setting, whether a dungeon or a dense forest. Under the direction of the DM, a glorified storyteller, the characters embark on quests, interacting with each other and characters controlled by the DM, with each character gaining Experience (XP) points as they progress. Many players would carry characters on from one gaming sessions to another, building up a body of experience and skill.

Although Gygax in particular was careful to distance the D&D game format from Tolkien's work, the creators of the game were forced to alter some names, so Hobbit became Halfling, Ent became Treent, and Balrog was changed to Type VI Demon (Balor). Nonetheless, with epic storytelling in a fantasy landscape, and the presence of Dwarves, Elves, Orcs, and Dragons, it is hard to ignore the influence of *The Lord of the Rings* on D&D. Certainly, many gamers sampled the game after having read the novels in the 1960s, or perhaps having seen the Bakshi movie in the late-1970s, just as D&D was enjoying its mainstream popularity.

More directly related to Tolkien's work—although just as often deviating from it—were the officially licensed games, ranging through card games and board game to videogames.

Alongside D&D and *DragonQuest* (a similar Tolkien-influenced customizable role-playing game), there were a series of officially licensed *The Lord of the Rings* role-playing games. Between the Bakshi and Jackson films came the *Middle-earth Role-Playing* (MERP) game from Iron Crown Enterprises (ICE), produced under license from Tolkien Enterprises. The game was supported between 1984 and 1999, when the license was revoked. ICE declared bankruptcy shortly thereafter, although fan groups continued to support the game unofficially throughout the 2000s mainly through the internet and the quarterly Tolkien-inspired role-playing game fan magazine, *Other Hands*.

While heavily focused on *The Lord of the Rings*, MERP also drew upon *The Hobbit* and *The Silmarillion*. Based around ICE's generic role-playing gaming system, dubbed Rolemaster, MERP was sometimes criticized for the more cavalier way it allowed player characters to wield magic not in keeping with Tolkien's depiction of its use. Despite this, the game was largely true to Tolkien's spirit, and was revamped in 1991–1993 in a streamlined edition called *The Lord of the Rings Adventure Game* aimed at new gamers.

The Peter Jackson movie trilogy was an opportunity for tabletop war game manufacturer Games Workshop to develop a strategy battle game based around *The Lord of the Rings*. Released in 2001, *The Lord of the Rings: Strategy Battle Game* built upon the sets of miniature figures released in the 1980s. The new "skirmish war game" allowed for the development of a range of 25mm miniatures allowing players to act out battles from the books (and films), perhaps even altering their outcomes. These figures, though, were also collectables in their own right, requiring a degree of skill and patience to paint in suitable styles.

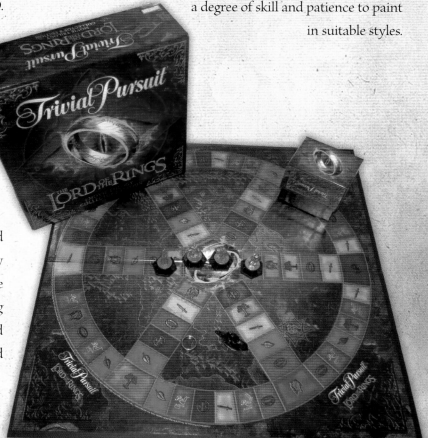

**Above: Trivial Pursuit released a special collector's edition of *The Lord of the Rings* featuring pewter pawns of key characters and a replica of the One Ring.**

# Fan-made Videogames

Thanks to the wider availability of computers, Tolkien fans have been able to create their own unofficial and unlicensed computer games, sometimes filling the gaps left by the official releases. Many used multi-user online gaming formats such as text-based Multi-User Dungeon (MUD) or Multi-User Shared Hallucination (MUSH, with the "H" sometimes standing for Hack or Holodeck) to re-create Tolkien's fantasy worlds, with some of the most successful being *Elendor* (1991) and *The Two Towers* (1994). Freely distributed, these games are not created to make money but to share enthusiasms.

*Elendor* serves as a prequel to the events of *The Lord of the Rings*, and while it draws heavily upon Tolkien's works the game play is not about re-creating events in the books and films but is more focused on freely exploring Middle-earth with a "what if?" attitude in mind. Another game set in this period is *Multi-User Middle-earth* or *MUME* (1992), but this one sets out to explore aspects of "nonlethal player conflict" where the majority of players are prohibited from killing other players.

*The Two Towers* boasts almost 100,000 "rooms" (or locations) for players to explore, filled with tens of thousands of objects and packed with computer-controlled nonplayer characters and a multitude of quests to play. Although built primarily around the siege of Minas

*Above: The iconic Commodore 64 introduced in 1982.*

Tirith, the game's open nature allows players to follow their own course. Starting as a student project, the game world of *The Two Towers* has grown, been overhauled and redeveloped, and is still active today. Variations of the game can now be played on popular social networking sites.

Many fantasy-based role-playing games have increasingly allowed for player customizations or player creation of custom maps and environments. Naturally, this has led to many games—such as *Warcraft 3*, the *Elder Scrolls* series and *Age of Empires*, among others—featuring additional quests built from elements of Tolkien's work. For example, a Tolkien "mod" (for "modification") of *Medieval 2: Total War* called *Third Age: Total War* was rated one of the best game variations by key Web site Mod DB, a database focused on computer game modding. The Middle-earth Role-Playing project is an ongoing effort to develop a Tolkien mod for the game *Elder Scrolls V: Skyrim*, featuring the full Ringbearer storyline of Frodo Baggins.

These games—whether official, fan-made, serious, or less so—are all expressions of fans' love of J.R.R. Tolkien's work. Using technology that the author himself could never have imagined, creative programmers and storytellers have co-opted Tolkien's worlds to their own ends, with varying degrees of fidelity. The creators and players of these games are driven by their wish to inhabit Tolkien's world, to spend more time with (and as) his legendary characters.

*Above:* A fantasy-set card game that drew heavily on Tolkien was *Magic: The Gathering*, produced by Wizards of the Coast beginning in 1993. "Gravehammer" is a piece from artist Daarken who created art for *Magic: The Gathering*.

# SHADOW OF MORDOR

## PERMANENT-EVENT

*Environment.* The hazard limit for each company is increased by one for every card over one drawn by that company during its movement/hazard phase.
   Additionally, if *Doors of Night* is in play, during each company's movement/hazard phase, the hazard player may draw one additional card for every card in excess of one drawn by his opponent. Cannot be duplicated.

"'...Alas! Mordor draws all wicked things...'"
   —*LotRI*

9

ART BY JOHN HOWE

©1996 Tolkien Enterprises

*Above: "Shadow of Mordor" game card featuring the art of John Howe from Iron Crown Enterprises' Middle-earth Collectible Card Game.*

The core rulebook for the game was updated and revised for each subsequent film release, adding battles and key events from *The Two Towers* and *The Return of the King* to the gaming system. Many Games Workshop stores held Saturday morning battles allowing players to face-off each against each other and giving them access to a wider range of prepainted figures than they might be able to afford individually—it could prove to be an expensive hobby.

Beyond the films, Games Workshop released a series of supplements to the core rulebook, featuring elements from the books not in the films such as Tom Bombadil, Radagast, and Glorfindel, and dealing with particular battles, such as the Siege of Gondor and the Battle of Pelennor Fields. When these options were exhausted, the company produced further supplements expanding beyond the books and the films, with mixed results. Original material included the Harad and Khand supplements, expanding upon the peoples and places Tolkien had created.

With the conclusion of Jackson's film trilogy, Games Workshop consolidated the various packages into *The One Rulebook to Rule Them All* (2009). In addition, fans often created their own rules and game variants popularized via the internet, while Games Workshop used their magazine *White Dwarf* to distribute additional mini-games and extra scenarios. Peter Jackson's *The Hobbit* trilogy gave a new lease of life

to the Games Workshop tabletop strategy battle game systems. Decipher Inc. adopted an entirely different set of rules for their *The Lord of the Rings Role-Playing Game*, released between 2002–2006 and drawing heavily upon the movies. Largely set between *The Hobbit* and *The Lord of the Rings*, the game offered players a high degree of freedom in exploring Middle-earth. The initial release won the accolade of Best Role-Playing Game of 2002 in the Origins Awards, issued for "outstanding work in the games industry." Decipher developed the game with additional supplements, until they let the license lapse in 2007, with the conclusion of the first Jackson trilogy. As with the ICE games, fans kept this third variation of a Middle-earth based role-playing game alive through online Webzines, such as *Hall of Fire* containing commentary and new fan-created gaming modules.

Collectible Card Games (CCG) were another popular form of *The Lord of the Rings Trading Card Game* was issued by Decipher in 2001, picking up where ICE left off, but was based upon the Jackson movie trilogy, as was Decipher's Tolkien RPG. Each movie saw Decipher release a 365-card "base set," supplemented by 122-card expansion sets every few months. The game built up a huge following and could also be played online. Decipher also won two Origins Awards, for Best Game in 2001 and for Best Graphic Presentation in 2001. Although still popular, both the printed card game and the online version were discontinued by Decipher in 2010. The company retains the rights to produce a CCG for *The Hobbit*.

*\*\*\**

While some role-playing games utilized a board (or graph paper) and miniature figures to enhance game play, neither was necessary. However, *The Lord of the Rings* has given rise to a series of dedicated board games, many based around existing gaming formats and drawing upon the movie trilogy.

The war board game *Risk* (first released in 1957) was revamped in 2002, replacing the more conventional world map with Middle-earth. The aim remained the same, challenging players to engage in conflict in order to conquer the world, which in this case was divided into nine regions from the three movies. Players would take on the guise of Elven Archers, the Riders of Rohan, Eagles, Trolls, and Orcs, while a pewter replica stood in for the One Ring whose movements dictated the length of time a session would run. The game generally followed the classic rules of *Risk*, with the addition of some "special event" cards unique to *The Lord of the Rings*. As well as the special "Ring Quest" rules, the game offered the more traditional "Global Domination" option familiar to players of *Risk*. The initial release excluded the domains of Gondor and Mordor, although both were included in the larger Trilogy Edition. There are also *Trivial Pursuit* and *Monopoly* editions based on *The Lord of the Rings*, as well as a Trivia Game quiz. Chess sets have also been created with the figures based on people and characters from the trilogy.

Using illustrations from John Howe to conjure up Tolkien's world, an original board game—simply called *The Lord of the Rings*—was released in 2000 by Kosmos/Fantasy Flight Games. Designed by Reiner Knizia, the cooperative game (where most board games are competitive) saw players team up as a party of Hobbits who have to work together to complete the aim of destroying the One Ring and so winning the game. Recognized by Spiel des Jahres—a German game of the year award—as the best use of literature in a game, *The Lord of the Rings* board game also won *Games Magazines'* 100 Honor in the Family Strategy category in 2004. Three expansion packs followed, based around Friends & Foes, Sauron, and Battlefields, extending the game's life.

There are other older variant games connected to Tolkien, but one in particular is worth noting. Now a popular collectors' item the 1977 Middle Earth Games from war gaming specialist Simulations Publications, Inc. consisted of a trio of games: *War of the Ring* (strategic, covering all three books), *Gondor* (tactical, covering the siege of Minas Tirith), and *Sauron* (covering the decisive battle of the Second Age). The games featured large-scale battles, and an individual game featuring the fate of the One Ring played across a detailed map of Middle-earth.

While the fantasy setting of *The Lord of the Rings* easily lends itself to computer adventure games, there have also been a

number of notable battle and strategy games based around the larger encounters featured in Tolkien's work.

The earliest home computers hosted games based on Tolkien's diverse worlds. Melbourne House—who had released *The Hobbit* as early as 1982—was behind a trio of late-1980s computer games. In 1986 the single player adventure *The Fellowship of the Ring Software Adventure*—as it was known in the United States, whereas the UK release reflected the books' original structure under the title *Lord of the Rings: Game One*—was available across a number of platforms, from the early Apple Macintosh to British favorites such as the ZX Spectrum, the Commodore 64, and the BBC Micro. The game, however, was widely seen as a backward step being less complex and involving than the same company's *The Hobbit* (see Chapter 4).

Despite that, in 1987 Melbourne House followed up with a game that was not called *The Two Towers* as might be expected, but *The Shadows of Mordor*, nonetheless based around events in Tolkien's second *The Lord of the Rings* book. This text-only adventure followed Frodo and Sam on their journey to Mordor, and featured Sméagol/Gollum as a computer-controlled "non-player character." Finally, the company completed the trilogy in 1990 with *The Crack of Doom*, based on the final book, *The Return of the King*.

**Above: One of the earliest home computers, the Sinclair ZX Spectrum Microcomputer was released in the UK in 1982.**

While these text-only adventure games were rather simple, Melbourne House also pioneered the Tolkien-based real-time strategy game with *War in Middle-earth* (1988). This allowed a single player to control larger "army" units and single characters in recreating battles from *The Lord of the Rings*. While gameplay and graphics were both rather simple, this displayed the potential for battle-driven Tolkien-based computer games.

There were other simplistic action-based games in the early 1980s, such as the side-scrolling *Shadowfax* (1982), which saw Gandalf battle endless waves of Nazgûl. It wasn't until the 1990s that computer power and the widespread acceptance of gaming consoles allowed for the proliferation of Tolkien-based computer games of all varieties.

Electronic Arts, who would later acquire the license to produce computer games based on Jackson's film trilogy, were the first to co-opt the then-cutting-edge CD-ROM technology to produce a pair of role-playing games (in association with Interplay), *The Lord of the Rings Volume I* and *Volume II* (1990), with *Volume I* including clips from the Bakshi film. The planned *Volume III* was never completed or released, although a later *The Lord of the Rings* game for the Super Nintendo Entertainment System (SNES) combined Tolkien's creations with *Legend of Zelda*–style graphic adventure gaming.

The release of the film trilogy between 2001 and 2003 saw a wave of new computer games able to capitalize on 21st-century advances in computer technology. Electronic Arts (EA), dominant in the field of sports simulation gaming, and also a major player in Sony PlayStation titles, obtained the license to create games based on the films, while Sierra Entertainment held a simultaneous license from Tolkien Enterprises to create games based only on the books. While Sierra released *The Lord of the Rings: The Fellowship of the Ring* based on the book, EA rolled the events of the first two films into their *The Lord of the Rings: The Two Towers* game to avoid confusion. Where Sierra had no access to the iconography of the films, they could draw upon aspects of the storyline not used in the movies. EA, meanwhile, could produce games that accurately reflected

Jackson's vision of Tolkien's creation.

This slightly confusing situation meant game players had to navigate their way among a series of titles carefully, especially if all they were interested in was replaying the events of the movies. The cross-platform EA games became bestsellers in 2002 and 2003, and won praise for the seamless integration of film footage and animation with game play graphics. Splitting the stories of the films into various levels, players could adopt the personas of Aragorn, Gimli, or Legolas— reflecting the Human, Dwarf, or Elf categories of many fantasy games—to play through. Actors Viggo Mortensen, John Rhys-Davies, and Orlando Bloom recorded additional game dialogue for their characters. *The Two Towers* (2002) largely sidelined the Hobbits, focusing on the more action-driven elements. *The Return of the King* (2003) broadened the world of the game and deepened the story elements. Players adopted various character roles throughout, from Gandalf at the Battle of Homburg, then through three "paths" (the Path of the Wizard, the King, or the Hobbits) that allowed the player to experience the storyline from differing perspectives. Some missions allowed for two-player cooperative gaming, but generally all relied on a "hack-and-slash" approach to successfully completing storylines. While these games deviated from the story where necessary and omitted much detail (even from the films), they were the most successful in allowing players to immerse themselves in Tolkien's fantasy worlds. Movie-based games have often come in for criticism, but these were largely positively reviewed, with minor criticisms made but high 80 or 90 percent scores awarded from major gaming magazines and Web sites.

A host of spin-off computer games built around the inventions of Tolkien but not directly retelling the story of the books or Jackson's films followed. Many of these took the form of battle strategy or real-time strategy games based around major battles,

*Above:* War of the Ring *is a strategy game created by R. DiMeglio, M. Maggi, and F. Nepitello and illustrated by John Howe.*

allowing players to reenact and even alter the outcome of some of the key conflicts in Tolkien's mythology.

Sierra followed *The Fellowship of the Ring* with *War of the Ring* (2003), a book-based combat game that saw players enact Good or Evil campaigns, playing the "war of the ring" from opposing sides. While the Battle of Homburg features directly, other skirmishes are drawn from Tolkien's wider writings, such as Gimli and the Dwarves tackling Orcs in the Iron Hills, or Grishnákh destroying the Beacons of Gondor. Playing fast and loose with Tolkien's creations, the game was aimed at general gamers rather than Tolkien purists.

*The Battle for Middle-earth* was EA's attempt at a real-time strategy game, using the full access to audio and video clips from the films that the license allowed, as well as Howard Shore's distinctive score. The warring factions included the Free Peoples—primarily the horse lords of Rohan and Gondor—against the "forces of darkness," consisting of the Uruk-Hai of Isengard and the Orc hordes of Mordor, backed-up by the Haradrim, Mûmakil, and Trolls. The game won three significant awards: the E3 2004 Game Critics Awards for Best Strategy Game, the 2005 GIGA Games award for Best Strategy Game, and the GameSpy award for Best of E3 2004 Editors Choice.

EA's follow-up, *The Battle for Middle-earth II*, came when the company secured the rights to adapt games from Tolkien's literary works as well as Jackson's films, allowing the inclusion of events from the War in the North and characters not in the films. Elements from *The Hobbit* were incorporated, such as the Giant Spiders of Mirkwood. Liberties also continued to be taken with Tolkien, with this game offering Tom Bombadil a combat role! Both games were designed for the Windows PC, and could be played across a network with remote players until

the license with New Line Cinema expired at the close of 2010. However, expansion packs, such as 2006's *The Rise of the Witch-King*, and console spin-offs—like *The Lord of the Rings: Tactics* for the PlayStation Portable (PSP) handheld console—had extended the life of these games.

<p style="text-align:center">***</p>

Role-playing games (RPG) often explored fantasy worlds imitating Tolkien, so this was a natural field for computer game programmers. The "turn based" game—meaning players could take time over decisions and actions—*The Third Age* (2004) from EA followed in the wake of acclaimed RPGs like the *Final Fantasy* series. In a similar vein, these games allowed players to explore Middle-earth, as well as follow missions from the movies and encounter random enemies. Players gained "experience points," allowing their characters to "level up" and gain extra skills and powers with which to vanquish their enemies.

*War in the North* (Snowblind Studios, 2011) offered an alternative role-playing game experience, exploiting the license now held by Warner Bros. following the end of EA's rights in 2010. Three playable protagonists—Eradan the Ranger, Farin from Erebor, and Andriel the Elven Loremaster—allowed players to explore areas of Middle-earth and aspects of the story not developed in depth in either the books or Jackson's films. Non-film locations included the Ettenmoors, Fornost, Mirkwood (a non-film location until the middle installment of Jackson's *The Hobbit* trilogy), and Mount Gundabad. Although generally well received, the game was criticized for repetitive game play.

Even more immersive than simple stand-alone role-playing games were MMORPGs (massive multiplayer online role-playing game), allowing online play in a virtual fantasy game world shared with thousands of players worldwide. While EA attempted to develop such a game (dubbed *The White Council*), their efforts were abandoned in 2007, leading to the release of another action game—*The Lord of the Rings: Conquest* (2009)—instead, marking the end of EA's Tolkien/Jackson license.

Turbine's *The Lord of the Rings Online: Shadows of Angmar* succeeded where EA failed, launching an open-world MMORPG in 2007. Realizing Tolkien's entire fantasyland even as a virtual world was a tall order, so the game initially restricted explorable regions to Eriador, from the Grey Havens to the Misty Mountains. Further geographical areas were added through expansion packs, with

*Above: "The Edge of the Wild" illustrated by John Howe for the role-playing game* **The One Ring.**

the first—*The Mines of Moria*—in 2008 (later expansion packs included Mirkwood, Rohan and Isengard). Within these online worlds, players could freely explore Tolkien's creation, with the game expressing surprising fidelity to the books. However, as in all MMORPGs, they become what the players make of them as they form unlikely alliances and fight fantasy battles, so deviation from the word of Tolkien was inevitable in the open framework of the online world. The game was acclaimed as "the third most-played MMORPG" of 2010, with a nonsubscription free-to-play option (and ongoing free scenario updates) bringing in many players new to Tolkien's worlds.

LINDON

BARANDUIN OR BRANDYWINE

MINHIRIATH

ENEDHWAITH

DUNLAND

The Doors of...

GREYFLOOD

R. ISEN

ERED NIMRAIS

ANFALAS

PINNATH GELIN

The Barrow-Downs

HOBBITON

ANDRAST

BAY OF BELFALAS

A MAP OF MIDDLE-EARTH

# Part III

# middle-earth
# on film

*Above: Forrest J. Ackerman, agent and editor of* Famous Monsters of Filmland, *approached J.R.R. Tolkien directly in 1957 to inquire about film rights for an animated movie adaptation for* The Lord of the Rings.

# The Early Attempts to Film

Following the mixed reception for the 1955–1956 BBC radio version of *The Lord of the Rings*, interest turned to bringing Middle-earth to life on film. This was despite the fact that in 1956 Tolkien had wondered, "[C]an a tale not conceived dramatically but (for lack of a more precise term) epically, be dramatized—unless the dramatizer is given or takes liberties . . . ? A very hard task."

Even so, Tolkien's publisher Stanley Unwin had warned the author to expect offers for film rights to be forthcoming. Their plan in the event of an approach was to request either the books should be treated respectfully in any adaptation or a sizeable fee should be paid or, in the words of Unwin, they should opt for "cash or kudos."

The first proposal to be taken seriously for a film was put forward in June 1957 by an American group. Leading the proposal was Forrest J. Ackerman, a prominent figure in U.S. science fiction fandom, literary agent, and later editor of the magazine *Famous Monsters of Filmland*. He teamed up with *Popeye* cartoon producer Al Brodax and writer Morton Grady Zimmerman, and approached Tolkien directly to inquire about the film rights to his best-known work, their plan being to create an animated movie. Writing to Rayner Unwin in June 1957, Tolkien noted:

"I should welcome the idea of an animated motion picture, with all the risk of vulgarization. I think I should find vulgarization less painful than the sillification achieved by the BBC [on radio]."

In 1957 Tolkien had been awarded the International Fantasy Award at the 15th World Science Fiction Convention held in London. While admitting that he did not have "any immediate use for the trophy . . . a massive metal model of an upended space-rocket . . ." there was "a back-wash from the convention" in the shape of "a visit from an American film agent." Alongside the agent were "strange men and stranger women," including Ackerman, who had "brought some really astonishingly good pictures (Rackham rather than Disney) and some remarkable color photographs." Writing to his son Christopher in September 1957, Tolkien noted that the prospective filmmakers had "apparently toured America shooting mountain and desert scenes that seem to fit the story."

The outline for the animated movie was another matter, however. According to Tolkien, "The storyline or scenario was, however, on a lower level. In fact bad . . . a compression with resultant overcrowding and confusion, blurring of climaxes, and general degradation . . . people gallop about on Eagles at the least provocation; Lórien becomes a fairy castle with 'delicate minarets,'

and all that sort of thing." However, the author had his agreement with Stanley Unwin in mind, telling his son Christopher: "I have agreed on our policy: art or cash. Either very profitable terms indeed, or absolute author's veto on objectionable features or alternations . . .[I]t looks as if business might be done."

Ackerman's group was granted a six-month option on *The Lord of the Rings*, based on the scenario and the artwork presented to Tolkien. According to Ackerman, "I went to school with James Nicholson, the president of [B-movie producers] American International Pictures, and I thought perhaps he would be interested, but the scope was too great for him." The "production notes" prepared for the movie indicated that the film would be a mix of animation, live action, and miniatures. Zimmerman prepared a more detailed "story line" for the film, including sample dialogue. When this reached Tolkien, he reacted badly as recorded in a letter to Rayner Unwin in April 1958. He accused Zimmerman of having "skimmed" the books, "then constructed his s.l. [story line] from partly confused memories. He gets most of the names wrong . . . I feel very unhappy about the extreme silliness and incompetence of Z. [Zimmerman] and his complete lack of respect for the original. He is hasty, insensitive, and impertinent. This document is sufficient, as it stands, to give me grave anxiety . . . ."

Despite this, Tolkien was aware of his publisher's interests in the financial benefits of a successful film, so he was willing to respond directly to the filmmakers with his concerns. In June 1958 Tolkien wrote to Ackerman, hoping that Zimmerman would not "be irritated or aggrieved by the tone of many of my criticisms." Tolkien had many individual criticisms about seemingly pointless changes made to his story, but he was far more concerned with the loss of his unique tone. "He has cut parts of the story upon which its characteristic and peculiar tone principally depends, showing a preference for fights; and he has made no serious attempt to represent the heart of the tale adequately: the journey of the Ringbearers . . . [He has] no evident appreciation of what it is all about . . . I should say Zimmerman is quite incapable of excerpting or adapting the book."

As well as the misspelling of names that had irritated the author (throughout Boromir was inaccurately rendered as Borimor), the substitution of the many scenes of walking with flights on the backs of eagles, the general increased presence of magic (described by Tolkien as "irrelevant magic . . . incantation, blue lights . . . "), the description of the Elvish waybread lembas as a

*Above: "Shelob and Samwise" by Neil McClements.*

science fiction-style "food concentrate" and the intrusion of "fairy castles," all served to cause the project to be rejected.

Perhaps the strangest and most unwarranted change to the story saw Sam abandoning Frodo during the encounter with Shelob, setting out to carry the Ring to Mount Doom himself. The producers intended the character to be driven by his duty to Middle-earth, overriding his loyalty to his friend. As Tolkien wrote in a marginal note on the story line document, this is the "opposite of [the] book." At the climax, as Sam is about to throw the Ring into the Cracks of Doom he is attacked by a crazed Frodo, who is in turn attacked by Gollum. Tolkien complained that there was "no indication of where either of them has been hiding since Shelob's lair."

There were certainly no "kudos" in this proposed adaptation, and as it turned out very little "cash" either. "Operation Ringslord," as Ackerman jokingly called the project (perhaps an indication of his less-than-respectful approach), was rejected when a requested rights extension from six months to one year was not accompanied by a suitable fee payment. This first attempt to mount a film of his books left Tolkien wary of future approaches, believing "*The Lord of the Rings* cannot be garbled like that."

***

In the late 1950s into the mid-1960s there were several other approaches to Tolkien or his publishers for the film rights to his work, all of them unsuccessful. In February 1959 Tolkien came across a letter from the previous December among some neglected fan mail that suggested making a film of *The Hobbit* in four sections. He passed this idea on to Rayner Unwin, who came

*Above: Author Robert Gutwillig who penned* The Fugitives *inquired about the film rights to* The Lord of the Rings *in July of 1959.*

back with an unfavorable reply to a film that would "incarcerate us in our local Odeons [cinemas] for nine or ten hours."

Author Robert A. Gutwillig (*The Fugitives, After Long Silence*) enquired about the film rights to *The Lord of the Rings* in July 1959. Tolkien replied to his letter, indicating he had "given a considerable amount of time and thought . . . " to a film of *The Lord of the Rings* "and have already some ideas concerning what I think would be desirable, and also some notion of the difficulties involved, especially in the inevitable compression." As a follow-up, Tolkien had a meeting with Gutwillig's agent (and occasional film producer and actor) Sam W. Gelfman that September. Tolkien found Gelfman intelligent and his proposals reasonable, and he passed the would-be Middle-earth filmmakers onto Allen & Unwin for further discussions, although nothing more came of their interest.

***

At just under 12 minutes, Gene Deitch's partially animated version of *The Hobbit* (1966) is one of the shortest films based on the work of J.R.R. Tolkien. Deitch was a Prague-based animator who produced *Tom and Jerry* and *Popeye* cartoons during the 1960s, when Hollywood studios were outsourcing much of their animation. Deitch animated his cartoons in a recognizable European style.

Commissioned by maverick producer William L. Snyder—who had obtained the film rights to Tolkien's work for his company Rembrandt Films covering the period 1964 to 1966—Deitch embarked upon what was intended to be a full-length animated version of *The Hobbit*. "The Tolkien craze was still a few years in the future. Snyder had

happened onto something of major value, and he had gotten the rights for peanuts!" claimed Deitch. Working with Bill Bernal, Deitch wrote a screenplay and enlisted Czech puppet filmmaker Jirí Trnka to work on the project (Trnka produced some illustrations and model concept drawings). "The great sweep of the adventure, the fabled landscapes, and the treasury of fantasy characters, made the story a natural for animation," noted Deitch on an internet blog recalling the production.

The contract with Rembrandt Films had first been mooted as early as 1961, when Tolkien noted of his "cash or kudos" policy that "one must either turn the matter down or put up with the many objectionable things they are sure to perpetrate in their production." A contract for a "cartoon film" of The Hobbit was agreed by spring 1962, but two years later Tolkien was wondering whether the company would ever produce anything and "what on earth, or in America, will it be like; and whether I shall ever see it?"

Unaware at this stage of The Lord of the Rings trilogy, as it had not been officially published in the United States, Deitch took liberties with The Hobbit that he later regretted. "I had introduced a series of songs, changed some of the characters' names, played loosely with the plot, and even created a girl character, a Princess no less, to go along on the quest, and to eventually overcome Bilbo Baggins' bachelorhood! I could Hollywoodize as well as the next man . . . ."

A proposed deal with 20th Century Fox to finance the film fell through, as—according to Deitch—Snyder demanded too much money. As the rights were due to expire, Snyder asked Deitch to create a one-reel (around 10 to 15 minutes) version of The Hobbit, purely as a way of extending the option. The animator was given one month to complete the project. The follow-up trilogy had by now taken off in a big way in the United States, and film producers were keen to exploit the cinematic potential of Tolkien's creations. Snyder had to produce a "full-color motion picture version" of The Hobbit by June 30, 1966, to retain the rights—there was no stipulation as to the length or nature of the film.

Deitch faced an almost impossible task. "All he had to do was to order me to destroy my own screenplay—all my previous year's work, and hoke [sic] up a super-condensed scenario on the order of a movie preview (but still tell the entire basic story from beginning to end), and all within twelve minutes running time—one 35mm reel of film."

Working with Czech illustrator Adolf Born and American broadcaster Herb Lass, who worked for Czechoslovakian radio's English language service, Deitch created a short film consisting of a series of still images and a hasty narration telling the story of The Hobbit. Václav Lidl, a composer friend of Deitch, provided the music. The final short is a neat little juvenile fantasy, but it offers little fidelity to Tolkien. Character and creature names were changed throughout, with Goblins becoming Grablins, Trolls became Groans, and the dragon Smaug was renamed Slag. The addition of a fairytale princess named Miko Milovana and the absence of Gandalf from much of the story are the least of its problems. The nonanimation—achieved simply by panning across and dissolving between still illustrations—made Deitch's cartoon little more than a filmed storybook. However, it does bring a unique European visual sensibility to Tolkien's source material, making the short an alternative to the more commonplace visualizations of fantasy environments in film.

The animator arrived in New York with his completed film at the end of June 1966, where it was screened in a Manhattan cinema. To fulfill the contractual need to have a public audience, Deitch, and Snyder rounded up customers off the street, promising a preview of "a forthcoming film" and offering to front them the ten cents admission fee. All audience members had to sign and date a statement saying that they had paid admission and viewed the film. This extended Snyder's film option on the Tolkien library, but, the seemingly unscrupulous producer had no intention of making any further films and promptly sold back the rights for $100,000. Deitch claims never to have received any of this money.

\*\*\*

Following Deitch's unsung version of *The Hobbit*, United Artists obtained the rights to film Tolkien's work, but only after a pair of American teenagers had unsuccessfully pursued the film rights to *The Hobbit* in the fall of 1966. Contrary to an oft-reported myth, Walt Disney never held these rights, despite some reference sources indicating that for a decade from the late 1950s Disney had been frustrated in his attempts to film *The Hobbit*. Tolkien had a longstanding "heartfelt loathing" for the Disney style, preferring that of Arthur Rackham. There had been discussions within Disney of adapting Tolkien's work, but no formal deal was ever struck. In a 1938 memo, an animator at Disney had suggested combining elements of *The Hobbit* with Wagner's Ring Cycle as a segment of *Fantasia* (1940). Animator Wolfgang Reitherman claimed that Disney had considered adapting *The*

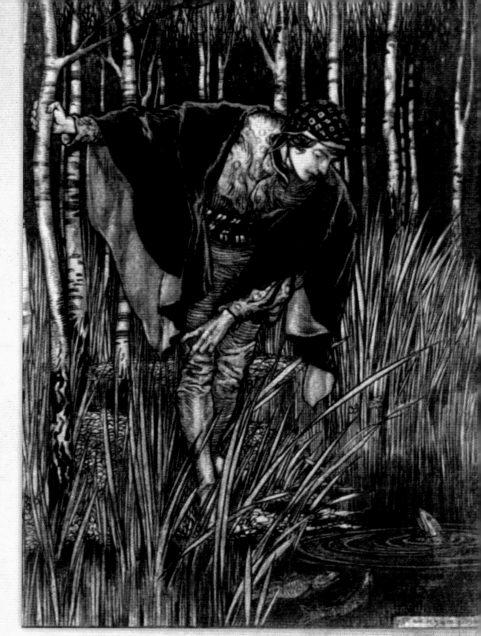

*Above: An Arthur Rackham illustration from the tale of "The White Snake."*

*Lord of the Rings*, but he had quickly realized that the story was simply too long and unwieldy to be turned into a Disney-style animated feature. It would not have mattered anyway, as Tolkien had long stated he would "veto anything from or influenced by the Disney Studios." Ironically, Disney subsidiary Miramax would hold the film rights to *The Lord of the Rings* for a short period in the 1990s.

United Artists obtained the rights to both *The Hobbit* and *The Lord of the Rings* in perpetuity in 1967 for $250,000. Tolkien apparently concluded that he would not live long enough to see any resulting film (he would die six years later in 1973), and so the film rights were no longer of great importance to him. United Artists could exploit the rights however they liked, including

*Above: Portrait of Arthur Rackham (1867–1939). Tolkien greatly preferred Rackham's illustration style to that of Walt Disney.*

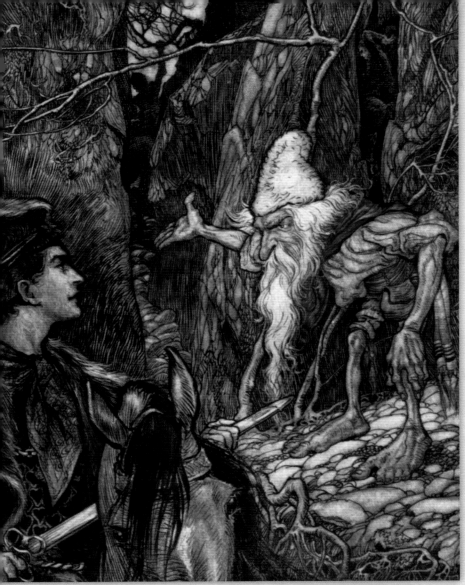

*Above: An Arthur Rackham illustration
from the tale of "The Water of Life."*

McCartney, identifying one reason why the project did not go forward. However, The Beatles were reported to have approached director Stanley Kubrick—then between *Dr. Strangelove* (1964) and *2001: A Space Odyssey* (1968)—with a view to him directing them in *The Lord of the Rings*. According to Kubrick biographer Alexander Walker, "Stanley preferred to find a book that very few people had heard of, and work on that." Peter Jackson later claimed that Tolkien himself killed the idea of the movie due to his dislike of The Beatles.

The Beatles lent their likenesses for animated movie *Yellow Submarine* (1968), whose designer and art director Heinz Edelmann attempted to mount his own animated version of *The Lord of the Rings*. Inspired by Disney's *Fantasia*, Edelmann wanted his production to be "a kind of opera, [with] a kind of operatic impression . . . a distillation of the mood and the story, but not follow[ing] every twist of the plot." American folk singer Arlo Guthrie (son of Woody Guthrie) was another creative artist—and huge fan of Tolkien's work—interested in *The Lord of the Rings* at this time. United Artists, however, concluded that animation was not the right medium for Tolkien's tale, and producers Sam Gelfman—who had first enquired after the rights as far back as 1959—and Gabe Katzka were attached to a live action project.

selling them on to other studios or producers, also in perpetuity. This deal excluded Tolkien's heirs from any influence over the film rights to their father's work, although in reality they have exercised a degree of moral authority over all adaptations since.

British pop group The Beatles were at the height of their popularity toward the end of the 1960s. The group—Paul McCartney, John Lennon, Ringo Starr, and George Harrison—had already been featured in three movies: *A Hard Day's Night* (1964), *Help!* (1965), and a BBC TV movie, *Magical Mystery Tour* (1967). Lennon was a fan of Tolkien's novels and saw the central roles as ideal for The Beatles. Lennon would take the small but attention-grabbing role of Gollum, with McCartney as Frodo, Harrison as Gandalf, and Starr as Sam. "We talked about it for quite a while," said McCartney. "The strength of the other films which we made is that we're all equal," suggested

By June 1970, United Artists finally had a director for their live-action movie of *The Lord of the Rings*. British director John Boorman's debut film had been 1965's *Catch Us if You Can*, a vehicle for The Dave Clark Five modeled after the first two successful films featuring The Beatles. He'd gone on to direct thriller *Point Blank* (1967) and had just completed *Leo the Last* (1970), for which he won Best Director at the 1970 Cannes Film Festival. He'd been working on a movie about King Arthur (later to emerge in the form of *Excalibur*, 1981) with screenwriter Rospo Pallenberg.

For Pallenberg, the Tolkien project would be his first big break in movies. With Boorman he developed a trio of possible approaches, compressing the three books into one film. "One was to do it like a Fellini movie in a neverland, or in a big studio like

*Moulin Rouge*—all sort of fake," he told journalist Ross Plesset. "Another was sort of a straightforward approach. What the third one was, I can't remember . . . it's been years!"

The result was to follow the second approach, with a single film telling the whole story. In the 1970s, it was common for longer films to be presented in cinemas with an interval, which Pallenberg and Boorman thought would work. Very roughly, each page of a movie script covers about a minute of screen time. Pallenberg's 176-page script suggested a running time of almost three hours, with an interval built into the action on page 81. The first half of the film focused on the events of *The Fellowship of the Ring*, with the second half after the interval condensing the remaining two books.

As with all approaches to the source material, Pallenberg's script took liberties. The back-story covering the history of Middle-earth—told as flashbacks in Jackson's movie—was to be conveyed in the style of Japanese Kabuki-style theater, performed before a gathering in Rivendell. Before Frodo was permitted to look into Galadriel's mirror, he was to have sex with her—a very 1970s change that echoes the spoof *Bored of the Rings*. Tolkien would have heartily disapproved. The character of the dwarf Gimli was expanded, purely because Pallenberg took a liking to him. It was to be Gimli who would discover the magic word for entering the mines of Moria, accessing it through his "unconscious ancestral memory." Pallenberg added Orcs to the Moria sequence, that were to be awoken from a long slumber due to the rhythmic footsteps of the Fellowship—an idea that Boorman liked. Additionally, Pallenberg saw the confrontation between Gandalf and Saruman as being one of words and ideas, rather than one to be conveyed through special effects. "Because it had to be one movie," noted Pallenberg, "we couldn't waste time with too many complicated special effects. I was an advocate of eliminating all flying creatures . . . instead of a flying stead, the Nazgûl Chief

*Below: "Gimli and Legolas" by Anke Eissman*

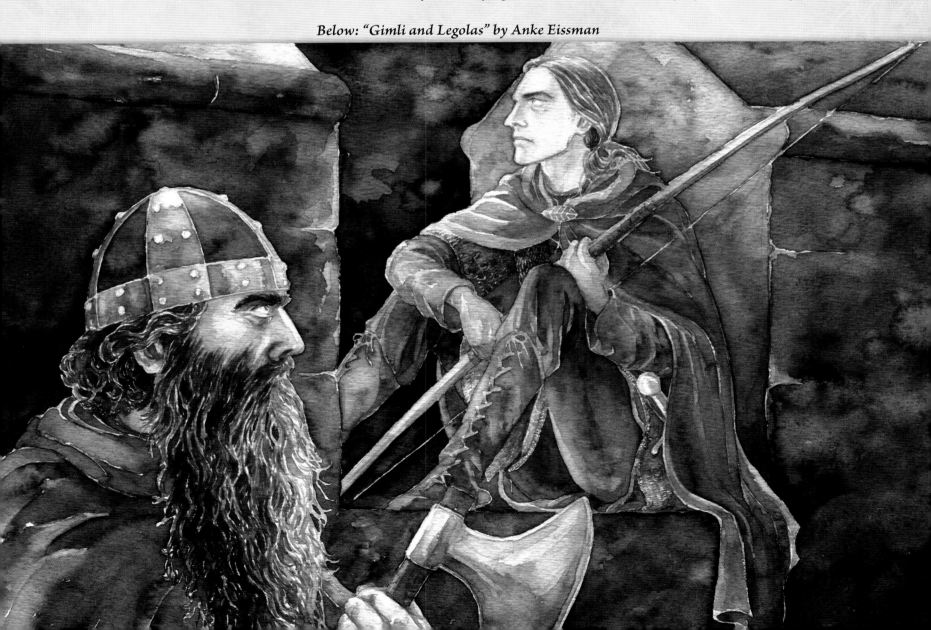

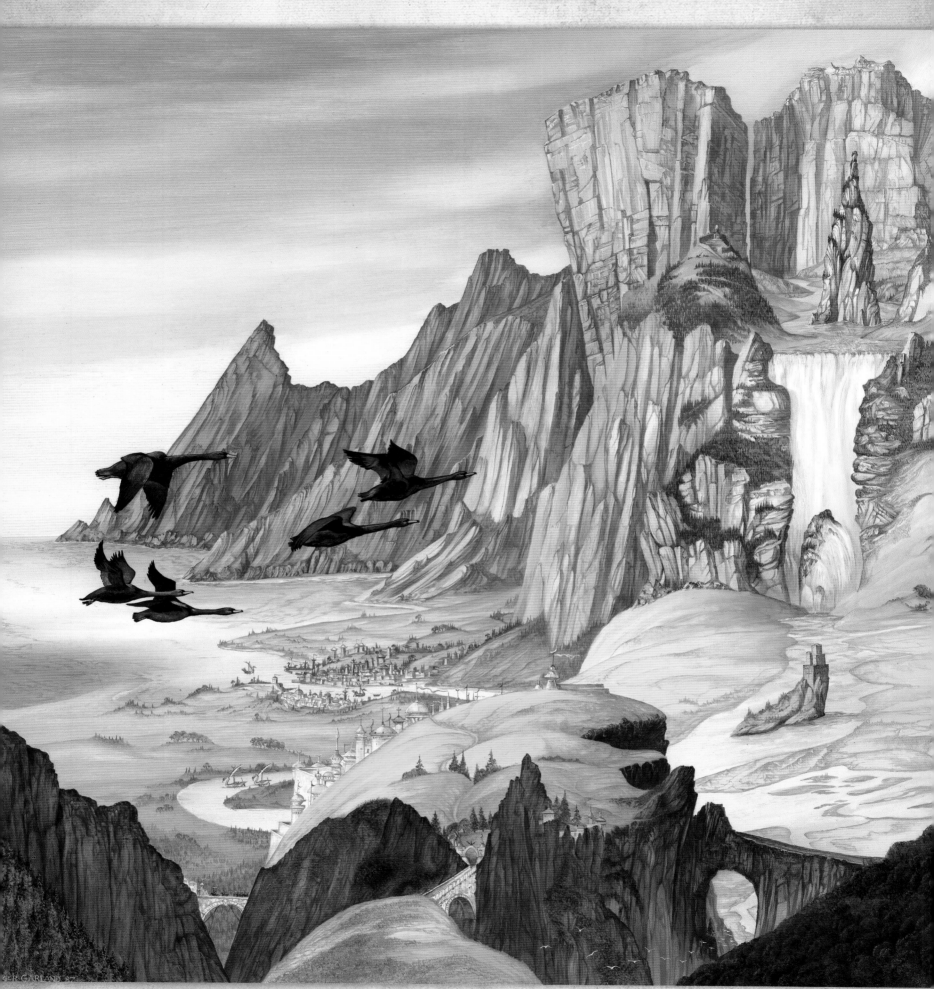

**Above: "The Shire" by Roger Garland**

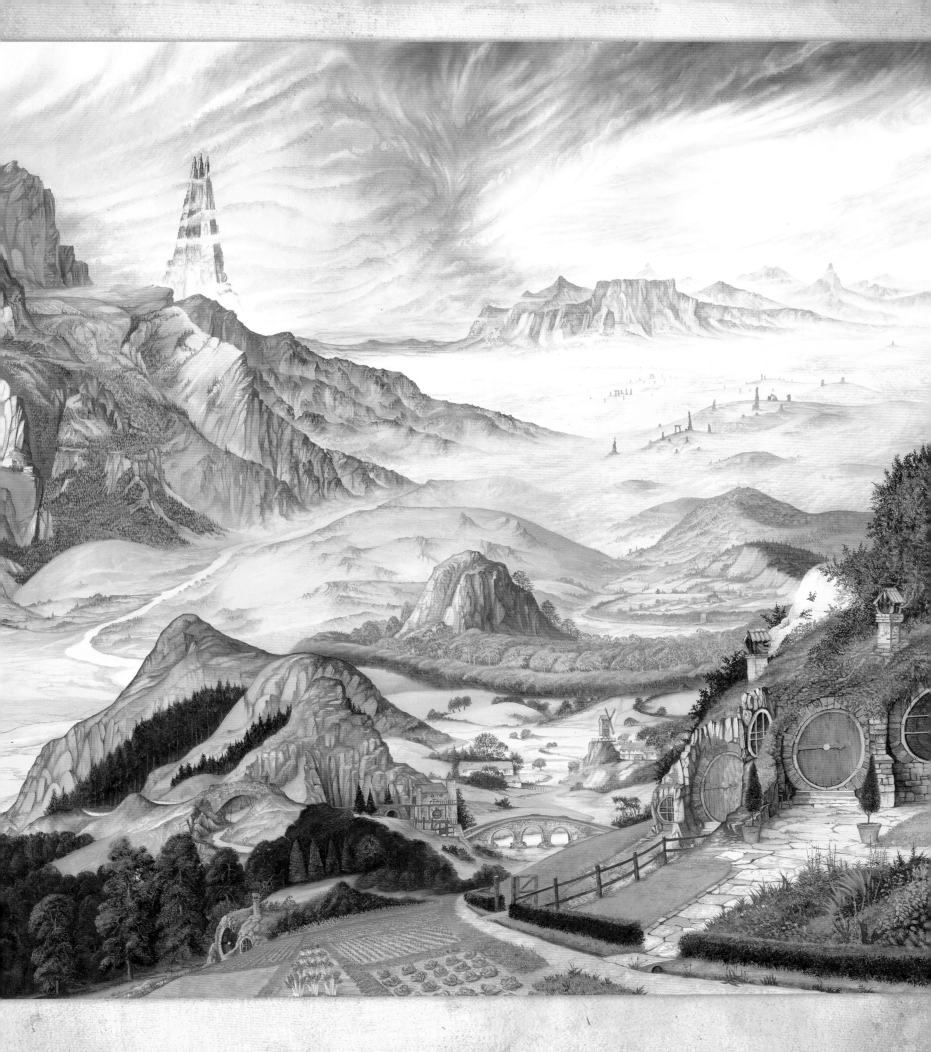

rides a horse that seems to have no skin: its live, raw, bleeding flesh is exposed."

According to Pallenberg, the idea of The Beatles members playing the four Hobbits was still around when he and Boorman were attached to the project, with McCartney as Frodo. That seems to have been rapidly put to one side, although there is no other indication that the project got as far as considering casting. To make the human actors appear smaller as the Dwarves, the plan was to feature them in oversized settings with giant props. One person that Pallenberg and Boorman hoped might play himself in the movie was J.R.R. Tolkien. In the screenplay, the film opens in Tolkien's book-lined study, where the author is disturbed by the arrival of the film camera—another idea unlikely to have won the author's approval.

"Boorman wanted to build a huge model of Middle-earth, as big as a film studio," claimed Pallenberg. Locations scouted for the proposed film included the highlands of central Ireland and the countryside surrounding Ardmore Studios in County Wicklow (later used for TV series *Camelot* and *The Tudors*). "Taking breaks from writing, I drove around [and] saw all sorts of places," Pallenberg told Plesset. "I remember there was one view that [we] could pass off as the Shire; it looked down to a little village called Annamoe." Several locations originally planned for *The Lord of the Rings* were used in *Excalibur*.

Pallenberg's script takes on the entirety of Tolkien's epic tale, ending with Frodo, Bilbo, Gandalf, Galadriel, Arwen, and Elrond leaving Middle-earth. As a rainbow appears over their departing ship, Legolas—watching from the shore with Gimli—exclaims: "Look! Only seven colors! Indeed, the world is failing . . . ". For Pallenberg this was the central point of the film. "That's from me, not Tolkien. From a physics standpoint, it is incorrect to say that there could be more than seven colors, but what it's saying is 'we live in a diminishing world.' "

Boorman was incredibly disappointed when United Artists canceled the film. In *Money into Light*, his book on the making of *The Emerald Forest* (1985), Boorman wrote: "During these

*Above: English film producer, director, and writer John Boorman in 1988. United Artists selected Boorman in 1970 to direct their live-action movie of* **The Lord of the Rings.**

six months, United Artists had suffered setbacks. . . .*The Lord of the Rings* was an expensive project dependent on innovative special effects. By the time we submitted it to United Artists, the executive who had espoused it had left. No one else there had actually read the book. They were baffled by a script that, for most of them, was their first contact with Middle-earth. I was shattered when they rejected it. We took it to Disney and other places, but no one would do it. Tolkien wrote asking me how I intended to make the film. I explained that it would be live-action and he was much relieved. He had a dread that it would be an animation film and was comforted by my reply. His death spared him the eventual outcome: United Artists gave it to the animator Ralph Bakshi. I could never bring myself to watch the result."

*Right: "Gimli and Legolas" by John Howe*

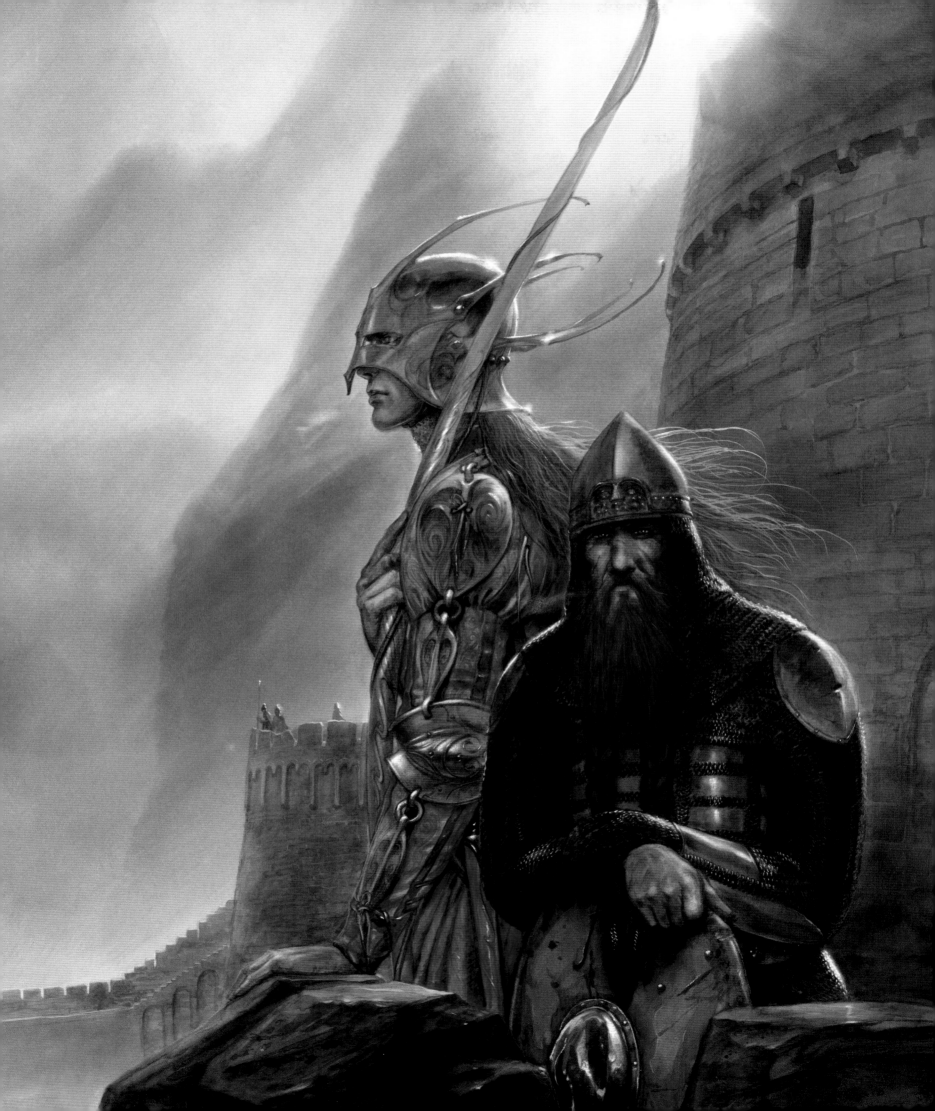

*Above: Black and white ink study of a Black Rider from artist Ian Miller,
who worked with Ralph Bakshi on* Wizards *and* The Lord of the Rings.

The first fully animated film drawn from the works of J.R.R. Tolkien was the 1977 Rankin/Bass television special of *The Hobbit* for NBC TV. Running for 77 minutes to fill a 90-minute slot, the television film was aimed at younger viewers during the Thanksgiving holiday. The film followed quite closely the plot of the novel, with the producers declaring that their $3 million production would add nothing to the story that wasn't in the original book. It wasn't an approach that every filmmaker tackling Tolkien's work would adopt.

Rankin/Bass was headed by Arthur Rankin Jr. and Jules Bass, a

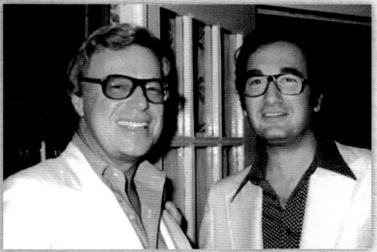

**Above: Arthur Rankin Jr. and Jules Bass, the animators behind the 1977 *The Hobbit* television special for NBC TV.**

pair of animators who specialized in stop-motion productions for major American holidays such as Christmas and Easter. Their specials had included *Rudolph* (1964) for Christmas, *The Mouse on the Mayflower* (1968) for Thanksgiving, and the Halloween-themed *Mad Monster Party* (1967).

*The Hobbit* was promoted as the most expensive animated television show in history. Rankin Jr. suggested in a *New York Times* interview that the popularity of *Star Wars* (1977) was down to the epic, mythic storytelling of Tolkien that had become incredibly popular in the United States in the late-1960s and early-1970s. "The old wizard with the Force in *Star Wars*—that's Gandalf, the wizard of *The Hobbit*. The young fellow having adventures—good versus evil—that's the White Tower versus the Black Tower in *The Lord of the Rings*," he claimed.

Rankin and Bass were aware of the previous attempts to film Tolkien's work, and they knew of the upcoming Ralph Bakshi animated film of *The Lord of the Rings*. "I decided that the Tolkien property that I could handle was *The Hobbit*," said Rankin. "[That] was because of the main character himself. Bilbo Baggins has attitudes and characteristics described by Tolkien that are 'animatable'. When you see him struggling to keep up with the others on his adventure, you feel sympathy for him. Our star is

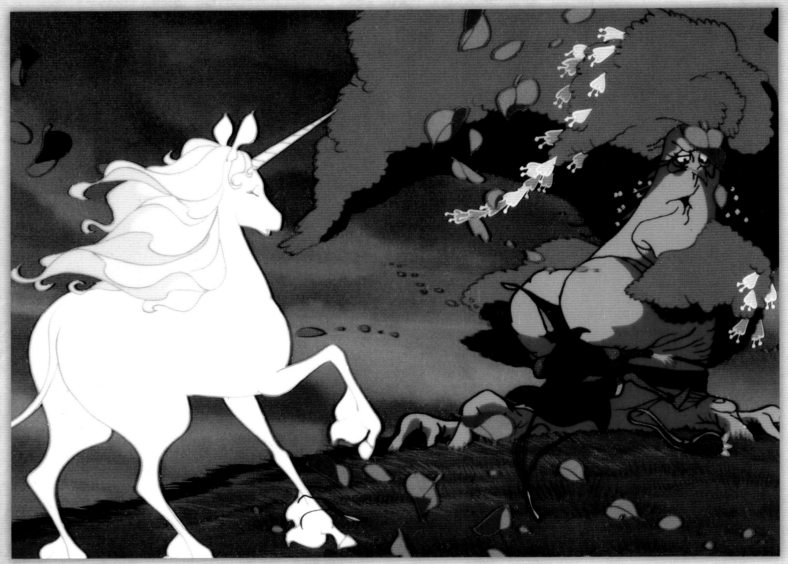

*Above: Still from the 1982 Rankin/Bass animated film,* **The Last Unicorn.**

the Hobbit, and the Hobbit is what the picture is about. He's a catalyst to all the bizarre things happening to him. Without that sympathetic character as a thread, you can't get away with doing a picture about Goblins and Dwarves."

The writer was Romeo Muller, who had previously worked on the most successful Rankin/Bass animated specials. Muller had a background in theater puppetry and had written comedy material for Jack Benny before coming to Rankin/Bass to write their first animated special, *Return to Oz* (1964). His script for *The Hobbit* would win a Peabody Award recognizing "excellence, distinguished achievement, and meritorious public service," and the Christopher Award for media that "affirms the highest values of the Human spirit."

Rankin and Bass shared directing duties on the film, with Rankin taking on the additional role of production designer. Bass often wrote lyrics for the songs in their specials, but in this case all the songs were adapted from Tolkien's originals. Japanese company Topcraft produced the animation, and would reunite for the sequel TV movie *The Return of the King* (1980). Rankin stated his aim was to draw on the illustrations of Arthur Rackham, a decision that would have met with Tolkien's approval. "I borrowed from a lot of sources," admitted Rankin, "but the Rackham influence is heavy. I couldn't think of anyone better in the history of illustration to visualize Tolkien than Rackham— but the color sense is Tolkien's and mine. There are about a dozen major sequences and each has its key color. The Hobbit Hole is springtime greens; Gollum's cave, purples; the Goblins' place, red;

*Above: Still from the 1982 Rankin/Bass animated film,*
**The Last Unicorn.**

Despite declaring their intention not to add to the Tolkien source material, Bass could not resist adding one original song. "There was no song that motivated Bilbo," said Bass, who adapted Tolkien's lyrics and poems to music by Maury Laws. Bass wrote "The Greatest Adventure (The Ballad of The Hobbit)" for Bilbo, and the song was performed by American folk singer Glenn Yarbrough.

*The Hobbit* TV special—broadcast on November 27, 1977—was supported by a variety of tie-in spin-offs, including an illustrated version of the novel published by Harry N. Abrams featuring concept art and stills, and both a soundtrack and a story LP album. The film lost out on the Hugo Award for Best Dramatic Presentation to *Star Wars*, but was critically well received. The *New York Times* called it " . . . curiously eclectic, but filled with effective moments . . . [T]he drawings frequently suggest strong resemblances to non-Tolkien characters. . . [T]he Goblins could have stepped out of a Maurice Sendak book. The dragon and Gollum, the riddle aficionado, bring some clever original touches . . . [W]hatever its flaws, this television version of *The Hobbit* warrants attention."

Smaug's cave, golden . . . Wherever Tolkien said that anything was a certain color, we have used that color."

Film and Broadway actor Orson Bean headed up the voice actors as Bilbo Baggins. "I didn't use a voice change to do Bilbo," said Bean. "I did an attitude change, making Bilbo kind of fussy—fussy and proper—then gradually dropped the fussiness and properness as the madness of battle really affected him." Film director and actor John Huston voiced Gandalf, with fellow film director Otto Preminger voicing the Elvenking. Thurl Ravenscroft sang the baritone voices of the Goblins. Smaug the dragon was voiced by Richard Boone, with comedian and performance artist Brother Theodore as Gollum.

Due to time limitations, several events and characters from *The Hobbit* were eliminated or severely compressed. Beorn was removed entirely, and several additional Dwarves lost their lives in the final battle. The Arkenstone was removed entirely, as was the Elvenking's feast. The Wood Elves were depicted as green and given Germanic accents by Preminger, making them quite distinct from the Elves of Rivendell. Gollum was more monstrous and amphibian than Tolkien's version. At the conclusion, in an attempt to foreshadow a planned sequel, Gandalf confides in Bilbo that the Ring he has recovered is the One Ring (a fact not revealed to Bilbo until the opening of *The Fellowship of the Ring*).

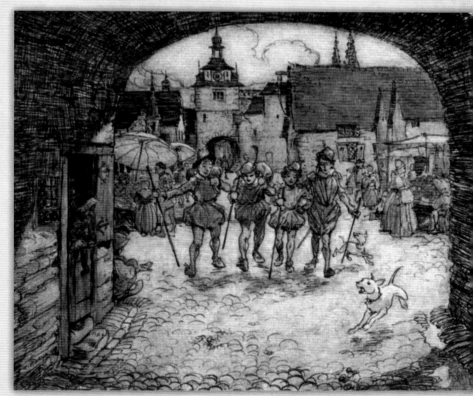

*Above: An illustration from noted English illustrator Arthur Rackham. Animator Arthur Rankin Jr. admitted that he drew heavily upon Rackham's style for* **The Hobbit.**

# Reassessing the Rankin/Bass Hobbit

## by Marco Palmieri

*Fade in. We open, appropriately enough, on the yellowed pages of an old book, a thin ribbon of rising smoke, the strumming of a few alluring notes on a lute or guitar, and a voiceover uttering the familiar opening line, "In a hole in the ground, there lived a Hobbit."*

**P**oll a random sampling of hardcore Tolkien fans and you'll discover a fair amount of dislike for the Rankin/Bass Productions animated adaptation of *The Hobbit*. Many of them will cite inconsistencies with the novel (and, indeed, there are a fair number of them); others will wrinkle their noses at the animation style of the era (admittedly not the smoothest by any measure, even for 1977); still others will bemoan the music (Glenn Yarbrough's original folk theme is perhaps not the best fit, and

it returns to haunt the audience far too often); and many share disapproval of the almost entirely American cast of voice actors (not to mention the bewildering German accent of the Elvenking). Yet, for all its faults, there's a lot to admire, even love, about this made-for-TV movie.

One may certainly take issue with the film's deviations from the novel, a sampling of which includes Gandalf wearing a hood instead of a hat; the complete omission of Beorn as well as the recovery of the Arkenstone; the five deaths among the Dwarven Company at the end of the film, instead of the three that are recorded in the novel. Some of these, such as the cutting of Beorn and the Arkenstone, are perhaps forgivable. Condensing the novel into a 77-minute dramatization demands that filmmakers think in terms of what is essential to the story. In that context, we can understand the producers' choices. Much like the encounter with Tom Bombadil in *The Fellowship of the Ring,* the parts of *The Hobbit* involving Beorn and the Arkenstone are arguably among the least integral to the overall narrative. It may seem like heresy to some, but objectively, the story really does work perfectly well without them.

The dispensing of Gandalf's hat seems arbitrary, since he's explicitly described with one in the book. On the other hand, the book also describes the wizard's eyebrows extending past the hat's wide brim, an image which has never been accurately translated in any popular depiction of the character—except the 1977 movie, which, by giving Gandalf a hood, elegantly remains true to that particular characteristic without appearing absurd. As for the number of Dwarf casualties at the end of the film, this is a little harder to defend. It may be that it was done to make the warfare at the story's climax seem more costly, which at the time of the film was still a fashionable statement

to make in popular culture. But this is merely speculation. The real reason for the higher body count within Thorin's Company may never be known.

Issues taken with the character designs are numerous. There's Thorin, who bears a suspicious resemblance to *Snow White*'s Grumpy; Elrond, who sports a goatee; Gollum, whose appearance makes it difficult to connect him to the Hobbit that *The Lord of the Rings* would later reveal him to have once been; the Wood Elves, who seem the opposite of the "fair folk" Tolkien imagined; and Smaug, who is strangely feline in appearance for a dragon.

But the animation style also has plenty of defenders. The backgrounds in particular are admired for being richly illustrated with a color palette of understated earthtones, unlike anything else produced at that time, for television. Equally striking, however, is the loyalty of that scenery to the source material. Bilbo's Hobbit-hole seems perfect, as does Gollum's dank and dismal cave, the bleak and menacing forest of Mirkwood, the layout of Lake-town, and the main gate of the Lonely Mountain. And though the other characters each have their puzzling qualities, there's little to complain about when it comes to portly, furry-footed Bilbo.

Despite complaints about the music, the animated film gets points for using actual verses Tolkien wrote for the novel, correctly placed within the story, even if they were only snippets. These include the Dwarves' ballad of the Lonely Mountain and their clean-up song in Bilbo's home; the welcome song of the Rivendell Elves; the Goblins' songs; and the barrel-rolling song.

The largely American voice-cast may not sit well with most fans, but in retrospect, the list of actors is both surprising and impressive. Most notable among them: Orson Bean (Bilbo) has been acting in film and television since the 1950s; Hans Conried (Thorin) was a character actor and voice-actor best known for his portrayal of Captain Hook in Disney's *Peter Pan*; Richard Boone (Smaug) was familiar to audiences, particularly as the star of *Have Gun, Will Travel*; comedic monologist Brother Theodore (Gollum) was well known on the U.S. talk show circuit; and then there are Otto Preminger (the Elevenking) and John Huston (Gandalf), two renowned actor/directors. Preminger was famous for directing boundary-pushing films that explored controversial or taboo subject matter, such as *The Man with the Golden Arm*, *Anatomy of a Murder*, and *Advise & Consent*. Huston is best remembered as the director of *The Maltese Falcon*, the original *Moulin Rouge*, and *Prizzi's Honor*—among others, but genre fans will also recall his unusual role as the Lawgiver in *Battle for the Planet of Apes*.

What stands out most about the Rankin/Bass television adaptation of *The Hobbit* is the obvious love that the participants had for the original material. Despite the controversy surrounding some of their creative choices or the movie's production values, it's right to give credit to the filmmakers for things they got right, and for the talent they brought together for one of the earliest attempts to bring Professor Tolkien's timeless tale to the screen.

*Above: Cartoonist and artist Ralph Bakshi in front of his large abstract painting entitled "Loft in L.A." at his studio. Bakshi adapted The Lord of the Rings to the big screen in the 1970s, and Peter Jackson would later use the Bakshi film as inspiration for his own undertaking.*

Even as production was underway on the TV version of *The Hobbit*, another animated take, this time on *The Lord of the Rings*, was near completion. Ralph Bakshi's 1978 cinema film was to become notorious for telling only half of Tolkien's epic tale.

Following the author's death in 1973, Bakshi investigated the availability of the film rights to *The Lord of the Rings* and discovered they were still held by United Artists. He was best known for his adult, counter-cultural animated films such as *Fritz the Cat* (1972) and *Heavy Traffic* (1973). He may not have been the obvious choice to bring Tolkien's work to the big screen, but his family-oriented Tolkien-inspired *Wizards* (1977) had been a big hit, giving Bakshi some industry clout, however briefly. He was also a huge Tolkien fan and feared what might happen to *The Lord of the Rings* if Disney were to try to adapt it.

Although he initially approached United Artists, Bakshi set up his Tolkien project at MGM. The management had changed at United Artists, and the studio felt it had wasted enough money on the aborted Boorman project. Bakshi persuaded MGM to finance the development of a script, a process that took two years and involved a trio of writers: Chris Conkling, who structured his version as a retelling of the story in flashback from the points of view of Merry and Pippin; fantasy author Peter S. Beagle (author of *The Last Unicorn*); and Bakshi himself. By the time the script was completed MGM had lost interest in the project. Bakshi turned to producer Saul Zaentz, who'd funded *Fritz the Cat*, reducing the planned number of films from three to two. As a result of his investment, Zaentz retained an interest in the Tolkien film rights through to the Peter Jackson movies.

Bakshi had been a fan of Tolkien's work since the mid-1950s and felt a responsibility to be true to the books in a way he felt Boorman was not in his condensed and rearranged script. The animator wanted the approval of the Tolkien estate, even though it wasn't required as part of the rights package. He contacted Tolkien's daughter Priscilla and explained his approach. "My promise to Tolkien's daughter was to be pure to the book. I wasn't going to say, 'Hey, let's throw out Gollum and change these two characters.' My job was to say, 'This is what [Tolkien] said . . . .'" Despite this laudable aim, the resulting film would be heavily criticized.

Bakshi faced a number of challenges in adapting the story, although he made great efforts to stick to Tolkien's tale. Bakshi took the view that he would rather omit material, such as Tom Bombadil whom he believed did nothing to advance the story, than invent. As a result, the early parts of Frodo's journey in *The Fellowship of the Ring* is significantly condensed, while some liberties were taken in depicting the battle of Helm's Deep in order to make it more visually dramatic.

In promoting the film, Bakshi claimed it was "the first movie painting" that employed an "entirely new technique in filmmaking." While Bakshi did achieve a unique look for the movie, the techniques involved were far from new. To speed up the process of production, Bakshi decided to use rotoscoping, a technique often used in classic Disney films that involved tracing animation over live-action footage. According to Marea

*Above: A variant of the Tolkien bestiary from artist Ian Miller who worked on Ralph Bakshi's Wizards and The Lord of the Rings.*

Boylan, writing in Jerry Beck's *The Animated Movie Guide*, "... up to that point, animated films had not depicted extensive battle scenes with hundreds of characters. By using rotoscope, Bakshi could trace highly complex scenes from live-action footage and transform them into animation, thereby taking advantage of the complexity that live-action film can capture without incurring

the exorbitant costs of producing a live-action film." The result, according to Bakshi, was a kind of "nasty realism" that he felt was true to Tolkien's world.

Bakshi began by recording the voice artists to provide a "guide track" for the animation. Among those voicing the film were Christopher Guard as Frodo, William Squire as Gandalf, and John Hurt as Aragorn. Anthony Daniels, *Star Wars'* C-3PO, gave voice to Legolas, while Peter Woodthorpe made a lasting impression as Gollum (a role he reprised for the 1981 BBC Radio 4 version).

Bakshi filmed the live-action material in Spain, where cheaply costumed actors performed the film's action sequences. Actor Billy Barty played the roles of both Bilbo and Sam Gamgee, with Sharon Baird as Frodo. Several of the voice actors also performed their roles for the purposes of rotoscoping. Due to time pressures, Bakshi also adopted the technique of "posterising" some of the live action, which gave a slightly different effect. Bakshi believed the techniques he employed gave the animated characters "weight" on screen and made their movements appear more "natural." To achieve his aims, Bakshi was essentially making the same film twice, once in rather rough live action, the second time through animation.

While some audiences criticized these techniques, arguably the biggest failing of the film was that it did not complete the story.

*Below: John Howe's "The Black Rider." Howe credits the Bakshi film for inspiration of this painting. He believes the Hobbits hiding from the approaching Black Riders was the best scene in the movie.*

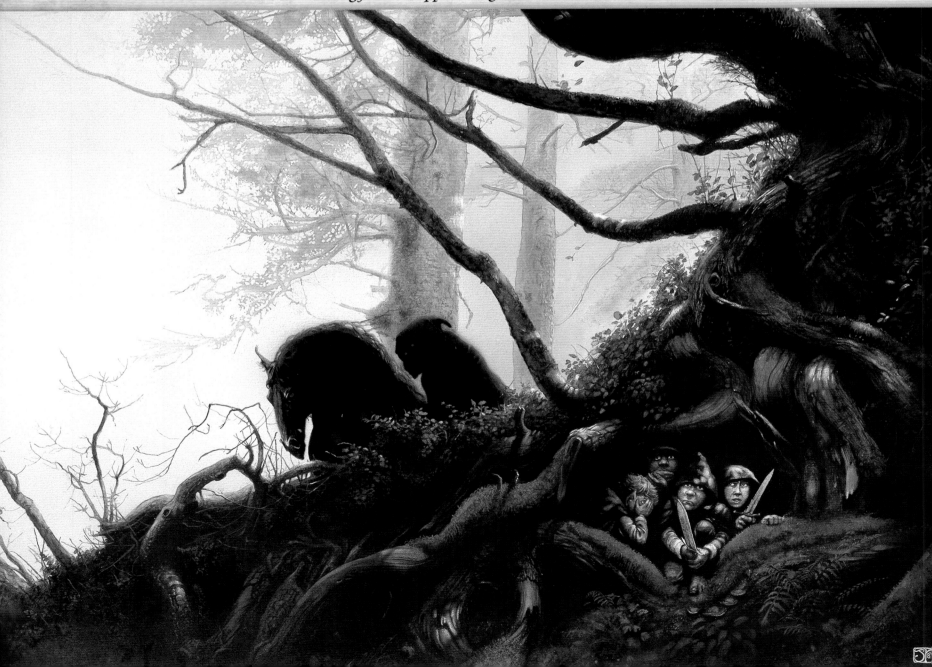

Bakshi argued that the original intention had been to issue the film under the title *The Lord of the Rings Part One*, but that Saul Zaentz and United Artists (who, ironically, ended up distributing the movie) dropped *Part One* from the title. United Artists feared no one would pay to see an incomplete story, while Zaentz was reconsidering his commitment to make the second film. "They screwed me royally," Bakshi complained, "because they never put 'Part One' on the screen. They were supposed to make two films, but they chickened out."

Despite all the issues, Bakshi's *The Lord of the Rings* was financially successful, grossing $30 million at the box office on a production budget of just $4 million. Critical reaction to the movie was mixed, with many appreciating Bakshi's attempt at fidelity to Tolkien's source material but feeling let down by the incomplete nature of the project. The *Hollywood Reporter* called the film "daring and unusual," while *Chicago Sun-Times* critic Roger Ebert felt the project offered "mixed blessings . . . an entirely respectable, occasionally impressive job [that] still falls far short of the charm and sweep of the original story." When he came to make his fuller version of Tolkien's tale, director Peter Jackson would refer to Bakshi's film as an inspiration.

\*\*\*

It fell to Rankin/Bass to complete Tolkien's story in their 1980 TV movie special *Return of the King: A Story of the Hobbits*. The animated film served as both a follow-up to *The Hobbit* (1978) and to Bakshi's half-completed version of *The Lord of the Rings*. Although planned and in production before Bakshi's movie was released, the second Rankin/Bass TV special provided a less-than-ideal conclusion to the animated trilogy of Tolkien films.

Reuniting much of the talent involved with *The Hobbit, Return of the King* has Orson Bean doubling up as the voices of both Frodo and Bilbo, with John Huston returning to the pivotal role of Gandalf; he provides the opening narration that fills in the narrative gap between *The Hobbit* and the new special (largely the story covered by Bakshi's movie, but also including the second half of *The Two Towers* not included in that film). *Planet of the Apes*

actor Roddy McDowall played Sam, *Scooby-Doo*'s Casey Kasem voiced Merry, and Brother Theodore returned as Gollum.

Despite the more adult story told in *Return of the King*, the animation and depiction of the characters matched *The Hobbit*, aiming at younger viewers than Bakshi's more realistic take. The Hobbits—Frodo and Sam—were the main viewpoint characters and they were depicted almost as animated children among the adults such as Gandalf and Aragorn.

As before, this film features many deviations and elisions from Tolkien's work, but perhaps the most egregious is the suggestion that Hobbits would eventually become humans over time. Gandalf notes that younger Hobbits are taller than their parents, and in time men might have a little Hobbit in them. There is nothing in Tolkien to suggest this. While the books do indicate the coming time of man, they are already represented in the world of Middle-earth by characters like Aragorn and Denethor. Although this ties in to the conclusion of the story when Gandalf predicts the coming of the Age of Men and the departure from Middle-earth of races such as the Elves, it is an odd direction to take. It is a clear attempt to connect the Hobbit heroes with the viewing children at home, with Gandalf almost addressing the audience directly toward the end.

While aimed at children and excluding elements like Aragorn's ghost army, *The Hollywood Reporter* criticized the TV movie for being too frightening. Despite the juvenile style of animation and the unnecessary songs, critic Gail Williams warned that the TV movie "should not be seen by children given to nightmares." She did, however, note that the animation was "magnificently intricate and powerfully fluid," while criticizing the screenplay's "bewildering structure" that caused viewers to devote "too much energy just trying to figure out what's happening."

Together these three animated films represent a compromised take on the epic work of J.R.R. Tolkien in *The Hobbit* and *The Lord of the Rings*. However, for *Rings* fans, these flawed films would have to suffice, until a little heralded New Zealand filmmaker turned his attention to Middle-earth.

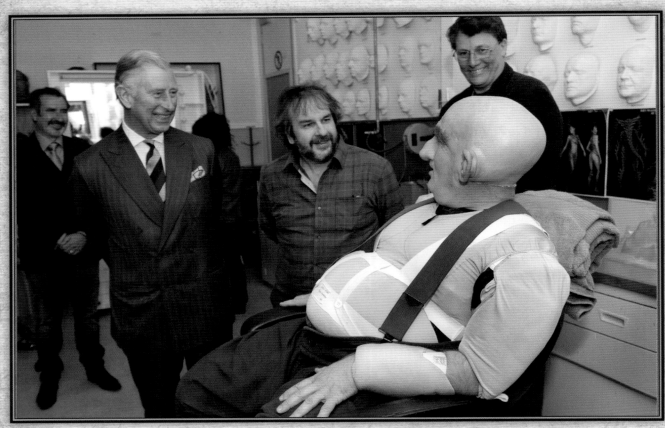

**Above:** Foreground from left to right, Prince Charles, Peter Jackson, and Peter Hambleton at the Weta Workshop in Wellington, New Zealand, on November 14, 2012.

# CHAPTER 11
# Peter Jackson's
# *The Lord of the Rings*

There aren't many film directors who have their own action figure, but such was the popularity of Peter Jackson's trilogy of movies based on *The Lord of the Rings* that even the small cameo part he played in the final film *The Return of the King* warranted commemoration in plastic. It wasn't just the movies that were popular. Jackson himself—for all the complaints from purists that his films weren't a word-by-word, comma-by-comma, exact rendition of Tolkien's books—became the object of fan adulation, a fitting reward for the many thousands of hours he spent on the translation of Tolkien's story from the printed page to the silver screen.

**Above: The Peter Jackson action figure.**

The son of two British emigrants to New Zealand, Peter Jackson grew up with a love of screen fantasy and science fiction, enjoying everything from the original 1933 version of *King Kong* to the British puppet series *Thunderbirds*—both of which he would later go on to remake. He was a solitary child, whose love of animator

Ray Harryhausen led him to want to emulate his hero. "I was happy to stay at home in my dad's toolshed making things and that is what I wanted to do," he recalled in 2006.

His interest in *The Lord of the Rings* stemmed initially from seeing the Ralph Bakshi animated movie, reading the original Tolkien text (in an edition which had a photo from that film on the cover) during a long train journey, and listening to recordings of the 1981 BBC Radio version when he was working in his dad's workshop. The thought of making his own version wasn't an overriding goal through his career—if anything, the remake of *King Kong* was much closer to his heart—but the subject came up in 1995 when he was discussing what his next project would be as he was working on a film for Robert Zemeckis, *The Frighteners*.

Jackson's first feature film, *Bad Taste*, was shot over four years, and completed in 1987 with help from money from the New Zealand Film Commission. The rights were sold at the Cannes Film Festival to 12 territories, marking Jackson as a filmmaker to watch. Although he worked on various scripts, his next completed project was the musical puppet comedy *Meet the Feebles*, which grew from a short film for television into a full-length movie. This was followed by *Braindead* (released in North America as *Dead Alive*), a zombie comedy, and then *Heavenly*

*Above: The movie tie-in edition of* The Lord of the Rings *by J.R.R. Tolkien from Unwin Paperbacks. Peter Jackson became interested in* The Lord of the Rings *after seeing the Bakshi movie and reading the book on a train ride.*

*Above: Peter Jackson directing*
**Heavenly Creatures** *in 1994.*

*Creatures.* This retelling of the true story of Pauline Parker and Juliet Hume, who were responsible for the death of Parker's mother, was the idea of Jackson's partner, Fran Walsh. Special effects house Weta Digital was established by Jackson along with effects artists Richard Taylor and Jamie Selkirk to cope with the script's fantasy elements, since there wasn't anywhere in New Zealand that could handle the requirements.

Opening at the 51st Venice International Film Festival in 1994, *Heavenly Creatures* brought Jackson to the attention of Miramax Films, an independent film distribution company, which had recently been purchased by Disney. They promoted the film in North America, and signed Jackson to a first-look deal. Jackson

*Above: A large Gollum sculpture installation at Wellington Airport on November 25, 2012 in Wellington, New Zealand, right before the world premiere of* The Hobbit: An Unexpected Journey.

went on to codirect a fake documentary *Forgotten Silver*, and then helmed the ghost story *The Frighteners* for producer Robert Zemeckis. The American had originally hired Jackson and Walsh to script the movie, with the intention of directing himself, but decided it would be better for Jackson to do so. Filmed, like all Jackson's movies, in New Zealand, it created a huge amount of extra work for Weta Digital.

This was the catalyst for a conversation between Jackson and Walsh in which they realized that there hadn't been a proper fantasy film for a long time—and with the computer capability at their disposal through Weta, they were in the perfect position to rectify the situation. Rather than do something like *The Lord*

of the Rings, why didn't they actually make a live-action version of the Tolkien classic, and do it in a realistic way?

Their Los Angeles agent, Ken Kamins, established that the film rights remained with Saul Zaentz, who, Jackson discovered, "didn't seem very keen on either making a picture or selling the rights." Not only that, there was clearly a minefield of other rights holders to be negotiated. The clout of a Hollywood studio would make things happen far quicker, so Jackson and Walsh took the project to Miramax—which, by coincidence, had helped Zaentz with a problem he had faced on the movie of *The English Patient* earlier in 1995. They pitched the idea to Miramax boss Harvey Weinstein in October 1995. Jackson would make a movie of *The*

*Hobbit*, and then if that worked, he would shoot *The Lord of the Rings* as two films back-to-back.

Around the same time, Universal offered Jackson the chance to remake *King Kong*, and for a time, the two projects were proceeding in tandem. Various difficulties arose: Jackson needed to get a clear idea of what his next film would be so he could ensure he didn't lose his Weta Digital staff once work on *The Frighteners* was complete; Harvey Weinstein discovered that Zaentz didn't own all the rights to *The Hobbit* and *The Lord of the Rings* (United Artists still had distribution rights to any movie of the former); and 20th Century Fox threw the possibility of Jackson working on a reboot of *Planet of the Apes* into the mix. To complicate matters further, Jackson was holding out for a very keen deal with whichever studio he worked.

With Weinstein still not able to confirm the rights with Zaentz, Jackson decided to work with Universal on *King Kong* before then starting on *The Lord of the Rings* (leaving *The Hobbit* aside for now), and to placate Weinstein, suggested that Miramax and Universal co-invest in the projects. Once a side deal was agreed upon—which gave Weinstein the financing needed to bring *Shakespeare in Love* to the big screen—both *King Kong* and *The Lord of the Rings* were ready to go.

Except that they weren't. When Universal backed out of *King Kong*, leaving Miramax to benefit from *Shakespeare in Love*'s eventual success, Harvey Weinstein stepped up and expedited the negotiations with Saul Zaentz. Jackson was able to keep his staff at Weta—who had been expecting to start work on *King Kong* imminently—by taking small jobs for TV shows like *Hercules*, and films like

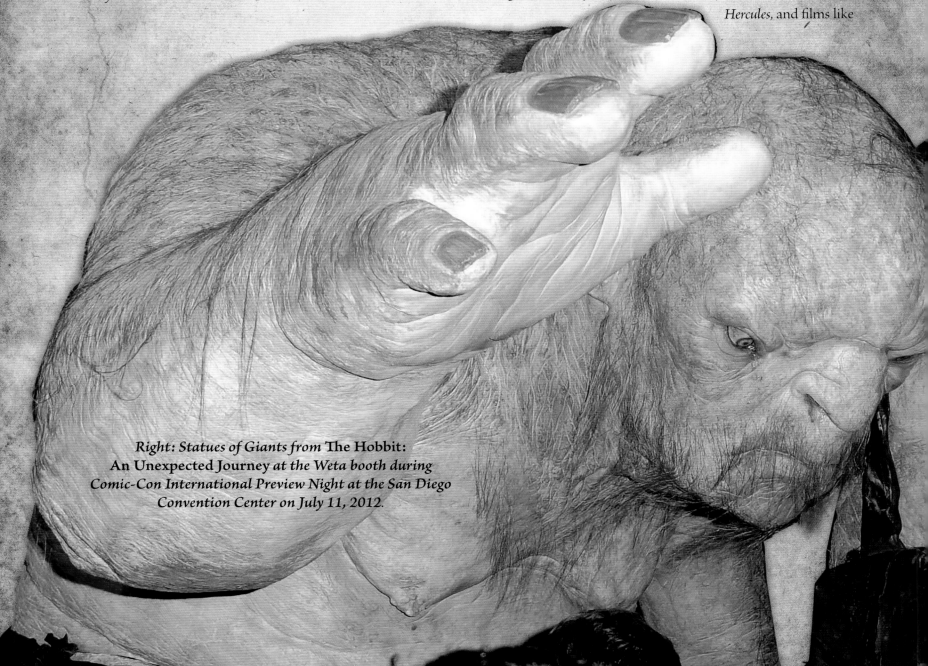

*Right: Statues of Giants from **The Hobbit: An Unexpected Journey** at the Weta booth during Comic-Con International Preview Night at the San Diego Convention Center on July 11, 2012.*

Zemeckis' *Contact*. And Jackson and Walsh began work on the script for *The Lord of the Rings*.

At this point, the New Zealanders were still looking at a two-picture version, and they asked Costa Botes, with whom they had worked on *Forgotten Silver*, to prepare a breakdown of the book. Even at this stage, it was clear that they wouldn't be able to include every strand that Tolkien had delineated. What Jackson summed up as "Hobbit goes on a journey to destroy the ring!" was the only part that was absolutely fundamental, and became the guiding principle. If a section didn't help maintain the focus on that journey, then it was jettisoned—hence the lack of Tom Bombadil, Old Man Willow, and the Barrow-wights. It's one of the distinctions Jackson draws between the eventual theatrical versions, and the extended editions prepared for DVD and Blu-ray release—most of the new footage for the latter focuses on characters other than Frodo.

The eventual treatment for the two films, codenamed *Jamboree*, began with a summary of Jackson and Walsh's vision of the movies. They were

distilling Tolkien's narrative into a movie format, and doing whatever was necessary to ensure it was told clearly—particularly for the benefit of the audience members who never had, and never would, open the original. The first film would cover *The Fellowship of the Ring*, the first half of *The Two Towers*, and Sam and Frodo's journey with Gollum to the Black Gates of Mordor from the second half of that book. The second film would conclude with the Elven ship heading for the Undying Lands. The plans took some liberties with the text, including adding to the Paths of the Dead sequence, a love triangle between Aragorn, Éowyn, and Arwen; and an early attempt by Gollum to snatch the Ring from Frodo.

Their decision to pitch the story at those who had never visited Middle-earth in literary form paid off. Bob Weinstein, the head of Dimension Films, who was brought onto the project by his older brother, had never read the book. At one point the younger Weinstein saw the movie as a magical version of the Alastair MacLean war film *The Guns of Navarone*; at another meeting, he insisted that one of the Hobbits had to die.

Miramax signed off on the idea of a two-film deal (refusing the idea of a trilogy) and a $75 million budget for the pair.

To help with the scripts, Jackson and Walsh brought in *Meet the Feebles* and *Braindead* cowriter Stephen Sinclair, who in turn introduced Philippa Boyens to the couple. Her input was invaluable, as a fan of the book; she would point out problems with the screenplays but then offer helpful solutions and

eventually acted as script editor, and screenwriter, particularly after Sinclair dropped out of the project during the redrafting process (he received a cowriting credit on *The Two Towers*).

Pre-production began as the scripts were being prepared. Locations around New Zealand were scouted; Weta started to research how to create the highly detailed version of Middle-earth that would make or break the project for the audiences

*Below: From left to right, Weta Workshop supervisor Richard Taylor; Director Peter Jackson; Andrew Lensie; Reg Arside; Grant Major; and Brian Van't Hul on the set of* King Kong.

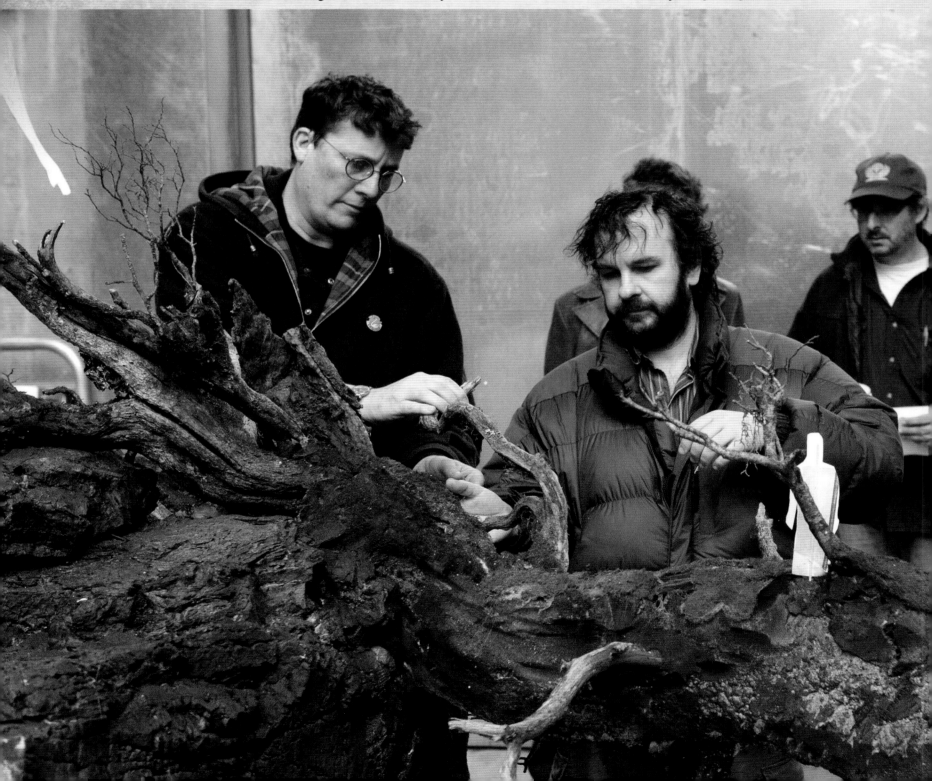

while Jackson investigated the various ways in which Tolkien's world had been brought to life by artists over the past half-century. The work of Alan Lee and John Howe particularly caught his eye (for more details on their previous contributions to the Tolkien mythos, see *Chapter 13*), and both came aboard.

As the scripts firmed up, so more changes to Tolkien's text developed, sometimes showing scenes that the writer had simply reported—such as Gandalf's imprisonment by Saruman—or building up characters—the substitution of Arwen for Glorfindel to rescue Frodo from the Ringwraiths, for example. Some changes would be ephemeral and appear in only certain versions of the scripts—such as a nude bathing scene for Aragorn and Arwen at the start of *The Two Towers*—while others, like Frodo's attempt to send Sam home on the Cirith Ungol stairs, survived to the finished film. (For those interested in the many changes, Brian Sibley's authorized biography of Peter Jackson contains intricate details, including script extracts of the unused material.)

Most movies, particularly those involving action sequences, are storyboarded by the director before filming begins. Drawings depict the intended angles, with arrows indicating the direction of camera or actor movement. Sometimes, as Jackson did here, the director will create an animatic—a crude animated movie that will indicate how long a shot should be held, combined with a rough recording of the dialogue and/or effects. This can be invaluable when there is more than one unit shooting simultaneously, as the director's vision is clear to all those involved. It can also expose flaws that need fixing, and there were various script rewrites as a direct result of seeing and hearing the film in this very crude version.

At this point, it was becoming increasingly obvious to everyone that a $75 million budget for two movies was going to be unviable, and that sort of figure was a more sensible estimate for each of the films. This, not surprisingly, was not what Miramax had hoped to hear, and various executives were sent to New Zealand to assess the situation. Twelve million dollars had already been spent; there was no way that the two films could be completed for $63 million.

Miramax therefore started looking for a partner. Disney declined—which no doubt would have pleased Tolkien, who was adamant that the film rights should not go to them. After viewing the animatic, Miramax summoned Jackson and Walsh to New York and informed them that they wanted to make just one film—not, as Jackson first thought, just the first film, but one film in total. They even provided a list of drastic suggestions

to eliminate or combine characters and situations to bring the running time down, which included eliminating the battle of Helm's Deep, and fusing Faramir and Éowyn to become Boromir's younger sister. Jackson and Walsh knew that a two-hour movie made to that template wouldn't be *The Lord of the Rings*.

After spending so much money on the pre-production (by June 1998 it had risen to $15 million), Harvey Weinstein was determined to make the film his way. He took Jackson off the script—Walsh would work with Hossein Amini on the revisions—and told the stunned New Zealander that if he wouldn't direct the film *Her Majesty, Mrs. Brown*, director John Madden would be brought in. Jackson and Walsh flew back to New Zealand knowing that they couldn't compromise their vision.

Ken Kamins then had the delicate job of telling Miramax that Jackson and Walsh were pulling out, but that they wanted to put the film into "turnaround"— in other words, attempt to interest another studio to take over the project, picking up the costs that Miramax had already spent. The conditions that Miramax imposed were stringent: whichever studio picked up *The Lord of the Rings* must make two movies, not just one; the costs incurred were to be repaid within 72 hours of a new deal; and, worst of all, they had just 28 days to find a new studio.

To do this, the team pulled together a 35-minute minidocumentary that would show potential new investors exactly how far the project had progressed. The currently existing merchandise was used to show the strength of the potential market for the film, and the various contributors explained how the film would be created. Alongside this, Weta prepared displays of concept artwork and models.

Before they could even head from New Zealand to Los Angeles, a lot of studios had turned *The Lord of the Rings* down, including Fox, Universal, Dreamworks, and Sony. Only the UK's Working Title Films and New Line Cinema seemed interested. The former might have proceeded, but the uncertainty over the sale of their parent company, Polygram, meant they couldn't meet Miramax's conditions.

That left New Line as the only game in town—at least for *The Lord of the Rings*. Jackson did have some meetings to ensure that he had directing work lined up in case the whole project collapsed. Jackson was taken to a one-on-one meeting with the studio's co-chairman, Robert Shaye, where he was told that even if New Line passed on *The Lord of the Rings*, Shaye hoped to work together on a future project. After that, Shaye viewed the animatic—and asked a question that bemused the team. "Why would anyone want moviegoers to pay $18 when they might pay $27?" In other words, why were they making only two movies, rather than three? Once the shock had worn off, everyone agreed that three movies was the way to go. New Line was keen to find another property that they could franchise successfully, as they had previously done with a string of hit horror movies—and *The Lord of the Rings* came with two built-in sequels. It meant Jackson could make the films without compromising his vision.

*Above: Sir Ian McKellen during the premiere of* **The Lord of the Rings: The Fellowship of the Ring** *at New York's Ziegfeld Theater.*

*Above: From left to right, Sean Astin, Elijah Wood, Peter Jackson, Billy Boyd, and Dominic Monaghan at Chateau Castellaras in Castellaras, France, a suburb of Cannes, on May 11, 2001.*

Of course, it wasn't all smooth sailing. There were considerable negotiations to sort out the messy situation, and although Miramax's deadline passed without their $15 million paid to them, it wasn't long before New Line had taken over responsibility for *The Lord of the Rings* and announced it to the world. On August 30, 1998, Jackson answered questions on the *Ain't It Cool* Web site and made it clear to the fans that this was going to be his interpretation of *The Lord of the Rings* and that therefore he might make choices that weren't exactly what Tolkien wrote in the book. "I want to take moviegoers into Middle-earth in a way that is believable and powerful," he concluded.

To create three scripts out of two meant the scriptwriters

returning to the original text, and reexamining every decision they had made when they thought they had a mere four hours or so in which to tell the story. The problems inherent in Tolkien's structure, where events happen simultaneously in the second and third books, meant that the chronological approach the film was going to take couldn't entirely respect the division of storylines that Tolkien had created. The scripts needed to be completed quickly, and, inevitably, various revisions were made during filming and indeed after the movies were complete. While shooting the final scene, Jackson quipped that it wasn't normal to be filming a scene for a movie that had already won an Academy Award! Fran Walsh would describe the ongoing scripting process as laying the track down in front of a moving train (for one scene,

Sean Bean had to read his lines from a script taped to his knee, since the dialogue had been changed so recently).

New Line had clear ideas regarding the casting, and where Jackson's disagreed, would sometimes insist on seeing screen tests before agreeing. The initial casting of Stuart Townsend as Aragorn was a case in point. They were also keen on Sean Connery for the part of Gandalf, but the veteran actor read the script and declined. Christopher Lee auditioned for that role, but was instead offered Saruman; it eventually went to Ian McKellen, although there were worries that he would not be able to get clear of his commitments on the first *X-Men* movie, in which he played Magneto. Elijah Wood filmed his own audition videotape for the part of Frodo; Dominic Monaghan also tried out for Frodo, but was cast as Merry; Billy Boyd played Pippin, with Sean Astin as Sam. Ian Holm, who had played Frodo for the BBC's 1981 radio adaptation, joined the film as Bilbo. Orlando Bloom auditioned for Faramir, but ended up as Legolas. Sean Bean was cast as Boromir, with John Rhys-Davies as Gimli, Cate Blanchett as Galadriel, and Hugo Weaving as Elrond.

The shoot began on Monday, October 11, 1999, on Mount Victoria, which overlooks Wellington, with a scene where the four Hobbits hide under the trees as the Black Rider approaches. Given that there could be no secrecy over the story of the film— apart from what changes the production might make—there was concern that the look of the movie should remain hidden, and security was kept tight throughout filming. Trusted members of the press and representatives of internet fan groups were permitted access on condition of secrecy.

Almost immediately, further changes had to be made. Stuart Townsend was not working as Aragorn, and a hurried search for his replacement got underway. Viggo Mortensen, who had recently starred in *A Perfect Murder*, the remake of *Dial M for Murder*, was quickly at the top of a list that also included *Speed 2*'s Jason Patric, and Australian actor Russell Crowe. After an hour-long conversation with Jackson and Walsh, Mortensen agreed to sign up for the role; luckily, he had on-

screen chemistry with Liv Tyler, who had been cast as Arwen. The original shoot lasted for 279 days, finishing on December 22, 2000, with up to seven units operating simultaneously on occasion. Jackson was "present" via video link-up as 150 locations across the entire islands of New Zealand became

the backdrop for the huge project. Nearly 2,500 people were involved when production was at its height.

As is usual with any TV or film project, scenes were shot out of order, with some of the key climactic moments, such as the argument between Frodo and Sam in *The Return of the King*, going in front of the camera far earlier in the proceedings than might have been expected—and certainly, before some of the actors anticipated. On occasions, there could be up to 12 months between the different takes of a scene, dependent on availability

*Below: Actor William Kircher who plays Bifur in* **The Hobbit: An Unexpected Journey** *in the leather room of the Weta Workshop in Wellington, New Zealand.*

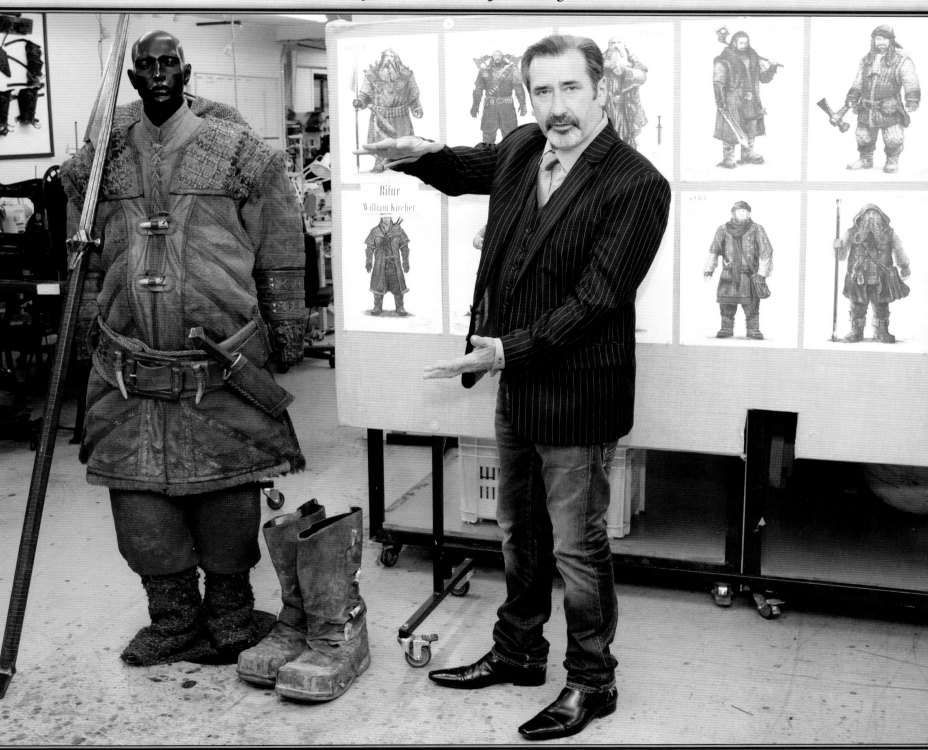

**Above: Hair and makeup artists Peter Owen (left) and Peter King (right) in 2002. Owen won an Oscar for his work on The Lord of the Rings: The Fellowship of the Ring.**

of actors and weather conditions.

It was never going to be an inexpensive movie to make, and the spending continued to spiral during production. New Line regularly chastised Jackson for the overspending, and started to ask for cuts in the effects—although Jackson typically found a way to overcome the objection by arranging for the second unit director to film a sequence they wanted removed. He didn't alter his style of directing. If he felt a scene needed multiple takes, he would go again until he was happy, and then probably just add "one more for luck."

Weta had developed new software, known as Multiple Agent Simulation System in Virtual Environment (MASSIVE), which had been a key part of the pitch that Jackson had made to New Line. This allowed him to create believable huge armies, since each participant would have up to 30 different individual movements. However, this was expensive, and as the script developed in size and scope (100 orcs would become 1,000 in a rewrite), so the budget increased. This caused some problems between the production team in New Zealand and the studio in Los Angeles, but a lot of the tension was dissipated when Robert Shaye visited the set and was shown twenty minutes of footage. This demonstrated the emotional depth of the film, and was sufficient to persuade Shaye to rein back the micromanagement—although that didn't mean that he was giving the production a blank check. Too many jobs were reliant on the final movies not only returning New Line's investment, but providing a very healthy

profit. The company wasn't in a situation to green light too many other projects while *The Lord of the Rings* was in production.

The final day's shooting was a debate between Gandalf and Aragorn followed by a shot of Aragorn putting on his armor (which was eventually not used in any variant of the film) with one unit, and a discussion between Théoden and Éowyn with the other. A huge wrap party followed—but the work, of course, was only just beginning.

Post-production continued for the following next three years, as the hundreds of miles of 35mm footage was edited, scored, and prepared for the premieres of the three films in successive Decembers. There were many different opinions as to what should go into the theatrical release version of the films, but Jackson had been given "final cut" rights by New Line— although, wisely, he chose his battles.

The ending of *The Fellowship of the Ring* had originally been intended to see Frodo pulled underwater by an Uruk. The Hobbit gets free and rejoins Sam in the boat to travel down the River Anduin into the second film. Looking at the footage in a completed edit, they decided to revert to an ending that was closer to the book, and this was one of the scenes that was shot during the pickups during the year. Once the footage was locked, composer Howard Shore recorded his score for the film. He had visited the set during filming, and created themes for the Fellowship as well as other leitmotifs that would appear throughout the trilogy.

A special extended 26-minute trailer was shown at the 2001 Cannes film festival, featuring a 14-minute sequence from the key battle in the Mines of Moria bookended with other scenes from across the first film. "*Star Wars* looks like a pale TV series compared to that," *Empire* magazine's French Web site said of the footage, a comparison that John Rhys Davies loudly proclaimed to anyone who would listen. Even Harvey Weinstein was impressed, telling New Line's Robert Shaye that they had done the films "exactly as they should be done."

Although the films were made in New Zealand, with an international cast, there was only one place where *The Fellowship of the Ring* could be premiered: London, to honor its creator's "Englishness." On December 10, 2001, the movie opened to rave reviews, as well as acclaim by Jackson's peers within the film industry. Nominated for 81 awards, the film triumphed in 70 of them, including four Academy Awards—for cinematography, makeup, original music score, and visual effects—and four BAFTAs, including Best Film.

In addition to preparing the other two movies, and shooting extra footage as required, Peter Jackson had one last gift in store for the loyal Tolkien fans: extended editions of each of the films was released on DVD, with *The Fellowship of the Ring* and *The Two Towers* both made available about a month before the next film in the cycle was in theaters, and *The Return of the King* a year after the final movie's initial release. Thirty minutes was added to the first, with 44 and 52 minutes respectively added to the other two. These didn't simply incorporate footage shot during the original filming; extra scenes were recorded or completed. Not all the footage was used either—Jackson still promises that an "Ultimate Edition" of the films is a possibility. A feature-length documentary by Costa Botes was also included in the collected version, which finally arrived on Blu-ray in 2011.

The editing of *The Two Towers* and *The Return of the King* for their theatrical runs was more problematical than *The Fellowship of the Ring*, with some scenes transferred from their original placements in the second film to the finale, and others (such as Saruman's death) removed entirely. The biggest problem with *The Two Towers* was keeping to Bob Shayle's initial demand, expressed at their very first meeting in 1998, that the middle film be a satisfying experience for an audience who hadn't seen the first movie, and might not choose to go to see the finale.

**Below:** The Lord of the Rings *cast photo at the world premiere of* **The Lord of the Rings: Fellowship of the Ring** *in Leicester Square, London on December 11, 2001.*

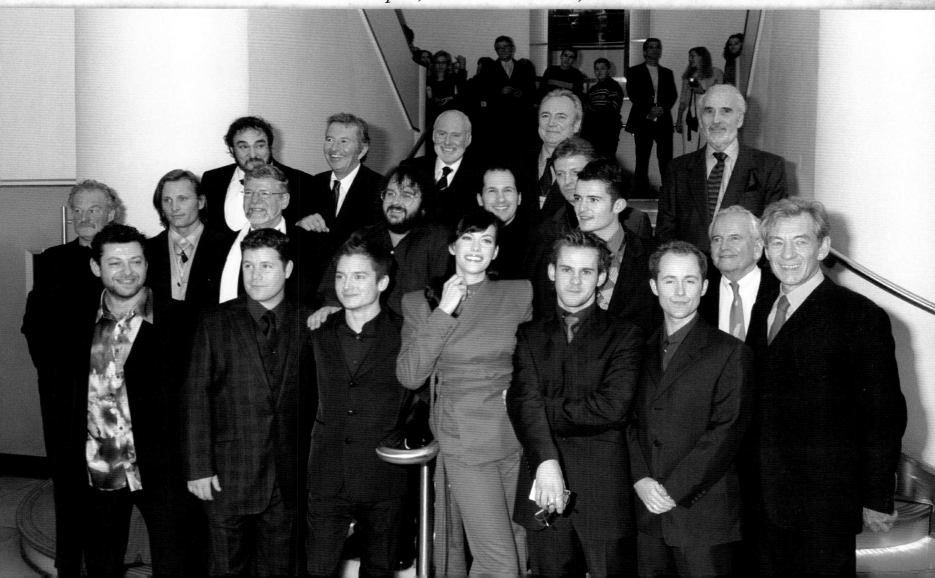

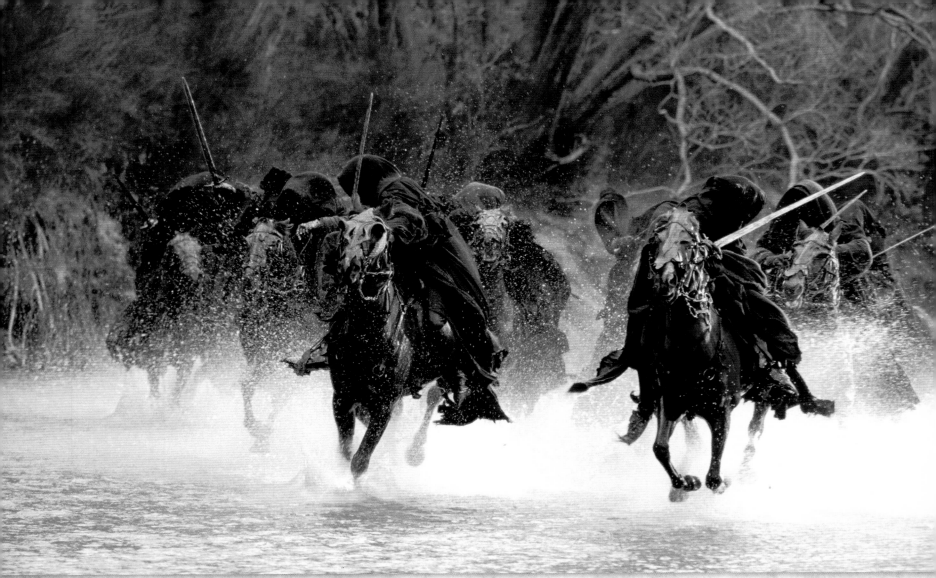

*Above: Both visually dynamic and charged with suspense, this scene in The Fellowship of the Ring features the Black Riders in pursuit of Arwen as she carries a mortally wounded Frodo to her father, Elrond, in Rivendell.*

*Above: MASSIVE (Multiple Agent Simulation System in Virtual Environment) was a new software developed by Weta Digital, which allowed them to create huge and believable armies, as illustrated in this incredible scene from The Two Towers where Saruman's forces scale the wall at the Battle of Helm's Deep.*

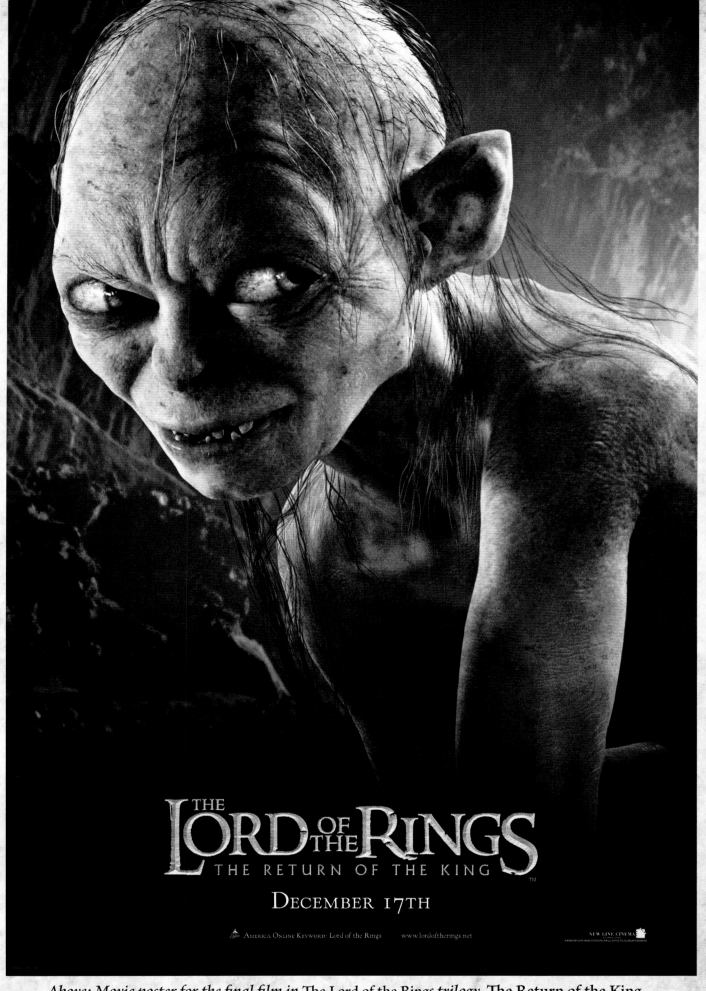

THE **Lord** OF **THE RINGS**
THE RETURN OF THE KING ™

DECEMBER 17TH

AMERICA ONLINE KEYWORD: Lord of the Rings          www.lordoftherings.net          NEW LINE CINEMA

*Above: Movie poster for the final film in The Lord of the Rings trilogy, The Return of the King,*
*with a crafty-looking Gollum front and center.*

# Aotearoa and Middle-earth: A Creative Partnership

### by Bernice Watson

*The impact of Peter Jackson's The Lord of the Rings trilogy on the New Zealand film industry was immediate and lasting.*

"*The Lord of the Rings* project has changed the aspirations of our filmmakers," explained Ruth Harley, the former Chief Executive of the New Zealand Film Commission. "It has extended the limit of their dreaming. It is expanding the possibilities of what they can achieve and this in turn will bring enormous benefits to New Zealand's visibility in the world. Bring on those dreams."

The impact of Peter Jackson's *The Lord of the Rings* trilogy on the New Zealand film industry was immediate and lasting. The short-term benefits of mass industry employment, international visibility, and an influx of overseas funds into the national economy were followed by the longer-term benefits of state-of the-art, internationally recognized production facilities, a tried and tested body of industry expertise, and the proven ability to produce financially successful films.

The two most prominent transitory effects that the production of *The Lord of the Rings* trilogy had in New Zealand were the overseas funds it brought into the local economy and the mass industry employment it generated. Between mid-1998 and early 2002, approximately 74 percent of the films' total production and post-production costs were spent in the country. By March 2002, the production company in New Zealand spent a total of NZ$352.7 million. At its peak, the production hired around 1,500 people per week, not including day laborers or extras. Additionally, 5,000 vendors were used during production, the majority of which were in New Zealand.

*Above: The view across Mildford Sound in Mitre Peak in Fiordland, South Island, New Zealand.*

However, possibly more interesting than the short-term effects of *The Lord of the Rings* on the New Zealand film industry was its more far-reaching impact: the resulting increase in the likelihood of other major international feature films being produced there.

In any film production scenario the choice of location is heavily influenced by the cost/risk ratio involved. One major by-product of the vast majority of the successful writing, directing, production, and post-production of *The Lord of the Rings* trilogy taking place in New Zealand was the reduction of this perceived risk for the creators of other large-scale, high-cost film production projects.

Adding to the increased competitiveness of New Zealand as a film location was the rapid up-skilling that *The Lord of the Rings* allowed within its film industry at technical, creative, and management levels. Many who worked on the films were able to gain skills and experience in a much shorter time span than would otherwise have been possible. As a result, New Zealand now boasts a depth of expertise that is on a par with international standards yet still retains its uniquely New Zealand approach.

Other factors that make New Zealand an attractive and viable choice for large-scale film production in the wake of the success of *The Lord of the Rings* include local resources; value for money; technical and post-production resources; availability of locations and scenery; and helpful regulations, alongside established working relationships with local and national government bodies. Taken together, these offer studios an enhanced ability to estimate cost and risk more accurately during a film shoot.

Of course, whether New Zealand can continue to build on the boost to the national film industry provided by *The Lord of the Rings* films remains to be seen. Although few would deny the positive effects of the trilogy on the New Zealand film industry, there are concerns that it has had a negative impact in certain areas. Some in the industry worry that aid given to *The Lord of the Rings* films, including significant financial support from the New Zealand government and rewritten labor laws, came at the expense of independent and art-house films by New Zealand filmmakers. However, others argue that a changing world film market and a robust New Zealand currency, rather than a lack of government funding, are what makes producing independent films in New Zealand increasingly challenging.

Prior to *The Lord of the Rings* trilogy, New Zealand could already boast a proud history of national film projects and also an international reputation for creative integrity. However, *The Lord of the Rings* films allowed the New Zealand film industry to prove itself on a much larger scale and to demonstrate an ability to manage big budget, complex, award-winning international productions. Combined with the benefits of state-of-the-art post-production facilities and internationally recognized local expertise, *The Lord of the Rings* production greatly improved the opportunities for future international feature films to be produced in New Zealand. Indeed, since production on *The Lord of the Rings* finished, a number of big-budget films have been produced, or partially produced, in New Zealand, including *The Hobbit, The Chronicles of Narnia, The Lovely Bones, King Kong,* and *Avatar.*

*Above: Actor Christopher Lee signing* The Lord of the Rings: The Fellowship of the Ring *DVD
in London, England on August 2, 2002*

As for *The Return of the King*, there was the concern about wrapping up everybody's stories successfully. This led to the movie running considerably longer than the three hours that New Line had hoped for (the theatrical version runs 202 minutes; the extended edition, without extra credits, 264).

*The Two Towers* premiered in New York on December 5, 2002, and earned 55 awards from its 70 nominations—its two Oscars were for sound editing and visual effects this time. *The Return of the King* opened in Wellington on December 1, 2003, and earned 161 nominations. This time there were 11 Academy Awards among them; it won every single one, including best film, and best director, as well as 108 other honors.

Each of the films did better at the box office than their predecessor: *The Fellowship of the Ring* grossed $871.5 million

*Above: Actor Elijah Wood at the premiere of* The Lord of the Rings: The Two Towers *at the Cinema Dome Theatre and after-party at the Sunset Room in Hollywood, California, on December 15, 2002.*

worldwide, placing it just outside the top 30 movies of all time at the end of February 2013. *The Two Towers* sits at 22nd on that list, grossing $926 million. *The Return of the King* outshone both of them, achieving $1.12 billon and sixth place.

Although many critics were reaching for every superlative, there were some who were less entranced. Looking back on the trilogy as a whole, Roger Ebert noted that it was "a work of bold ambition at a time of cinematic timidity," but when he watched *The Fellowship of the Ring*, he felt that Jackson had "transmuted it into a sword-and-sorcery epic in the modern style, containing many of the same characters and incidents."

The London *Guardian*'s Peter Bradshaw also had problems with the first film. "Signing up to the movie's whole Hobbity-Elvish universe requires a leap of faith, a leap very similar to the ones that characters are always doing across bridges and crumbling, vertiginous precipices. It's a leap I didn't feel much like making—and, with two more movie episodes like this on the way, the credibility gap looks wider than ever." He received hate mail as a result of the review, but didn't appreciate *The Two Towers* any better. "For long, long periods of time the nagging question is—does it have to be quite so boring?" he enquired. And although he acknowledged that *The Return of the King* was "such terrifically enjoyable escapism," his overall view of the series was, "It's tripe. But [Jackson has] made it mind-blowing tripe."

There were those fans, of course, who, echoed that opinion and didn't believe that Jackson's movies were proper renditions of Tolkien's work. Jackson had anticipated this reaction from the start, with his comments during his Web chat before filming began, and his commentaries on the DVDs do address many of the issues that the fans bring up, such as the absence of Tom Bombadil. Some fans took advantage of computer technology to reedit the films themselves (the so-called "Purist Edition" discussed in *Chapter 13*). Although Tolkien's son Christopher kept diplomatically quiet for much of the time, he did express his feelings in an interview with French newspaper *Le Monde* in summer 2012: "The commercialization has reduced the aesthetic and philosophical impact of the creation to nothing,"

he complained. "They eviscerated the book by making it an action movie for young people aged 15 to 25."

There are certainly considerable changes to the characters: Frodo is 33 at the start of the book, and there's a 17-year gap between Bilbo's departure and the main action of the story, which isn't present in the film. That made the Hobbit 50 years old at the time of his quest; Elijah Wood was 18 years old for the majority of the filming. Elrond, Aragorn, Gandalf, and Faramir were all modified in action and intent; Elves fought at the battle of Helm's Deep. The romance between Aragorn and Arwen is given far more prominence in the films than in the book. Indeed Arwen assumes a prominence in the movie saga that Tolkien never gave her. The decision to remove the scouring of the Shires from the end of *The Return of the King* meant that Saruman's death is brought forward chronologically. Inevitably, moving from the printed page to the screen, Tolkien's use of language suffers, and although Howard Shore's score, and the songs that were included across the trilogy, were appreciated, for many fans they didn't match the poetry of Tolkien's own work.

Some fans, while still bemoaning the fact any changes were made, did spring to Jackson's defense. Gabriel Ruzin noted how many of the alterations served to speed up the story, and kept an audience of non-fans interested in the storyline. "Most people don't care to unravel Aragorn's lineage seven generations back," he commented. "Most people don't care about the names of the mountain ranges surrounding Mordor. Most people just don't care. They want to see a story that makes sense without the advantage of prior knowledge. They want to see a rip-roaring tale of good versus evil, without the entanglements of characters with dubious motives, a complicated and philosophical nature versus industry argument, or an equally complicated nature versus nurture debate. Simplicity leads to digestibility, which leads to profits large enough to have made the endeavor worthwhile for all involved." Undeniably, that is what Peter Jackson achieved.

*Right: "Aragorn" by Jenny Dolfen.*

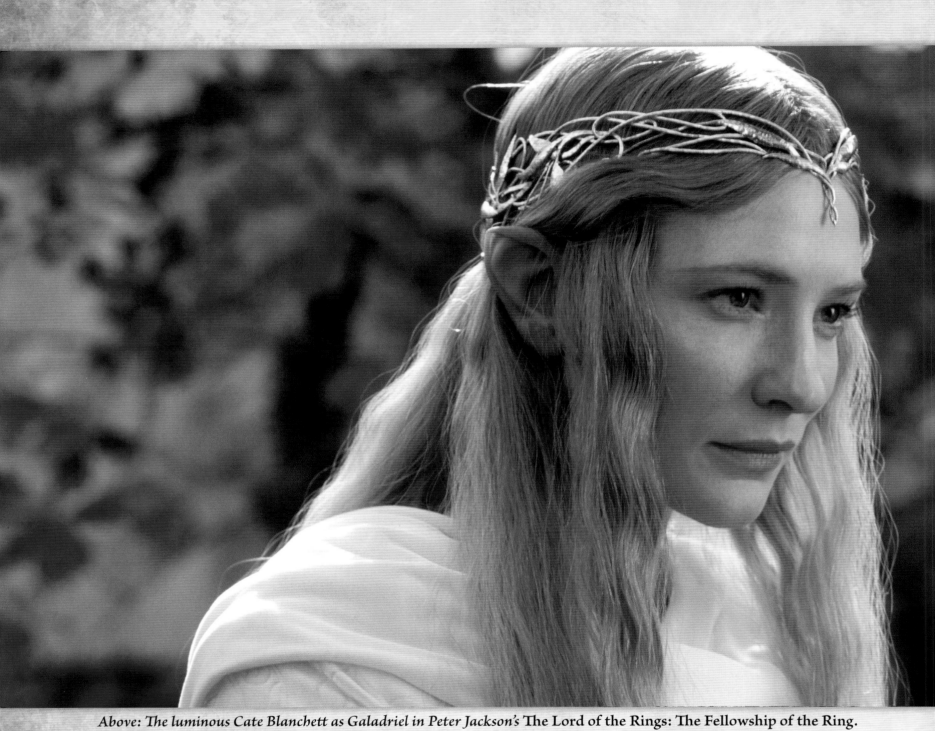

*Above: The luminous Cate Blanchett as Galadriel in Peter Jackson's* The Lord of the Rings: The Fellowship of the Ring.

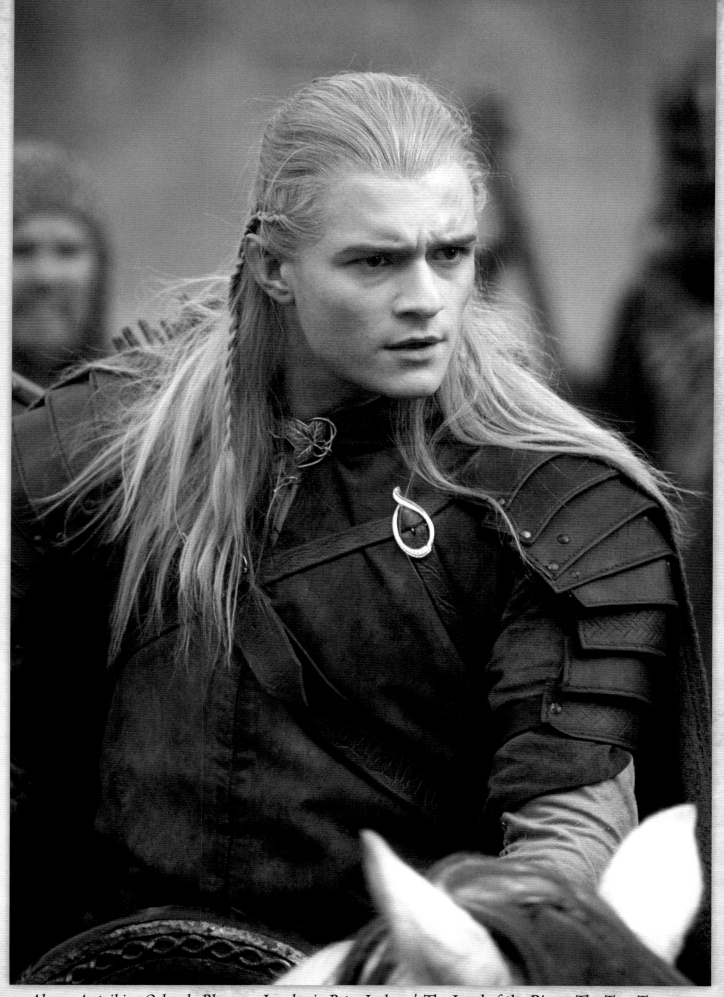

*Above: A striking Orlando Bloom as Legolas in Peter Jackson's* The Lord of the Rings: The Two Towers.

# The Fighting Styles of Middle-earth

## by David A. McIntee

As epic fantasies, Tolkien's works are filled with suitably epic battles, especially in *The Hobbit* and *The Lord of the Rings*, and so it's hardly surprising that screen adaptations of these works sometimes focus on these cinematic battles and fight scenes. As with any film, it's up to the stunt coordinators and swordmaster—in the Jackson films' case, the late, great Bob Anderson—to decide upon a fighting style for the characters and races, based on what the writer has created originally.

Tolkien was not a fencer or student of historical martial arts, so he doesn't actually describe much of the characters' fighting styles in his writing, which meant that the creators of the movies had to provide their own interpretation for the actors and stuntmen.

Nevertheless, there are some clues in the original texts that could be built upon, and that show through in the screen versions.

Legolas, for example, in the books, has his bow and "a long white knife at his side," which would be appropriate for an archer in medieval times. In Jackson's movies, this knife is transformed into two white-handled blades, which Legolas dual-wields in a suitably graceful style. Having expanded upon Legolas's white knife, in Jackson's films the other Elves use variations and larger versions of the type of weapon and style used for Legolas, which is a logical development.

There's surprisingly little description of actual fighting in Tolkien's books. For example, think of the lengthy fight involving Boromir at the end of Jackson's *The Fellowship of The Ring*; it's created entirely by Bob Anderson and the stunt team. In the book, Boromir simply runs off at the end of *Fellowship*, and is found dying at the beginning of *The Two Towers*.

Where Tolkien's talent at battle scenes lay was in his descriptions of the preparations and aftermaths. Tolkien had experience of large-scale battles in World War I, in which he had been involved at the battle of Thiepval Ridge, in the autumn of 1916, and the taking of the Germans' Schwaben Redoubt.

This battle had been fought in heavy rain, and mud, and so the battle of Helm's Deep in *The Two Towers* is a battle fought in rain and mud, with the fire from Orthanc taking the place of artillery. In the book, this is one of the most believable and gripping sections, taken from Tolkien's own

experience, and the Jackson movie nails it perfectly, putting the audience in the battle, and, on a subconscious level, with Tolkien on the Western Front. When we read about the bodies littering the area around Gondor, or see them in the movies, we're seeing something of what Tolkien saw at Thiepval Ridge. Likewise, the wounding of Frodo at Weathertop, and his delirium on the flight from there to Rivendell, is so compelling and dizzying both in prose and film because it's based on personal experiences. In the film, Jackson captures what Tolkien tells us about how it feels to be hurt in combat and lose blood.

In the case of the Dwarves, and especially Gimli, axes are the order of the day. In Tolkien's text, Gimli and his kind simply use axes to cut or hit, with no mention of any special techniques for doing so, as Tolkien seems to have been unaware that an axe meant for combat needs to be kept moving all the time, in big circles, to keep up a useful momentum. In the screen adaptations, Dwarves still use them for single hits, like a hammer or hatchet, even though the styles are developed by people who do know better. In this way, they give us a vision of how Tolkien saw the Dwarves fighting. Of course this style also reflects melee combat in the trenches, using tools, and this is something else Tolkien would have been familiar with from Thiepval Ridge.

Tolkien's Orcs are described in the books—particularly in the chase through Moria—as being very fast, and this is actually envisioned most effectively in Ralph Bakshi's animated film version, in which the Orcs are always running, and suddenly appearing in front of our heroes. This movie also has the

*Above: Armor and weapons on display inside the Weta Cave on June 15, 2008 in Wellington, New Zealand.*

characters bearing arms and armor of much simpler, Saxon-style design, befitting the era of the original sagas and legends, which Tolkien had studied and based his world-building upon.

It's interesting that *The Lord of the Rings* puts the sympathetic and viewpoint characters in the defense of their fortifications—essentially in the position of the Germans at the Schwaben Redoubt. The defensive trebuchets seen in Jackson's trilogy are a far dafter idea than artillery at the German fortress.

For the human characters, screen versions have given Aragorn, Boromir, and the others, the type of fighting style that best suits film, to use the screen effectively, and look good. This does tend to mean that moves from different martial arts are brought in, which a medieval or earlier warrior wouldn't have known, and even moves from sports that simply look good in visual terms.

Ironically, the one character in Jackson's films who actually fights most correctly in terms of how a medieval type warrior would have fought, without doing screen-friendly but suicidal moves such as random spins, is Sean Bean as Boromir, whose reward for being the one correct fighter is to be the one of the Fellowship who gets killed! Sometimes it feels as if there's no justice!

**Above: Angela Rizza's Dwarf sketches inspired by The Hobbit.**

# Peter Jackson's *The Hobbit*

**I**t seemed inevitable that Peter Jackson would produce the definitive screen version of *The Hobbit*, even if the route to its release was a long and winding one. After the triumph of *The Lord of the Rings: The Return of the King* at the Oscars, Jackson was frequently asked if he would continue to bring the worlds of J.R.R. Tolkien to the big screen, perhaps with a film of *The Hobbit*. It would take almost a decade before the first film in a new trilogy based on Tolkien's 1937 children's book would appear.

Jackson made three other films during that decade, from his epic-reimagining of *King Kong* (2005), through his poorly received

**Above: Peter Jackson on December 5, 2005, at the premiere of King Kong in New York City.**

adaptation of *The Lovely Bones* (2009), to his coproduction with Steven Spielberg of *The Adventures of Tintin* (2011). While Spielberg directed that film, Jackson was heavily involved in conceiving the project and in producing the digital animation and performance capture effects. He would take on the director's role for the sequel. Jackson had also been involved in a failed attempt to launch a movie based on the award-winning videogame series *Halo* (he also produced innovative sci-fi movie *District 9*, 2009). It's not as though he wasn't busy, but he found the lure of Tolkien and the call by fans for a new Middle-earth movie too strong to resist.

In the years after the triumph of *The Lord of the Rings* trilogy, the possibility of a new series of Tolkien-based films from Jackson looked extremely unlikely, due to business issues between his production company, Wingnut Films, and New Line Cinema. In March 2005, while working on *King Kong*, Jackson took legal action against New Line over payments related to merchandising, video, and computer game releases tied to *The Fellowship of the Ring* (the suit alleged breach of contract, failure to calculate revenue, and unfair competition).

Jackson believed that funds had been withheld and was requesting an independent audit (Hollywood studios were notorious in their accounting practices, often denying creative participants

additional profit-sharing payments by downplaying potential profits). Instead of producing the outcome Jackson was expecting, relations between him and the studio took an antagonistic turn when studio head Robert Shaye, who had taken the gamble on *The Lord of the Rings* back in 1998, announced in early 2007 that Jackson would never again direct a film for New Line "while I'm still working at the company." According to a posting by Jackson to fan site TheOneRing.net, Shaye was actively looking for a new director for *The Hobbit*, having effectively "fired" Jackson. The pressure was on New Line as their rights to film *The Hobbit* (obtained through the deal with Saul Zaentz) were due to expire in 2010. According to a report in *Entertainment Weekly*, "once the law suit was filed, *The Hobbit* was roadkill." The film had been in development as a joint project between Metro-Goldwyn-Mayer (who through their ownership of United Artists held distribution rights to any film of *The Hobbit*) and New Line. However, the executives at MGM wanted Jackson to be involved in making the film, given his track record.

After a 40-year history as a colorful independent, New Line Cinema (which had launched movie monster Freddy Krueger in the *A Nightmare on Elm Street* series in 1985) was fully subsumed in 2008 by owners Warner Bros. as "a small genre arm ... focusing on horror, comedy, and urban genre pics," according to *Variety*.

Company founders Shaye and Michael Lynne were not to be part of the new arrangement. The new setup at Warner Bros. allowed MGM chief Harry Sloan to revive *The Hobbit*. The lawsuit had been resolved just before Shaye left New Line, with the company fined $125,000 for failing to provide accounting documents, and Shaye extending an olive branch to the director: "I really respect and admire Peter and would love for him to be creatively involved in some way in *The Hobbit*." By the middle of December 2007, just before the absorption of New Line by Warner Bros., New Line and MGM were able to announce that *The Hobbit* was back in development as two films with Peter Jackson acting as executive producer, and with someone else sought to direct.

In February 2008, release dates for the two films were announced as December 2011 and 2012. Jackson said he decided not to direct because he feared he would simply be competing with his previous work. Further legal action against New Line (from the Tolkien Estate) over unpaid fees threatened to derail the project once more. It took until September 2009 for that action to be settled and the legal storm surrounding the film to be fully resolved. However, preproduction had begun in earnest by April 2008, with filmmaker Guillermo del Toro hired as director.

Del Toro—director of the *Hellboy* (2004, 2008) movies, as well

*Above: "Erebor at Sunrise" by Anke Tollkühn.*

**Del Toro's take on the book was heavily influenced by what he saw as the effect of World War I on Tolkien.**

**Above: "Elven Archer" concept art by John Howe for Peter Jackson's The Lord of the Rings.**

as fantasy films including *Blade II* (2002) and *Pan's Labyrinth* (2006)—had been involved with Jackson in his planned movie of videogame *Halo*. Although he wasn't a natural fan of Tolkien (del Toro had previously stated in 2006 that he didn't like "little guys and dragons, hairy feet, Hobbits . . . I don't like sword and sorcery, I hate all that stuff"), the director was a fan of Jackson's vision of Middle-earth. He added to his childhood reading of *The Hobbit* with a crash course in the rest of Tolkien's works.

The screenplay—to be written by Jackson, Philippa Boyens, and Fran Walsh, with del Toro—was developed alongside the visual look of the films through spring of 2009, with the writing expected to continue to the start of shooting in the summer of 2010. This timetable meant the first film would now not be released until the end of 2012, with the second the following year.

Having del Toro on *The Hobbit* alongside Jackson promised to bring a different feel to the films than Jackson had achieved with *The Lord of the Rings*. This may have been Jackson's intention, given his concern about competing with his previous work. The creative quartet spent much time analyzing the structure of Tolkien's earliest work, carefully crafting two distinct movies from it. Del Toro saw the film beginning in light and innocence, and moving into a darker mode toward the end. The director noted: "The first film will stand on its own and the second will be a transition and fusion with Peter's world. I plan to change and expand the visuals from Peter's and I know the world can be portrayed in a different way. Different is better for the first one. For the second, I have the responsibility of finding a slow progression and mimicking the style of Peter."

Del Toro's take on the book was heavily influenced by what he saw as the effect of World War I on Tolkien. He saw Bilbo

Below: "The Shire—view of Bywater" by Cor Blok.

*Above: "Bilbo: One Last Look" by Angela Rizza.*

Baggins as the moral center of the work, while greedy characters like Smaug and Thorin Oakenshield represented the corruption of the post-war years. In addition to using Jackson's visual artists John Howe and Alan Lee, del Toro brought in comic book artists Mike Mignola (*Hellboy*) and Wayne Barlowe (*Babylon 5*) to give a unique look to the creatures of *The Hobbit*, distinct from the previous films. The director also wanted to use more physical effects, not just models and painted backdrops, but animatronics combined with CGI enhancements. A controversial choice (if this version of the film had come to pass) may have been del Toro's desire to have the animals of *The Hobbit* speak, so when Smaug talks it would not seem so out of place. When it came to

casting, del Toro hoped to involve Ron Perlman (with whom he frequently worked) possibly as Beorn or to voice Smaug, while he also considered casting Brian Blessed (*Flash Gordon, Star Wars: Episode I—The Phantom Menace*) as Thorin Oakenshield, and *Deadwood* star Ian McShane as one of the Dwarves. It was del Toro who first suggested casting *Doctor Who* lead Sylvester McCoy as Radagast the Brown, a suggestion Jackson was later happy to stick with as he was a fan of the BBC series. Throughout his approach, del Toro was keen to make *The Hobbit* more fairytale in atmosphere and less the epic adventure that Jackson had produced in *The Lord of the Rings*.

*Above: "The Great Eagle Rescue" by Angela Rizza.*

As things transpired, the Guillermo del Toro version of Tolkien's book was to remain a fantasy. In the spring of 2010 the director announced he was to leave the production. There were several reasons given for his unexpected departure. He had several of his own projects in the planning stages that were being delayed due to his ongoing involvement with *The Hobbit*. Mainly, though, his departure was forced due to the uncertainty hanging over the project thanks to MGM's financial troubles during pre-production (the same problems delayed filming of the James Bond movie *Skyfall*). All the while he was working on the movie,

# Middle-earth Style and Fashion

## by Brigid Cherry

When it comes to visualizing the world and characters of Middle-earth, there is no shortage of illustrative and narrative inspiration. Tolkien describes the landscapes and dwelling places of *The Hobbit* and *The Lord of the Rings* in rich detail, but what of the fashions of Middle-earth? Tolkien is not always as forthcoming when it comes to details of clothing. The opening page of *The Hobbit* tells us that Bilbo's Hobbit-hole has "whole rooms devoted to clothes" and "lots of pegs for hats and coats," but aside from bright colors and no shoes, little is revealed about Hobbit couture. Dwarves wear hoods, and Gandalf is dressed in a tall pointed hat, a long cloak, a scarf, and immense boots. In *The Lord of the Rings*, Sam looks around for his cloak, jacket, breeches, and "other Hobbit-garments."

From these scant details, though, it's easy to imagine how the characters might dress. Gandalf wears traditional fairy-tale wizard garb, medieval in tone, and the Dwarves' color-coded hoods might easily come from an Edwardian nursery book illustration of Brothers Grimm by Jessie Willcox Smith or Arthur Rackham. The Arts and Crafts movement (influential in Britain up to the 1930s), and William Morris in particular, were an inspiration to Tolkien. These artists drew on medieval, romantic, and folk styles, and many of the most famous paintings associated with the movement depict men in medieval armor and women in long flowing dresses with wide sleeves and girdles around the hips (clearly an influence on Peter Jackson's version of Galadriel).

These medieval folkloric influences remain strong in the depictions of clothing in various illustrations for *The Hobbit* and *The Lord of the Rings*. Ingahild Grathmer's woodcut illustrations show swordsmen and archers in medieval armor, while the more whimsical Pauline Baynes illustrations dress the Fellowship in a colorful range of hoods, cloaks, and boots that are decidedly fairy tale in style. Alan Lee's and John Howe's illustrations have proved most influential, though neither has moved very far from traditional medieval fantasy. Lee's misty pastels and soft lines suit the females' flowing garments particularly well, while Howe's sharper lines and saturated colors bring an edgier quality to the winged helms and chainmail of men ready for war.

Howe and Lee worked on Jackson's films as conceptual artists, but Ngila Dickson and Richard Taylor brought the medieval style of clothing and armor respectively to the big screen. This richly detailed and realistic costuming now dominates our ideas of the characters' appearances

in Middle-earth, whether it be the rugged, travel stained clothing of Strider giving him an aura of darkness; the dull, angular armor of Sauron so suggestive of evil; or the sumptuous, embroidered robes of Elrond evoking wisdom and power.

The costumes of Middle-earth serve to identify the wearers as belonging to particular classes or groups. Gandalf and the other wizards' dull, neutral robes resemble religious garb—they are priests or monks. The practical, tough clothing of the Dwarves is protective and durable, suitable for their lives in the mines; they are a sensibly clad working-class people. Elves are associated with nature in their color palettes, of forest and glade, but their clothing also displays their aristocratic and ethereal qualities. Aragorn, the riders of Rohan, and other members of the race of Men, are efficiently and practicable garbed for ease of movement and action.

The female characters, their roles enlarged from the books, all reproduce the closely fitted dress of the Middle Ages, with gored, flowing skirts and sleeves, as reenvisioned in pre-Raphaelite art. Arwen, Galadriel, and Éowyn wear a range of gowns that encapsulate these fashions—cotehardie-style overdresses, funnel sleeves falling to the calves, and excess

*Above: "The Ringbearers" by Jenny Dolfen.*

fabric at the hem pooling around their feet. The medieval theme is embellished with art nouveau swirls in embroidery, jewelry, and diadems.

Perhaps it might be expected that Hobbits, too, dress like the popular image of gnomes, pixies, or fairies. Although Tolkien's illustrations are predominantly focused on landscape, he does provide one picture of Bilbo in the hall of his home. This reveals that rather than dressing in folkloric fantasy clothing, Hobbits apparently dress in jacket, waistcoat, shirt, and breeches that recall a Georgian style. The 18th-century theme in Hobbit dress was carried directly over to the films, and the costumes, including those of the young female Hobbits in their ditsy print kirtles, bring to the fore the sense of the pastoral idyll that Bilbo and Frodo both reluctantly leave behind. This sets the Hobbits apart from the other races and positions them as more accessible, more down-to-(Middle-)earth, than the fantasy Elves and Dwarves associated with a mythical past. This perfectly underscores the Hobbits as the point of identification for the reader or film audience. Like them, we are viewers of another, other-worldly, way of life.

*Above: A Hobbit hole at "Hobbiton" on the Alexander family farm near New Zealand's north island town of Matamata on December 2, 2012. The rolling countryside resembles the "Shire" in J.R.R. Tolkien's fantastically imagined world and has subsequently attracted fans and tourists from all over.*

*The Hobbit* had not actually been given a "green light"—official permission by the studio to begin filming. The project seemed stuck in limbo with no immediate resolution in sight, and after del Toro had spent the better part of two years on it, he felt he had to move on. "There cannot be any start date until the MGM situation is resolved," he said. "We have designed all the creatures . . . the sets . . . We have done animatics [video storyboards] and planned very lengthy action sequences . . . We are very, very prepared." In explaining his departure, del Toro blamed "the mounting pressures of conflicting schedules [that] have overwhelmed the time slot originally allocated for the project."

With the loss of its director, *The Hobbit* production was thrown into immediate turmoil. Other names were mentioned as possibilities to take over the project, including *District 9* director Neill Blomkamp (who already had a working relationship with Jackson), *X-Men: The Last Stand* director Brett Ratner, and *Harry Potter*'s David Yates. However, the most obvious director for the

project was to be found rather closer to home. By June 2010, New Line and Warner Bros. confirmed that Peter Jackson would be directing *The Hobbit*, which was still formatted as two films, with release dates confirmed as Christmas 2012 and 2013, as they were previously. While some attempted to depict Jackson as Gollum, keeping Middle-earth for himself as Sméagol had done with the One Ring, others were more inclined to see him as the wizard Gandalf, creating cinematic magic from Tolkien's texts. The continuing delays—from the first announcements in 2007 to Jackson's confirmation as director in 2010—had frustrated fans of the Tolkien films who were keen to see further cinematic explorations of Middle-earth as quickly as possible. With Jackson's confirmation as director, though, came the long-awaited start date for principal photography: February 2011.

There was a final obstacle to be overcome in September 2010 when the International Federation of Actors recommended their members should boycott the film as it was a nonunion

project. At the same time, the studios investigated the possibility of filming somewhere other than New Zealand, including in Eastern Europe or Scotland, where it was felt Middle-earthlike environments could be found. Popular protests against such a move—and the awareness by the New Zealand government of the economic impact (not least in tourism) that the continuing Tolkien film franchise had for the country—forced a resolution that many felt was to the detriment of organized labor. Another controversy that arose during the making of the film was the treatment and care of the various animals involved, with accusations that their housing at a farm located in treacherous terrain had caused the unnecessary deaths of more than 25 animals. The Animal Humane Association, which monitors the use of animals on films, noted that following complaints from animal handlers they had "made safety recommendations to the animals' living areas. The production company followed our recommendations and upgraded fence and farm housing among

others things." The controversy, and the involvement of PETA, left a sour note attached to the production.

After the extended drama of pre production, filming finally began on the two-part *The Hobbit* on March 21, 2011, in Wellington at Stone Street Studios. Playing the part of the heroic Hobbit Bilbo Baggins was Martin Freeman, star of the UK TV series *The Office* and the film version of Douglas Adams's *The Hitchhiker's Guide to the Galaxy*. So set was Jackson on Freeman as his lead that he was prepared to break filming around the actor's preexisting commitments to *Sherlock*, the BBC's modern-day resetting of the Sherlock Holmes stories, in which Freeman played Dr. Watson. Freeman's Sherlock, Benedict Cumberbatch, was tapped by Jackson to give voice to the dragon Smaug and physical shape to the shady Necromancer. Richard Armitage, another star of British television (*Robin Hood, Spooks*), was recruited as the lead Dwarf Thorin Oakenshield, while James Nesbitt and Ken Stott

**Above: Actor Martin Freeman attends the premiere for The Hobbit: An Unexpected Journey at New York's Ziegfeld Theater on December 6, 2012.**

**Above: Actor Andy Serkis signing his book The Lord of the Rings: Gollum: How We Made Movie Magic at Barnes & Noble in New York City on January 12, 2004.**

*Above: "Smaug" by Anke Eissman.*

played his lieutenants Bofur and Balin. Australian comic and actor Barry Humphries would give voice to the digitally created King of the Goblins. Returning in cameo roles from *The Lord of the Rings* were Andy Serkis (as Gollum, also handling second unit direction duties), Cate Blanchett, Ian Holm, Elijah Wood, Hugo Weaving, and Christopher Lee (as Saruman). Location filming took place around New Zealand, including at Matamata, which was featured in *The Lord of the Rings* as Hobbiton. In July 2011 shooting was carried out for four days at Pinewood Studios in the UK to accommodate the then-89-year-old Lee. A second block of filming began in August 2011 back in New Zealand and continued until December 2011.

One of the earliest and most-effective scenes to be filmed at Stone Street Studios was a simple two-hander featuring Freeman as Bilbo and Andy Serkis as Gollum, based upon the chapter "Riddles in the Dark." While special effects were involved in terms of the motion capture technology required to bring Gollum to life, it was a scene shot several times over a two-week period that leaned heavily upon performance, rather than the epic special effects or the expansive vistas of New Zealand, the keynote signatures of Jackson's Middle-earth. Officially, principal photography on the two-film version of *The Hobbit* was completed in July 2012, following 266 days of action-packed production.

As if to emphasize the differences between *The Hobbit* and *The Lord of the Rings* even more, director Peter Jackson decided to use

*Above: Philip McCarthy, an amateur pitcher, throws a test pitch for analysis during a "motion capture" demonstration at the Massachusetts General Hospital Sports Performance Center. This technology was also used to bring Gollum to life on screen.*

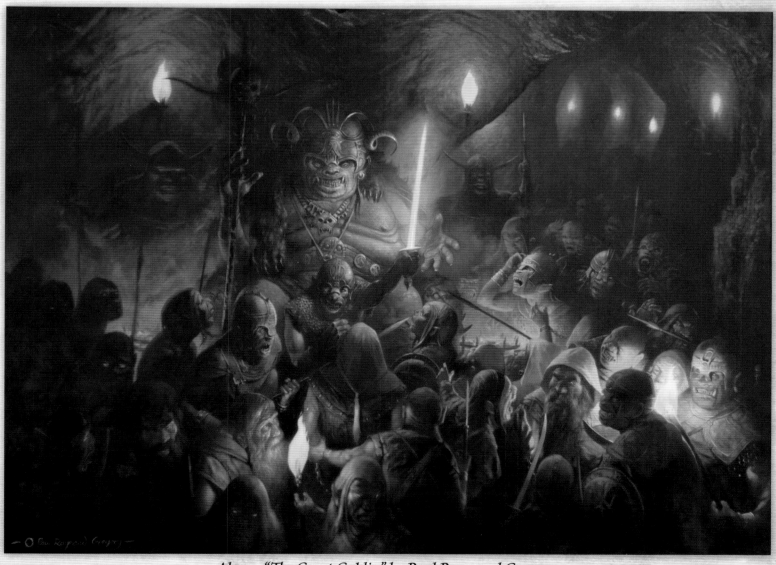

*Above: "The Great Goblin" by Paul Raymond Gregory.*

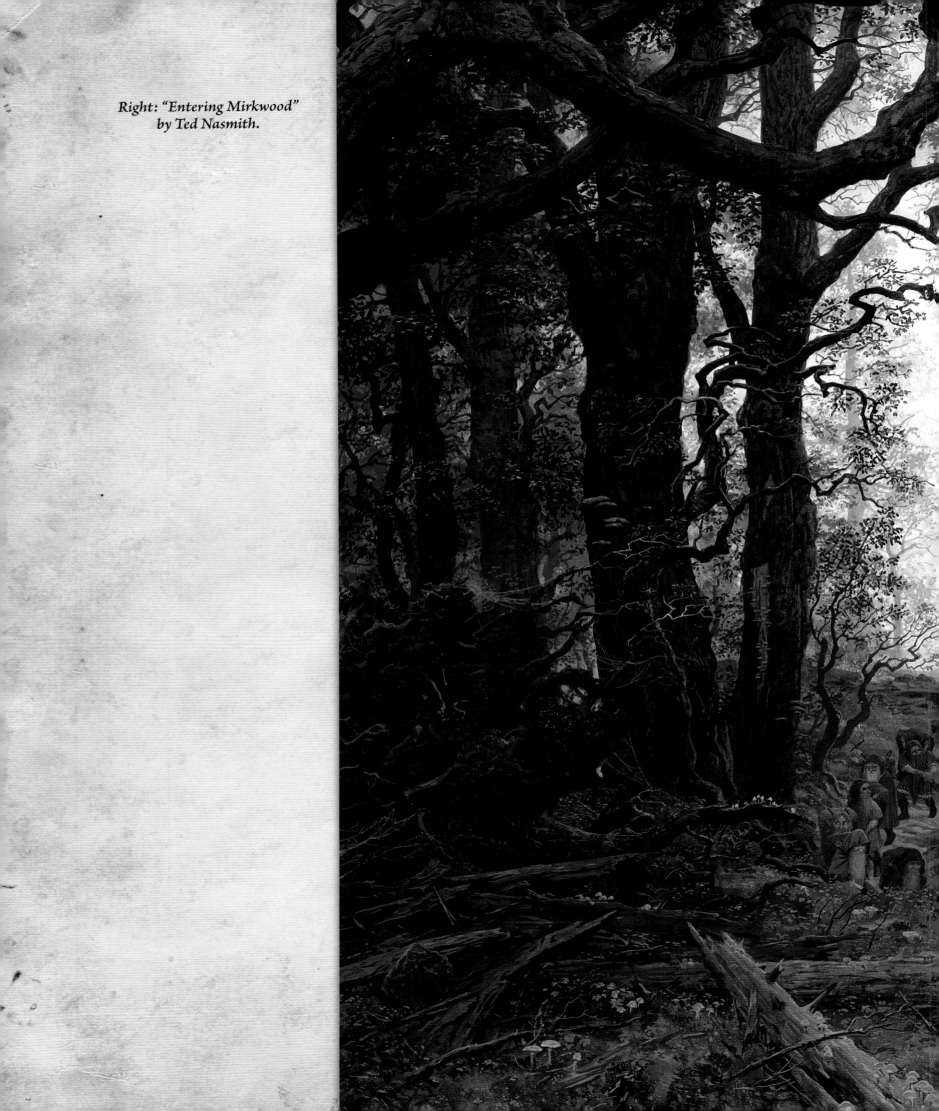

Right: "Entering Mirkwood"
by Ted Nasmith.

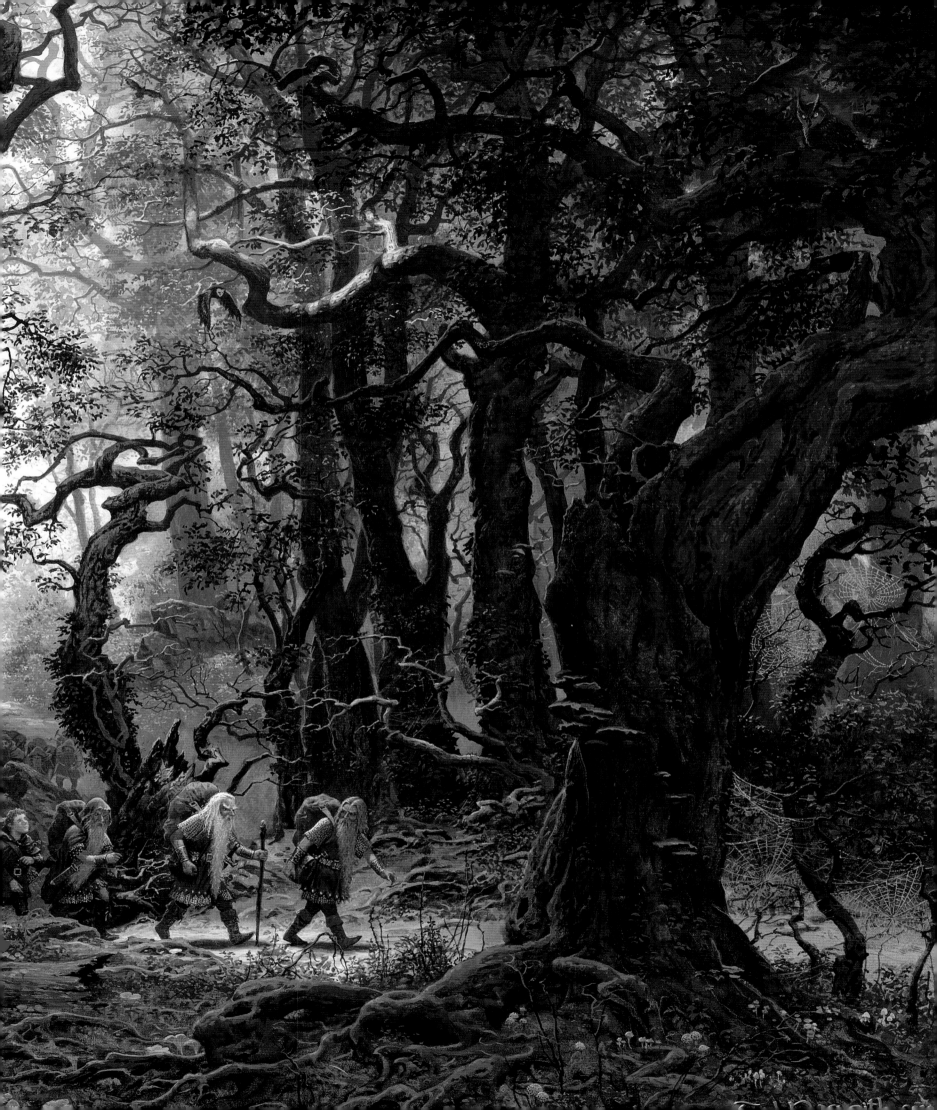

the film to innovate. As well as utilizing the more common 3-D and IMAX formats for the movie, Jackson also opted to shoot the film in High Frame Rate, a new standard that digitally records images at 48 frames per second (fps) rather than the traditional 24fps of film. In the early days of filmmaking, cameras were hand-cranked so there was no standard frame rate for recording and projection. With the arrival of sound recording in 1929, a standard frame rate of 24fps was established as the lowest that maintained persistence of vision and so created the illusion of movement from the projection of sequential still images. Over the decades, there had been several attempts at varying the frame rate, either as a novelty or an attempt to devise a new standard. However, no alternative frame rate had ever caught on for general filmmaking, and 24fps reigned until moviemaking made the transition to digital capture early in the 21st century.

Shooting *The Hobbit* digitally using the industry standard Red Digital Cinema Camera Company's "Epic" system, Jackson could more easily adopt the High Frame Rate of 48fps. Jackson claimed the results would be "more lifelike and [a] comfortable viewing experience. Take it from me, it will look terrific!"

On his Facebook page, the director argued that the new technology would help eliminate the motion blur, judders, and strobing effects that were sometimes visible on normal 24fps movies, especially during fast-moving action sequences. Jackson's pioneering effort interested other filmmakers in adopting the format, including James Cameron who was looking to use it on his *Avatar* sequels and *The Hobbit*'s second unit director Andy Serkis, who hoped to use it in his planned version of George Orwell's *Animal Farm*. Upon release, however, only a limited number of cinemas worldwide were equipped to screen the movie at 48fps (about 400 out of a total of 4,000 screens in the United States), so the majority of audience members experienced it as a standard 2-D release, in 3-D, or in IMAX.

The use of High Frame Rate cinematography attracted much criticism, and early viewers of the film complained of headaches or nausea. An early industry screening of footage had set the tone for the reaction when feedback described the experience of 48fps HFR as "underwhelming." *Variety* noted that the footage "looked distinctly sharper and more immediate than everything shown before it, giving the 3-D smoother movement and crisp sharpness." Jackson claimed any negative reaction was due to the fact that only ten minutes of film was screened as a sample and that was too short a time frame for viewers to get used to the new experience. Audiences compared the 48fps HFR experience to watching HD TV or behind-the-scenes videogame footage. Critics noted that previously invisible items, such as Ian McKellen's contact lenses (pointed out by Mike Ryan of *The Huffington Post*) and the fakeness of the Hobbit feet were more apparent in the new format.

In a widely predicted move, Peter Jackson announced in July 2012 that *The Hobbit* would become a trilogy, just like *The Lord of the Rings*. In a media statement Jackson said: "Upon recently viewing a cut of the first film, and a chunk of the second, [cowriters] Fran Walsh, Philippa Boyens, and I were very pleased with the way that the story was coming together. We recognized the richness of the story of *The Hobbit*, as well as some of the related material in the appendices of *The Lord of the Rings*, gave rise to a simple question: Do we tell more of the tale? And the answer from our perspective as filmmakers and fans was an unreserved 'yes.'"

As they had done with *The Lord of the Rings*, Jackson and his collaborators felt they could expand the story of *The Hobbit* by drawing upon ancillary material Tolkien had consigned to the appendices of his epic trilogy. The relationship between Aragorn and Arwen in *The Lord of the Rings* trilogy had been drawn mostly from this additional material. The writers had to restrict themselves to the central books as they did not have the film rights to *The Silmarillion* or any of Tolkien's other tales. However, they felt there was more than enough material to show events in the wider world of Middle-earth during *The Hobbit* that set the scene for *The Lord of the Rings*.

Key to this expansion of the tale was Appendix A, Section 3 (Durin's Folk) from *The Return of the King* that told of the attack on the Dwarves at Erebor (as seen in the prelude to *An Unexpected Adventure*) and the menace of the great orc Azog

(Manu Bennett). Taking this approach also meant that the entire tale could be framed as a story told by Bilbo to Frodo, drawn from Bilbo's memoirs, *The Red Book of Westmarch*.

In this way, the new trilogy of films would also function as a cinematic prequel series to *The Lord of the Rings* trilogy, as well as a faithful adaptation of *The Hobbit*. "We know how much of the tale of Bilbo Baggins, the Dwarves of Erebor, the rise of the Necromancer, and the Battle of Dol Guldur would remain untold if we did not fully realize this complex and wonderful adventure," said Jackson. The director saw these films as his final opportunity to visit Middle-earth, so he wished to elaborate on Tolkien's rather simpler tale of *The Hobbit* and shape it into a suitable companion piece to the more epic and expansive *The Lord of the Rings*. To that end, the second film released in December 2013 was to be called *The Desolation of Smaug*, while the third and final film entitled *There and Back Again* (Tolkien's original sub-title for *The Hobbit*) would be released in the summer of 2014.

Some critics complained that stretching *The Hobbit* to three movies was simply a money-making ploy on behalf of the director and the studios involved. While it was likely that three movies would make more money at the box office than two, the costs also increased accordingly. Even with Jackson deferring his directorial fees, the first two movies had been estimated to cost $315 million each (studio sources claimed the direct cost was more like $200 million per film). Together, this made for a close to $1 billion gamble for the three movies that make up *The Hobbit*. Even though following *The Lord of the Rings* movies with a further three visits to Middle-earth was probably as close to a sure thing as Hollywood ever gets, it was still a venture that was not without risks. The convoluted route to production had demonstrated that any attempt to recapture the magic of a much loved film series

**Above: "Smaug, Dragon of the Ered Mithrin" by Paul Raymond Gregory.**

at a later date could be fraught with difficulty (as George Lucas discovered through his *Star Wars* prequel trilogy of 1999–2005).

\*\*\*

The first film in the trilogy, *The Hobbit: An Unexpected Journey* turned out to be an entirely expected success at the box office in the United States and worldwide, opening at number one in the U.S. box office with just short of $85 million in ticket sales—the biggest-ever opening weekend in December. By the start of March 2013, after just three months on international release, the film had crossed the $300 million barrier in the US, taking an additional $700 million in overseas markets. The total take of $1 billion placed the film at number 15 in the all-time worldwide box office charts. It was anticipated that the next two films, especially the concluding installment, had the potential to exceed these figures.

Just like the adventures that Bilbo Baggins finds himself on, bringing *The Hobbit* trilogy to the screen had been a long, grueling, and unexpected journey for director Peter Jackson and his creative collaborators Philippa Boyens, Fran Walsh, and Guillermo del Toro. So tight was the production schedule that the first film in the trilogy, *An Unexpected Journey*, had been delivered to Warner Bros. just eight days before the New Zealand premiere in December 2012.

Although *The Hobbit* was unlikely to repeat the success of *The Lord of the Rings* trilogy—how could it, as the novelty of Jackson's cinematic Middle-earth had worn off somewhat—the filmmakers' ambition to present the newest Tolkien trilogy as both an adaptation of the author's first tentative visit to Middle-earth and as a suitably epic and all-encompassing cinematic prequel series to the triumph of *The Lord of the Rings* seemed to pay off. In that, and in so many other ways, Peter Jackson's *The Hobbit* can be considered to have been an unparalleled success.

THE DOORS OF DURIN

THE BARROW-DOWNS

HOBBITON

A MAP OF

MIDDLE-EARTH

LHÛN

MINHIRIATH

ENEDHWAITH

DUNLAND

LOND DAER

ENEDWAITH JAUR

ERED NIMRAIS

PINNATH GELIN

ANFALAS

ANDRAST

BAY OF
BELFALAS

Scale

Miles     50    100   150   200   250   300

# Part IV

# the cultural legacy

*Above: The cover of this 1968 paperback edition of The Lord of the Rings reflects a reproduction of one part of Pauline Baynes' "triptych" painting of*
**The Lord of the Rings.**

CHAPTER 13
## Artwork and Music
## Inspired by Middle-earth

**T**here is a lengthy tradition of art inspired by *The Lord of the Rings*, and a roster of big-name artists who have devoted their skills to visualizing the world of Middle-earth.

The first to illustrate his work was Tolkien himself in *The Hobbit*, although he claimed to be no artist. An expert in calligraphy, Tolkien's illustrations tended toward simple landscapes, often avoiding portraiture of the characters. The author was unhappy with the illustrations in a 1937 version of *The Hobbit* published in the United States, and was wary of the "Disney-fication" of his work through excessive illustration.

In his essay *On Fairy Stories* (1947), Tolkien made clear his dislike for illustrations of stories based in fantasy or upon fairy tale: "However good in themselves, illustrations do little good to fairy-stories. The radical distinction between all art (including drama) that offers a visible presentation and true literature is that . . . literature works from mind to mind and is thus more progenitive. It is at once more universal and more poignantly particular."

Despite his own reservations Tolkien did create a large number of illustrations drawn from characters and situations in *The Lord*

of the Rings, largely for his own amusement. A selection was published posthumously. Tolkien's publisher Rayner Unwin seemed to share his distaste for illustrated versions of the books, writing in a letter in March 1967: "As far as an English edition goes, I myself am not at all anxious for *The Lord of the Rings* to be illustrated by anybody whether a genius or not . . ." Despite the views of both men, many artists have followed Tolkien in illustrating *The Hobbit* and *The Lord of the Rings* in a variety of formats.

One of the earliest illustrators associated with *The Lord of the Rings*—one Tolkien approved of—was Pauline Baynes. Best known for her work illustrating C.S. Lewis's *The Chronicles of Narnia*, Baynes had first worked on Tolkien's non-Middle-earth book *Farmer Giles of Ham*, and *The Adventures of Tom Bombadil*. The English artist painted two landscapes for the slipcases of the 1963 three-volume deluxe edition of the books (now something of a collectors' item) and the cover of the more familiar 1968 single-volume paperback edition. Tolkien liked these illustrations so much he bought the original paintings. Baynes also produced poster versions of the maps of Middle-earth.

A more unusual early illustrator of Middle-earth was Princess Margrethe (now Queen Margrethe II) of Denmark, who sent

*Above: "Gandalf on the Tower of Orthanc" by Mary Fairburn.*

copies of her illustrations directly to Tolkien. Her work subsequently adorned a Danish translation of *The Lord of the Rings* in 1970, under the nom de plume of Ingahild Grathmer. In 1977 a Folio Society edition of the books used her art, as did the CD inserts for music by the Tolkien Ensemble released between 1997 and 2005.

Perhaps the least known of the earliest artists was a 35-year-old art teacher from London named Mary Fairburn. She was in contact with Tolkien in the late 1960s, sending him samples of her work. In the late 1950s she'd worked in Iran, where she had been introduced to *The Lord of the Rings* by a friend. Inspired by Tolkien's prose, she created a suite of illustrations that the author described in a 1968 letter to her as "splendid. They are better pictures in themselves and also show far more attention to the text than any that have yet been submitted to me."

Tolkien was converted by Fairburn's illustrations—including a pen-and-ink sketch of Gandalf on the tower of Orthanc and a sketch of Gollum—to the belief that an illustrated version of *The Lord of the Rings* "might be a good thing." Tolkien differentiated between competent artists and those whom he believed might faithfully illustrate his books—he wanted the resulting art to be "noble or awe-inspiring."

A house move and a period of hospitalization for the then-76-year-old Tolkien delayed matters, but the author responded to Fairburn's letters expressing his great interest in her work "especially since they caught in style and coloring something of my own feelings . . . I like the pictures—certainly some of them—to make you a private offer of purchase." Despite her own straitened circumstances, Fairburn turned down Tolkien's offer as she had already promised the pictures to a friend in partial payment of a debt. They were duly returned to her, apart from an image of Galadriel at the Well in that Tolkien asked to retain. The rest of Fairburn's

*Right: "Lothlórien" by Mary Fairburn.*

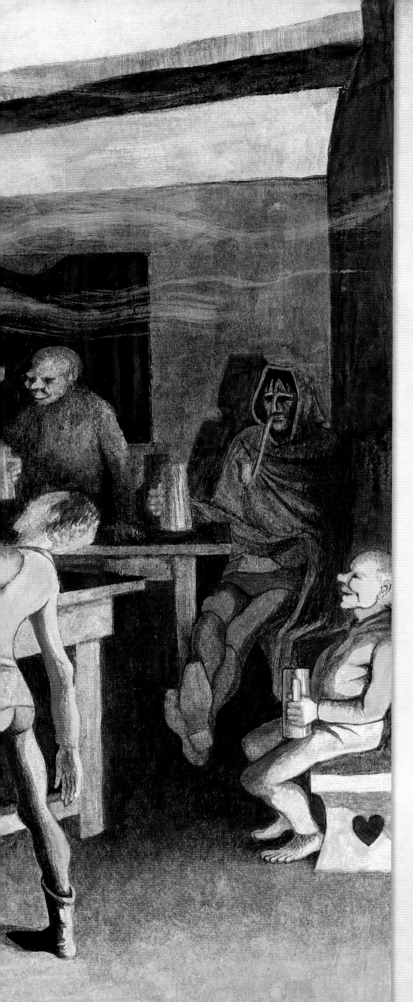

*Left: "The Inn at Bree" by Mary Fairburn.*

work—believed to be one illustration per chapter for the first 26 chapters of *The Lord of the Rings*—was thought lost, except for the illustration of Gandalf at Orthanc, a copy of which the artist had retained. Nine works were later rediscovered hanging on the wall of a friend of Fairburn's in Derbyshire. These included depictions of The Inn at Bree, The Bridge at Khazad-Dum, and Sam and Frodo in Mordor confronting a Nazgûl.

The flood of illustrations that followed in the 1970s probably owed a great debt to Fairburn, especially in the area of Tolkien's (and his heirs' and agents') tolerance.

Perhaps the best-known of Tolkien artists in the 1970s were the twin brothers Tim and Greg Hildebrandt. They began illustrating a series of calendars from 1976. "The [Tolkien] calendars put us on the map, in terms of fan following," said Greg Hildebrandt in 2009. "Over the next three years, we painted 42 pieces. The [Tolkien] family didn't like anything [in illustration] that anybody did. [Our editor] Judy-Lynn Del Rey told us after our first calendar [that] we had a big fan following, but that the Tolkien Estate didn't like our art." Despite that, the Brothers Hildebrandt would go on to create many more iconic works of pop culture art, including other Tolkien illustrations and an early poster for *Star Wars* in 1976.

Also in the mid-1970s, *Conan the Barbarian* artist Frank Frazetta turned his hand to Tolkien for a series of limited edition prints. Illustrating scenes from both *The Hobbit* and *The Lord of the Rings* in his distinctive style, Frazetta created a portfolio of Tolkien images that was limited to 1,000 copies in 1975. Many of his illustrations focused on Gandalf and the Dwarves, but he also produced a fierce-looking version of Gollum. He employed his signature fantasy illustration style to brilliant creatures, heavily muscled men, and armored warriors, although female characters were often depicted as wearing as little clothing as possible. This technique backfired in his illustrations of Éowyn, however, who defeats the Nazgûl while disguised as a man. In Frazetta's illustrations, her high-cut bikini-style shorts and stylized armor completely fail to disguise her feminine attributes!

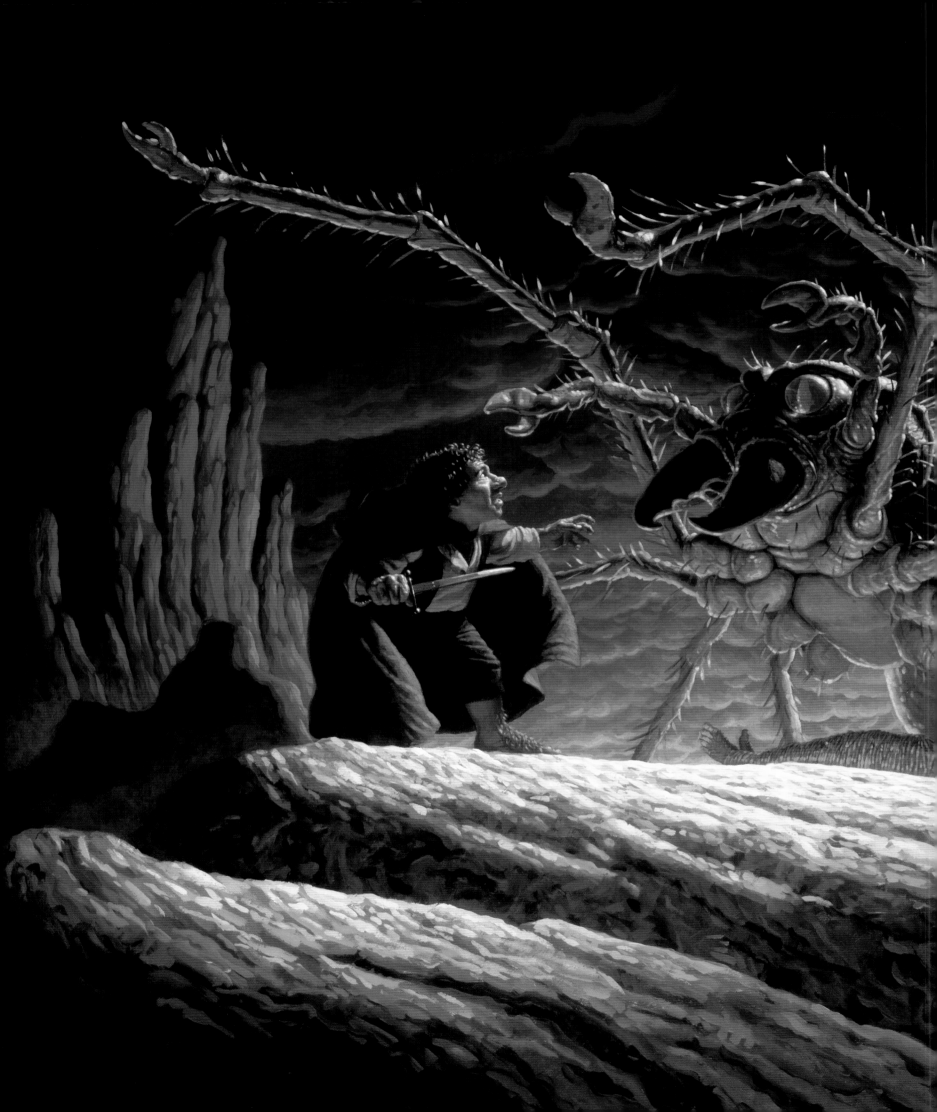

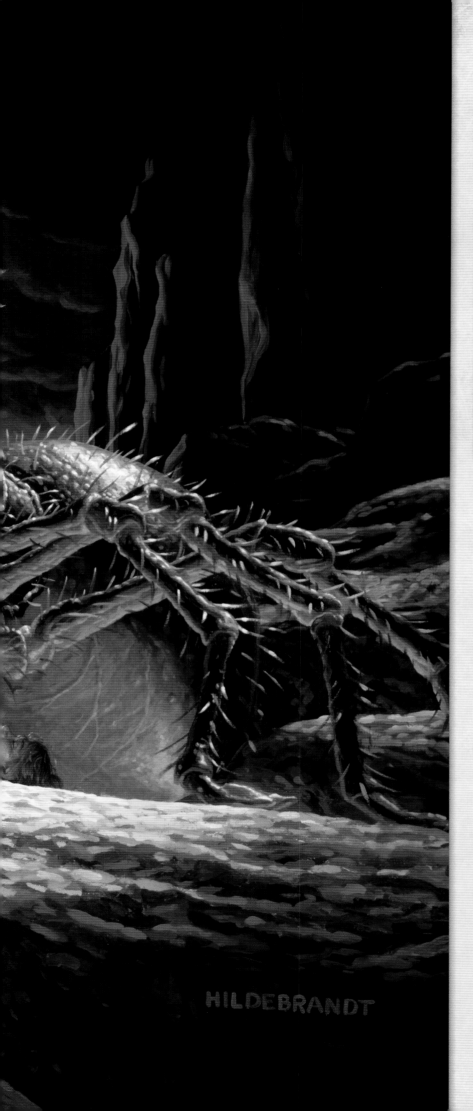

HILDEBRANDT

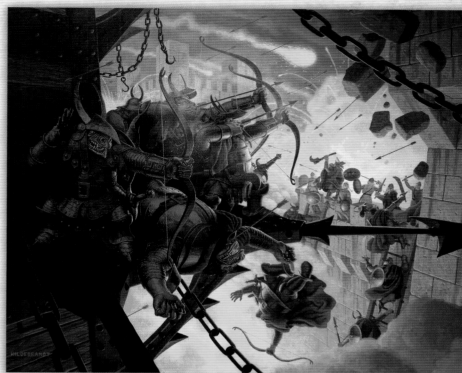

In 1973 to 1976, British provocative artist, prankster, and pop musician  graphic artist Jimmy Cauty created an iconic poster based on *The Lord of the Rings* (see page 184) for publisher Athena. The then 17-year-old's poster featured Gandalf and the Hobbits, and adorned many bedrooms of Hobbit-loving readers in the 1970s.

More recently, a trio of acclaimed artists became indelibly associated with Tolkien. John Howe, Alan Lee, and Ted Nasmith each contributed work to various editions of Tolkien's books, and all three either directly worked on or heavily influenced the design of Peter Jackson's movies. Lee won an Academy Award (Oscar) for Best Art Direction for *The Return of the King* (2003).

Canadian John Howe read *The Lord of the Rings* during his adolescence, and got a "real spark" from the Hildebrandt calendars of the mid-1970s. While learning his craft he drew inspiration from those calendars and from comic books, creating his own versions of scenes the Hildebrandts had depicted. His

*Left: "Shelob" by the Brothers Hildebrandt as featured in the November 1978 Tolkien calendar.*

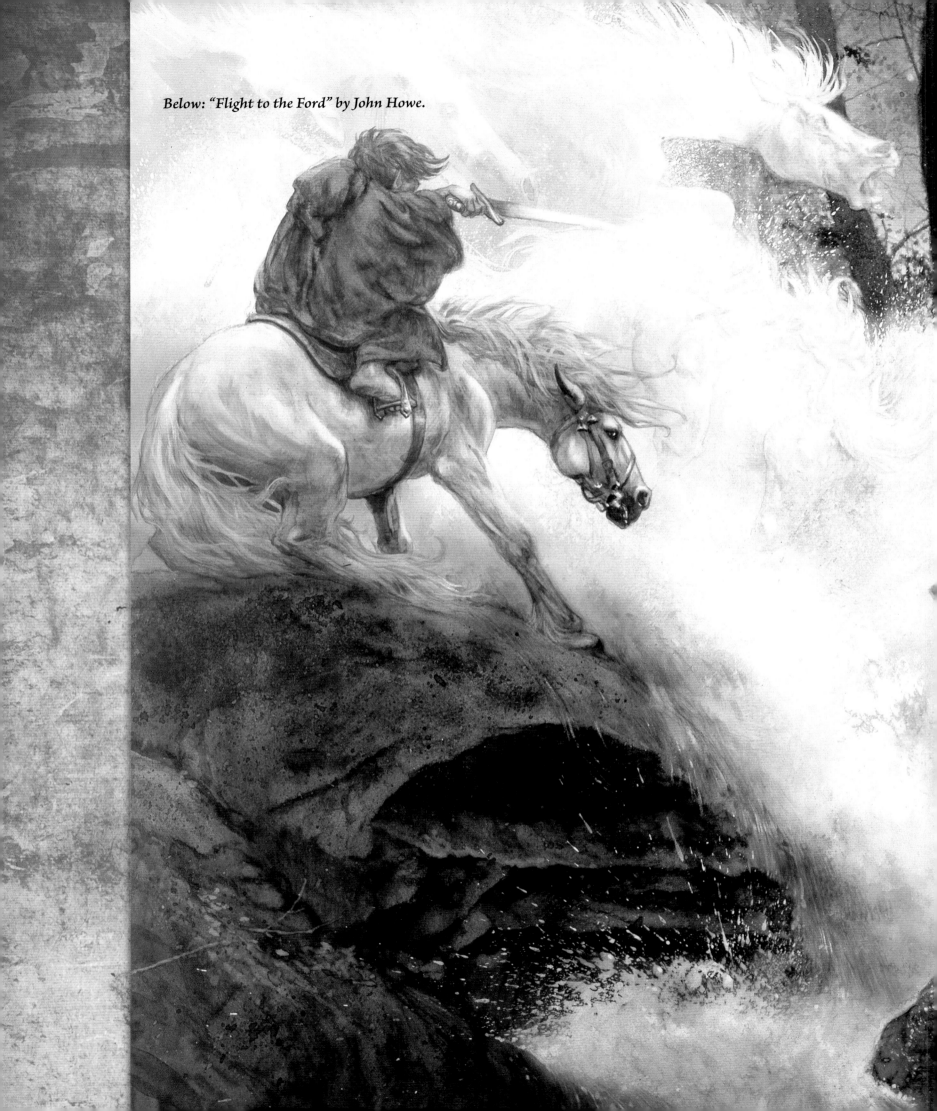

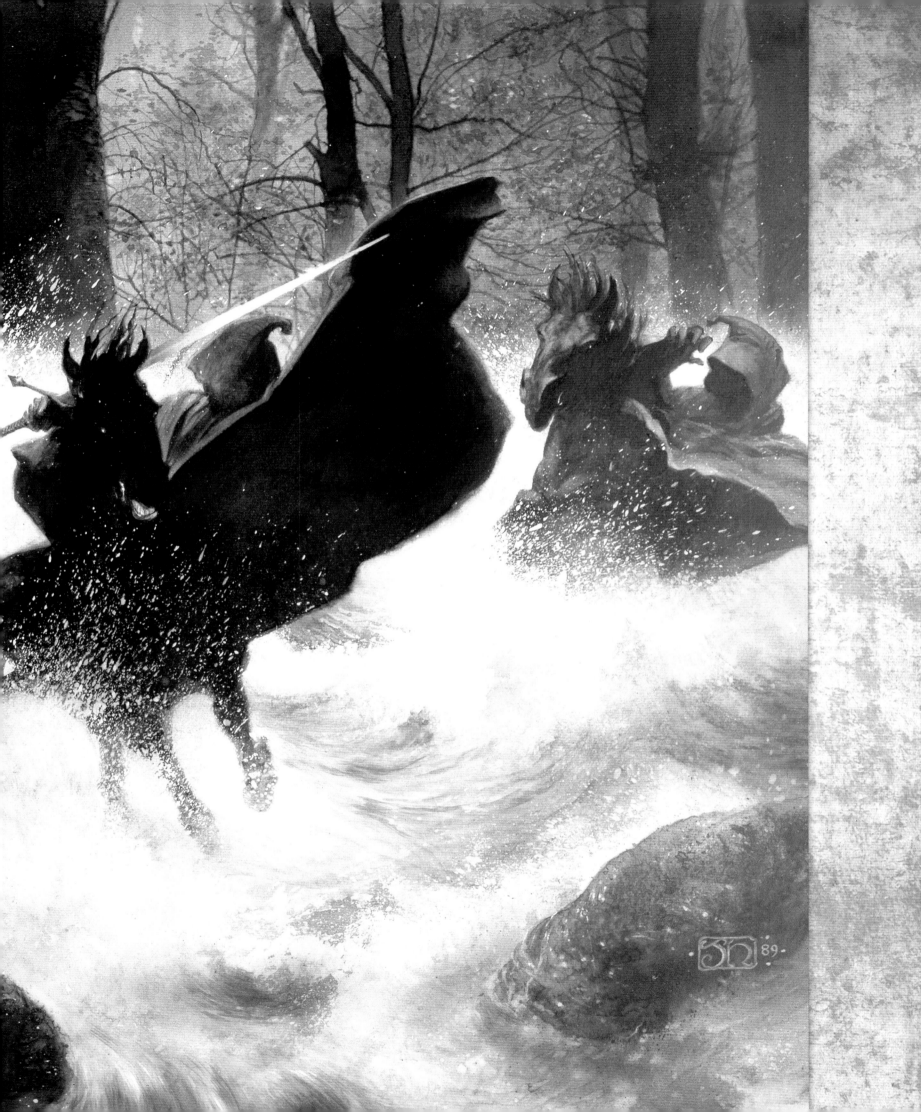

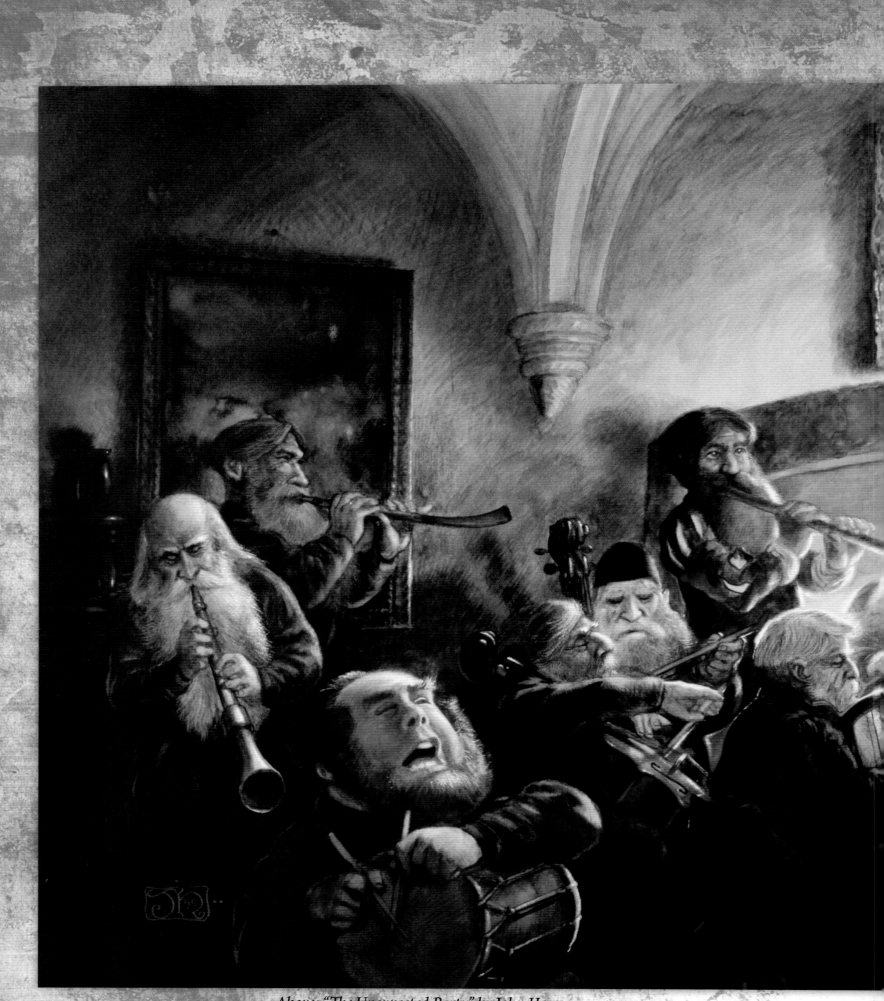

Above: "The Unexpected Party" by John Howe.

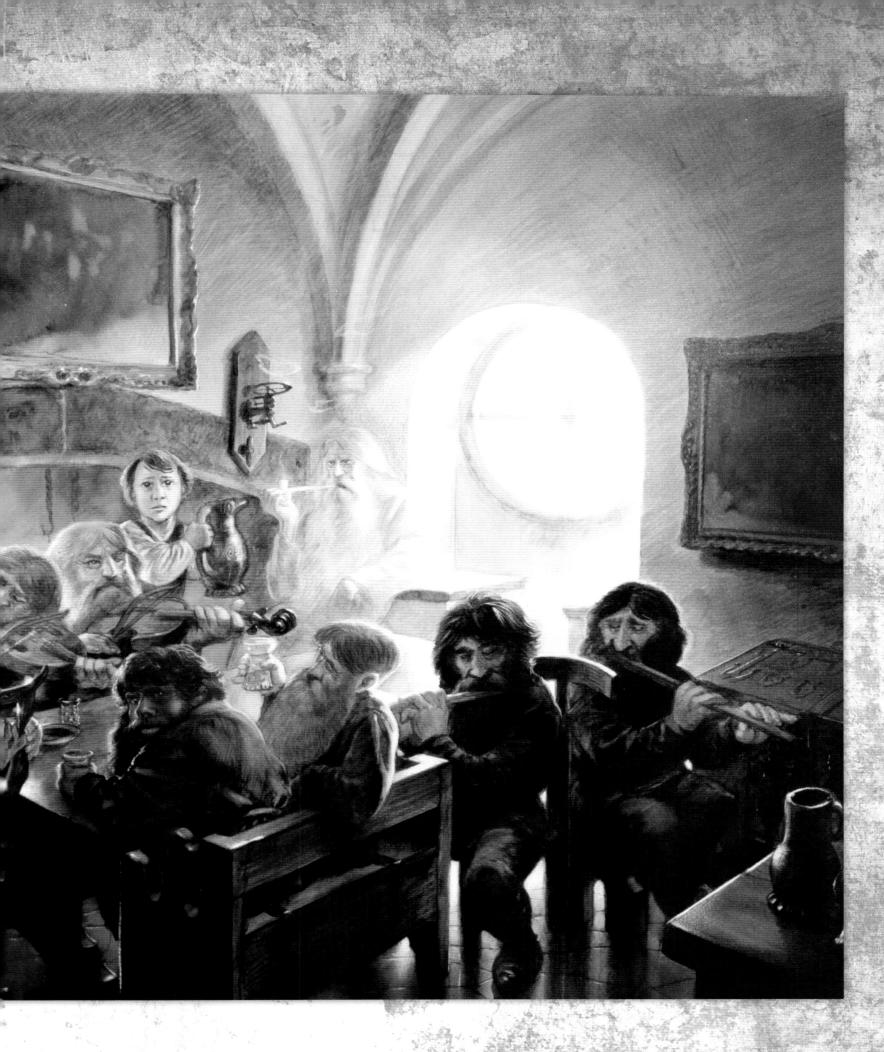

# The Influences That Show

*by Lesley McIntee*

**D**espite the older Norse and medieval framework upon which Tolkien wove his new mythology, Peter Jackson's films more closely resemble the great multi-strand fantasy narrations of the 19th century. They tighten the original texts' plot strands, refine the cast to key figures given roughly equal weight and screen time, and hone dialogue to maintain the dramatic tension of the everyman battling ultimate evil, while foreshadowing, Hollywood style, that all will turn out right in the end.

Pre-Tolkien fantasy espoused Western hero myths with their moral and mythical landscapes, thresholds, and dangers. The protagonists developed from local nobodies to world-savers, irrevocably altered by their otherworldly encounters.

It evoked terror and wonder, featured sudden reversions of fate and interventions of benevolent higher powers, such as Merry and Pippin's discovery in Fangorn of a resurrected Gandalf.

The Grimms' fairy tales, William Morris' *The Wood Beyond the World* (1894), and Lord Dunsany's *The King of Elfland's Daughter* (1924) are all examples of this literature—and Tolkien knew all three. The initial narration of *Fellowship of the Ring* places the action in the "Wood (of) the World," also a trope of de la Motte Fouqué's *The Magic Ring* (1825). The latter featured a quest to recover a stolen ring of power, a sorcerous opponent in northern wastes, and an otherworldly lady's mirror which gives glimpses of possible futures—Frau Minnetrost's mirror. Fouqué and Tolkien shared inspiration from the *Nibelungenlied* and the *Volsungsaga*. Fritz Lang's *Die Nibelungen* (1922–1924) in turn inspired the starker, rotoscoped battle scenes in Ralph Bakshi's animated *The Lord of the Rings*.

Tolkien, of course, hated Wagner's *Nibelungen*, and denied there was any similarity between it and his work, other than that a ring is involved. This misdirects attention away from what *The Hobbit* owed to the original Norse version from which Wagner also borrowed, with its Dwarves, dragon, and so on.

The Ring of the recent films reveals itself as a McGuffin linking several strands of narration; the lesser ring Aragorn wears resembles the description of its namesake in Fouqué's text. Fouqué's *Four Seasons* (1851–1860) boasts a Frode (!) the Skald, together with the water-sprite Undine, whose tale follows a traditional theme favored by Tolkien. This is the doomed love of immortal for mortal, where, as with Beren and Lúthien, the immortal partner

must embrace mortality. This is then shown in Aragorn and Arwen's subplot in the film trilogy.

Female Elves in Jackson's films reference this paradigm as much as Celtic/British myth with its Faerie Queen dallying with mortals, or the Wood Elves in *Sir Gawain and the Green Knight*. Their costumes hail from the wardrobe of Keats' *Belle Dame Sans Merci*—fatal glamour teamed with the ethereal shades of silver, white, or gray, in chiffon, lamé, or gored velvet. The sorcerous foreign noblewoman in S. R. Crockett's *The Black Douglas* (1899) appears in shimmering grey with a silver girdle, identical to Jackson's on-screen Galadriel. Flaxen hair and flowing medieval robes is the look in John Douglas's 1912 painting *Riders of the Sidhe*, fixing the image in the popular imagination, both of Tolkien and Jackson.

Associating Elves with power over water is another echo of the *Belle Dame* who lives by a lake—and of Undine. As part of Jackson's deliberate expansion of her significance, Arwen—not Glorfindel—rescues Frodo at the ford. The waves form stampeding horses, like the steeds of Celtic sea deity Mannanan Mac Lir. Her words "lasto beth nin" are originally Gandalf's.

The Aragorn/Arwen/Éowyn plot is a modern love triangle that takes up 20- to 30-odd minutes of viewing time, and displaces key moments like the reforging of Narsil. Jackson's Aragorn is much more the romantic than in the book or the Bakshi version, where he is a stark Saxon hero. He rejects Éowyn immediately in the novel, but in *The Two Towers* film, there is clear on-screen chemistry between Viggo Mortensen and Miranda Otto's characters.

Arwen's sacrifice of the life of the Eldar for love is stressed physically as well as prophetically, overshadowing the bigger picture in the book that everything built by the three Elven rings, especially Lothlórien, will fade when the Ring dies. Éowyn's dilemmas as a female warrior are emphasized—in the text she is already in armor when we first encounter her, her later disguise part of a ritual code drawn from sagas like the *Gylfagining*, not a deliberate transgression of patriarchal rules.

The Rohhirim themelves are Beowulf brought to life, their design ethos Anglo-Saxon mixed with Viking. Éowyn's song when her cousin is buried is in Old English, and Gandalf's talks with Frodo about Gollum stress qualities of mercy as well as moral choices that have their origins in part in Christianized Norse sagas.

The Dwarves in *The Hobbit* (despite a passing nod at *Star Trek's* Klingon Empire) are also, in tone and dress, true to their Old Norse namesakes, more Skalla-Grimm than Grimms' fairy tale. The films' landscapes emphasize the liminal world of Northern myth, of safe areas bordered by outer chaos like the ford that the evil Black Riders can't cross. Storms, snow, mists overpower our heroes, but even CGI weather can't match Billy Boyd's song for Pippin for eerie atmosphere with its "shadows at the edge of night."

Last but not least, the Elf-Dwarf enmity of Old Norse literature provides comic relief in the Legolas-Gimli friendship— Orlando Bloom and John Rhys Davies's scorekeeping on the battlefield is well played in the style of grim-humored saga heroes, Dwarf-tossing aside!

*Above: "Sam pursues the Orcs (the Orcs carrying Frodo off)" by Cor Blok.*

earliest surviving piece of Tolkien artwork is "The Lieutenant of the Black Tower of Barad-dûr." His first published book of Tolkien art was in 2000 with *Images of Middle-earth*, followed by an edition of redrawn Middle-earth maps (actually drawn between 1996 and 2003) as well as a host of merchandise, such as the illustrations for *The Lord of the Rings* board game designed by Reiner Knizia, and Tolkien book covers. Alan Lee's illustrations for the centenary edition of *The Lord of the Rings* and a 1995 edition of *The Hobbit* caught Jackson's attention. Lee illustrated other works of literary fantasy, but always found himself returning to Tolkien. Lee was reluctant to become involved with the movies, but was persuaded thanks to the entreaties of Jackson and Fran Walsh. His conceptual artwork was collected in 2005 in *The Lord of the Rings Sketchbook*. Of Lee, Peter Jackson said: "His art captured what I hoped to capture with the films."

A "personal crisis" prevented Canadian Ted Nasmith from being as heavily involved as the other two artists in Jackson's films, but his artwork was used as reference by the movies' art department. His youthful exposure to Tolkien's work "opened up in me a dormant love of lost and misty times, myth, and legend. I began immediately to draw scenes inspired by this magical, nostalgic realm, becoming absorbed for many hours . . . ." Nasmith corresponded with Tolkien in 1972 after sending the author some of his paintings. Tolkien replied to the then-teenaged Nasmith, criticizing his Bilbo Baggins as being too childlike, but generally praising the work. This gave Nasmith the ambition to continue to illustrate Tolkien's fantasies, but also to strive to improve his depictions of the peoples and places of Middle-earth. Eventually, four of his paintings found their way into the official 1987 *Tolkien Calendar*, and he would go on to become a solo featured artists on these calendars in 1990, 2002–2004, and 2009. The first illustrated edition of *The Silmarillion* (1998) featured his artwork, and he has become something of a Tolkien

*Right: "The Journey Down the Anduin River"*
*by Mary Fairburn.*

scholar (and is a member of the Tolkien Society). Nasmith has even dabbled in Tolkien-inspired music with *Beren and Lúthien: A Song Cycle*, composed with his friend Alex Lewis.

While most people's first visual impressions of Tolkien's diverse worlds are likely to be from Peter Jackson's blockbuster series of films, at least those movies drew on the rich tradition of Tolkien art and illustration that preceded them.

<p style="text-align:center">***</p>

Songs, singing, and music proliferate throughout *The Hobbit* and *The Lord of the Rings*. While not a musician himself, Tolkien understood the importance of poems and music in ancient cultures and their tales, so incorporated this into his own creations. However, he never published any music, leaving that up to others. One of the earliest—approved by Tolkien—was Donald Swann's song cycle *The Road Goes Ever On* (1967).

English composer Swann was best known as half of the partnership of Flanders & Swann, in which he and Michael Flanders performed comic songs between 1956 and 1967 in London's West End and on Broadway. Like Tolkien, Swann was interested in language, having read modern languages at Oxford in the 1940s. The initial version of *The Road Goes Ever On* consisted of a cycle of seven songs and poems selected from *The Lord of the Rings* and set to music, written by Swann during the last two years of his tour of *At The Drop of Another Hat*, his second musical revue with Flanders. A recording with Swann on piano and Covent Garden Opera baritone William Elvin singing was released. The pair performed the cycle at Tolkien's Golden Wedding anniversary in 1966 at a party in Merton College. Tolkien noted that William Elvin had "a name of good omen."

Among the seven tracks was the title song "Upon the Hearth the Fire is Red," the Quenya chant "Namárië" sung by Galadriel as the Fellowship depart Lórien and based upon a tune supplied by Tolkien, and "I Sit Beside the Fire", which Swann sometimes included in his stage show and is featured in the video release of his Broadway performance. The second edition added "Bilbo's

Last Song" in 1978, a particular favorite of Swann's. "The lyric was handed to me at Tolkien's funeral," Swann recalled in his autobiography. "I was stirred up that day and went off and wrote a tune for it . . . People love it and I feel very strongly about it." The third edition in 1993 added music for "Lúthien Tinúviel," which Swann noted was "the name Tolkien called his wife. She looked the part." The original LP release (titled *Poems & Songs of Middle Earth* [sic], and now difficult to find), also included recordings of Tolkien reading five poems from *The Adventures of Tom Bombadil* and the Elvish prayer "A Elbereth Gilthoniel." The book of sheet music included a chapter of "Notes and Translations" written by Tolkien, which offered a "glossary of Elvish terms and lore that appears nowhere else" (according to the cover), as well as Elvish calligraphy from Tolkien. This—and the lengthy sample of Quenya that "Namárië" represented—was a boon to those in the 1960s who were interested in the languages of Middle-earth.

<p style="text-align:center">***</p>

There are countless rock and pop bands and songs influenced by characters, events, and locations in the varied works of J.R.R. Tolkien, so it is only possible to deal with some of the most prominent or the most interesting. Scottish rock band Marillion derived their name from Tolkien's *The Silmarillion*, and other rock bands named after Tolkien places, characters, or books include Gorgoroth, Burzum, Cirith Ungol, Shadowfax, and Amon Amarth, while the lead singer of Dimmu Borgir used the stage name Shagrath, after the Orc captain. Perhaps one of the earliest—and certainly one of the silliest—Tolkien-inspired pop songs was the rendition by Leonard Nimoy (Spock from *Star Trek*) of "The Ballad of Bilbo Baggins" (1967), Charles Randolph Green's novelty song condensing the story of *The Hobbit* into a minute-and-a-half. An early 1970s fan campaign touted Nimoy as a possible candidate to play Aragorn in a live action film of *The Lord of the Rings*.

There are some obvious giveaways in lyrics or titles that peg a song as Tolkien-inspired. "Nimrodel/The Procession/The White

**Right: "The Old Forest" by Mary Fairburn.**

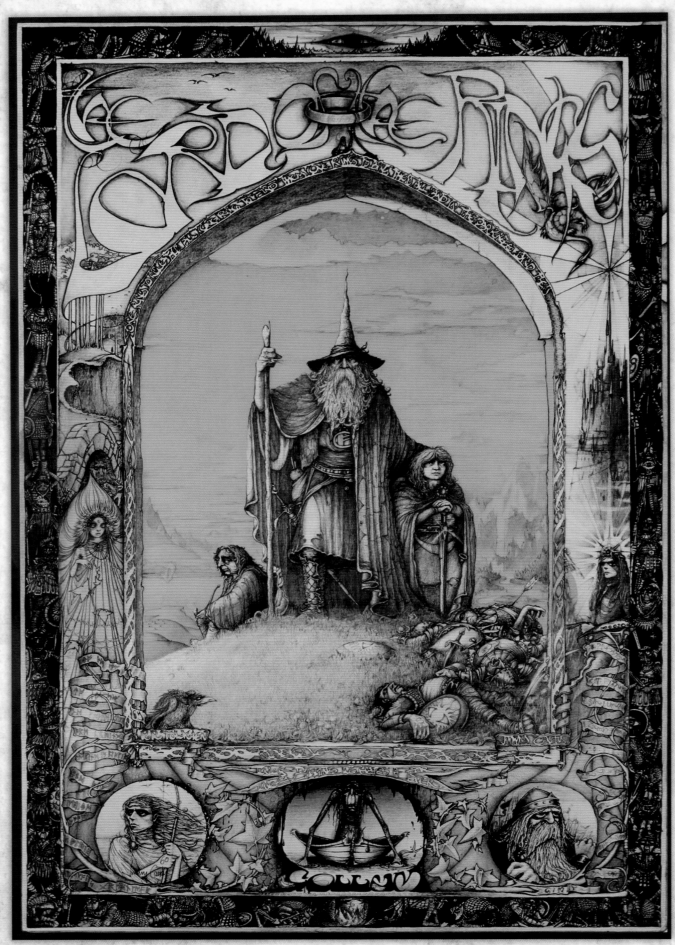

**Above:** The iconic poster based on The Lord of the Rings created by British artist and pop musician Jimmy Cauty in 1973.

Rider" by Camel is clearly taking influence from the character of Gandalf, while Tom Rapp's "Ring Thing" (in Pearl Before Swine's second album *Balaklava*, 1968) sets the majority of the One Ring verse to music. Led Zeppelin released several Tolkien-inspired tracks—including "The Battle of Evermore" (with the lyric "The ringwraiths ride in black"), "Misty Mountain Hop," "No Quarter," and "Ramble On." British prog rock outfit Magnum released an album entitled *Middle Earth* [sic], entirely themed around *The Lord of the Rings*, while Texas-based rock band Hobbit have released several albums. Other rock bands that have dabbled in Tolkien include Rush (the song "Rivendell," 1975), Mostly Autumn (the album *Music Inspired by The Lord of the Rings*,

*Above: Patrick Currie Flegg's "Anduin—The Mighty River," a Tolkien-inspired piano suite detailing the journey of the Company of the Ring down its great tide to Gondor. Flegg was Mary Fairburn's husband, and her artwork is also featured on the cover.*

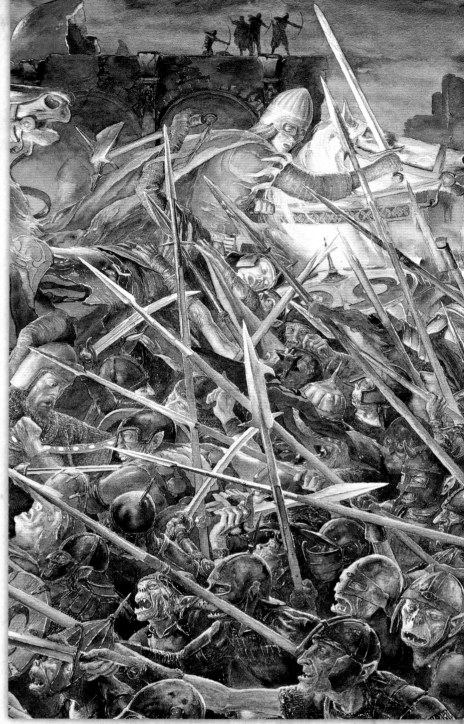

*Above: "Battle of the Hornburg" by Alan Lee.*

2001), Bo Hansson (an album also called *Music Inspired by The Lord of the Rings*, 1970–1972, that won Hansson gold discs for high sales in the UK and Australia), and Seattle-based Gatsbys American Dream [sic] (on their album *Volcano*, 2005).

Much heavy metal music has been influenced by Tolkien. Germany's Blind Guardian produced a Tolkien concept album

called *Nightfall in Middle Earth* [sic] taking its influence from *The Silmarillion*, as does much of the work of Italian band Ainur. Finnish heavy metal group Battlelore built almost their entire discography from Tolkien, including such albums as . . . *Where the Shadows Lie* (2002), *Third Age of the Sun* (2005), and *The Last Alliance* (2008), and songs about the wizard Radagast, Éowyn, the Eagles of Middle-earth, and the voyages of Eärendil. Others who took the same tack included Austrian band Summoning who make extensive use of Tolkien's work in their lyrics (as in albums *Minas Morgul*, 1995, and *Dol Guldur*, 1996), and

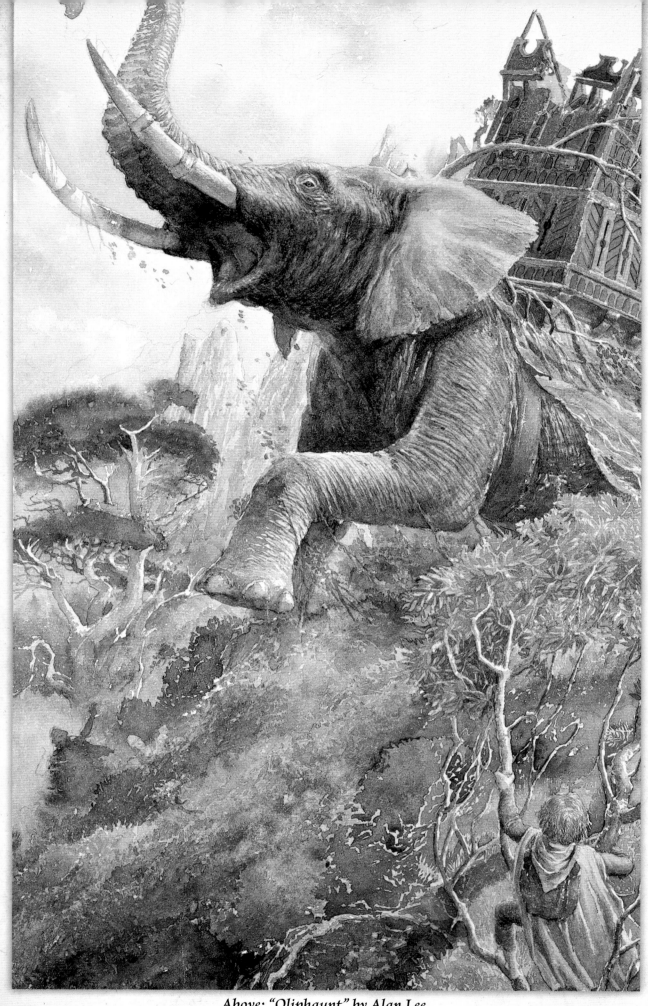

*Above: "Oliphaunt" by Alan Lee.*

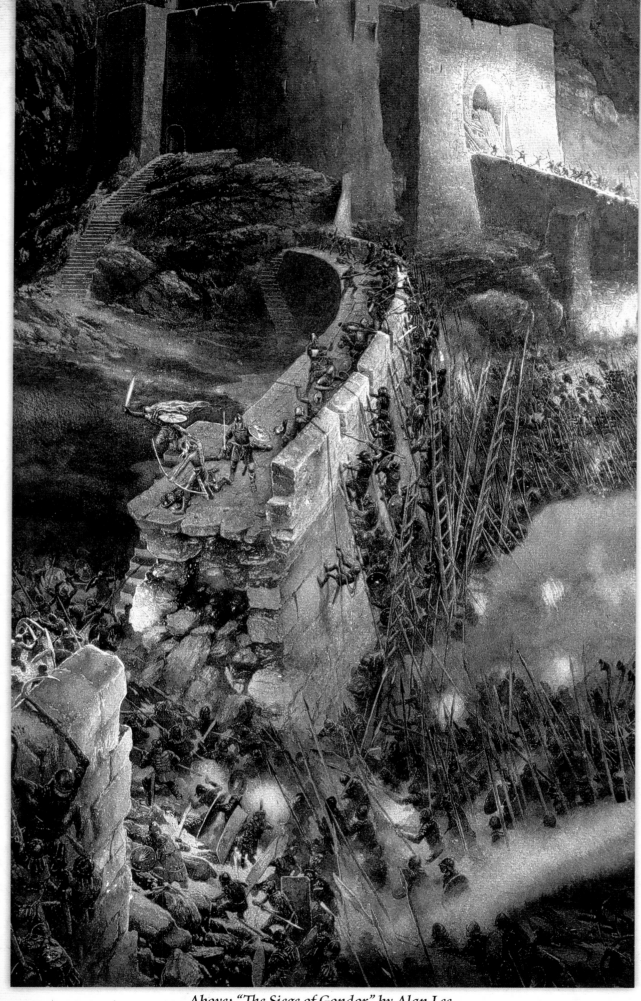

*Above: "The Siege of Gondor" by Alan Lee.*

"power metal" bands Epidemia and Nightwish (whose song "Elvenpath" includes an audio sample from the prologue of Bakshi's animated *The Lord of the Rings*). Better-known acts, such as Megadeath with their song "This Day We Fight!" also explored the wider Tolkien mythos.

*\*\*\**

Given the kind of music Tolkien himself preferred and the clues available in the Middle-earth texts, it comes as little surprise that the most fertile areas for music based on Tolkien's works should be in the classical, neoclassical, and folk music fields.

From a Dutch folk group named The Hobbitons (who released a CD of 16 songs based on *The Hobbit* and *The Adventures of Tom Bombadil* with the permission of the Tolkien Estate in 1996) to Swedish neofolk group Za Frûmi, who sings songs in the Orc "black speech," there are many examples. David Arkenstone, an American "new age" musician takes his name from the jewel featured in *The Hobbit* (and one of his children is called Valinor, after Tolkien's Undying Lands).

## The Megadeath song "This Day We Fight!" explored the wider Tolkien mythos.

The various subdivisions of folk music even extend to so-called "anti-folk," with bluegrass performer Chris Thile adopting the description for his work that includes a 2001 instrumental album called *Not All Who Wander Are Lost*, after a quote from Gandalf. A song on the album is entitled "Riddles in the Dark," after the chapter in *The Hobbit*. Sally Oldfield's (sister of *Tubular Bells*' Mike Oldfield) debut solo album *Water Bearer* (1978) was also inspired by Tolkien, as is evident in track titles such as

**Right:** *"A Conversation with Smaug" by Ted Nasmith.*

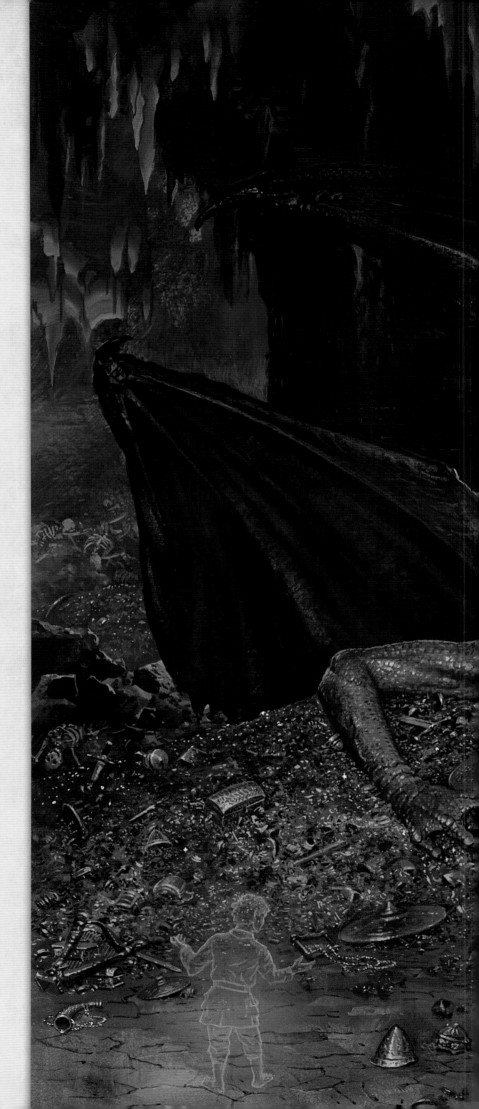

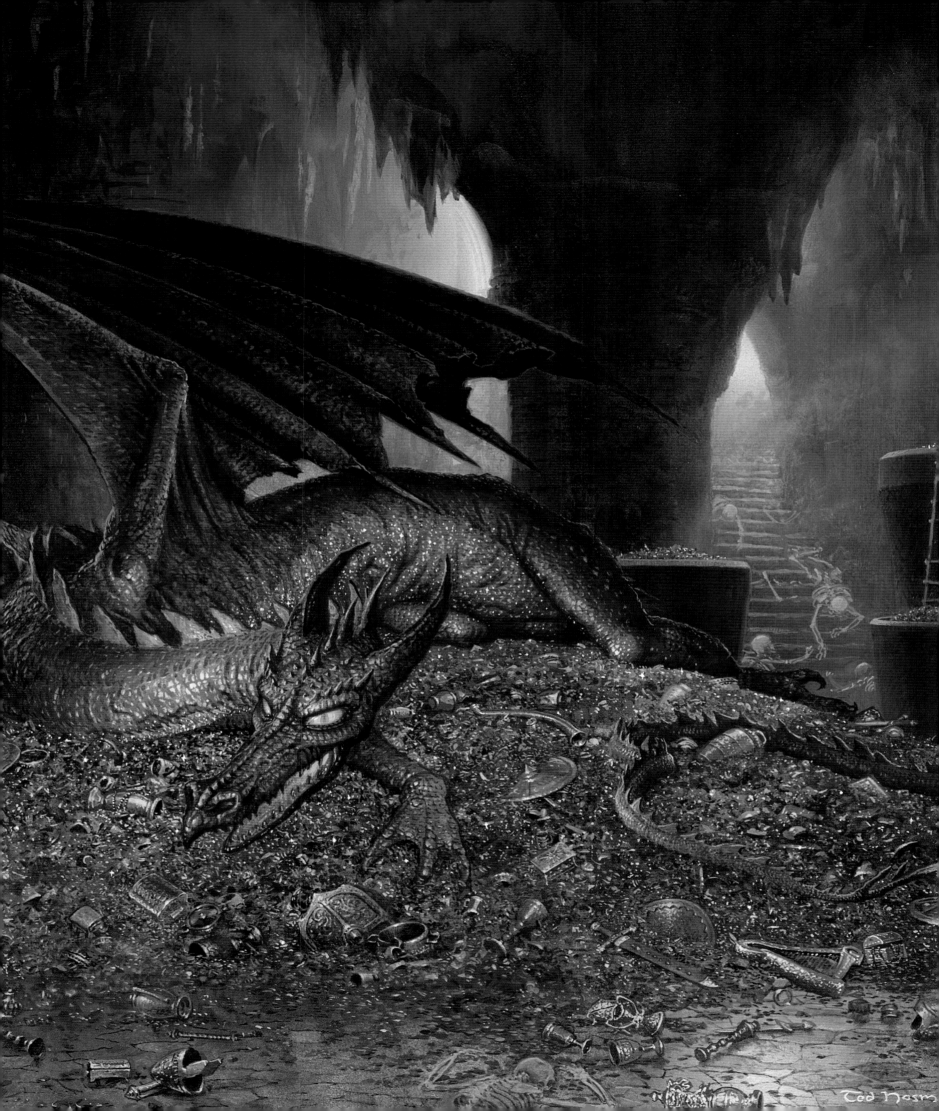

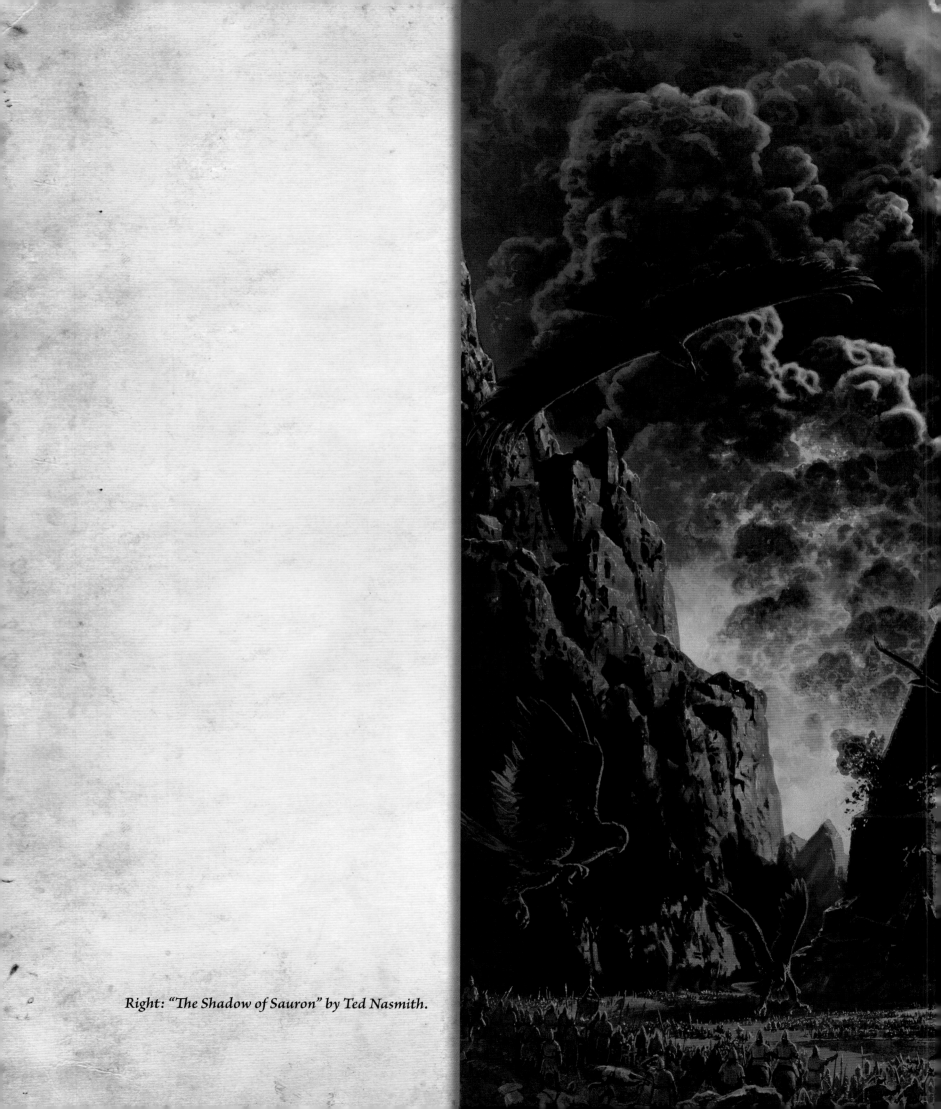

*Right: "The Shadow of Sauron" by Ted Nasmith.*

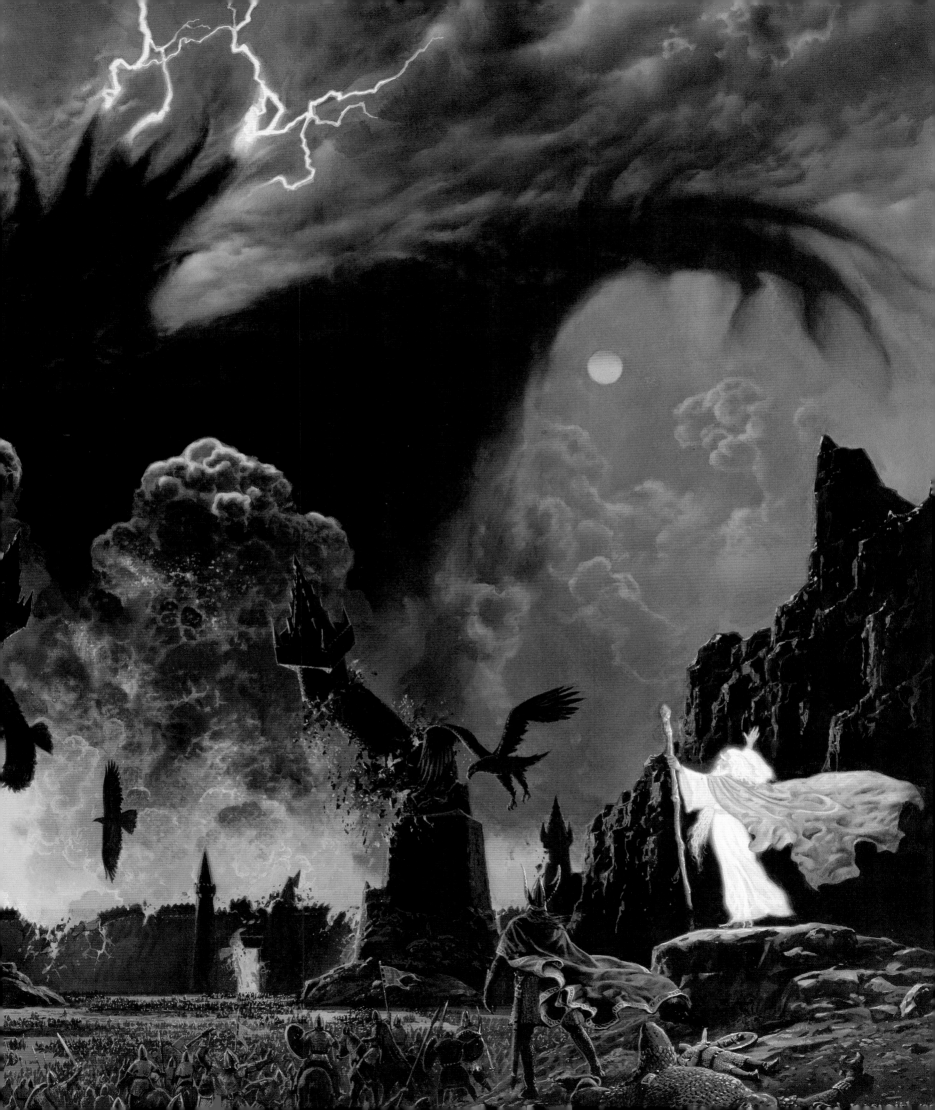

"Songs of the Quendi," after the name the Elves call themselves, and "Nenya," after the Second Ring of Power, made of mithril and wielded by Galadriel to sustain Lothlórien. Heavy metal band Lyriel turned more "symphonic" and pseudo-classical, with their work including songs sung in Sindarin, the language of the Elves, such as "Lind e-huil."

More traditional classicists have also found inspiration in Middle-earth, including Johan de Meij who composed a symphony released in 1988 based upon *The Lord of the Rings*, consisting of five movements each illustrating an important character or event from the story. Paul Corfield Godfrey created a cycle to be performed over four evenings from *The Silmarillion*, as well as a trio of operas based on *The Lord of the Rings* and other song cycles and musical works.

A dedicated Tolkien Ensemble—founded in 1995 and based in Denmark—released four CDs of Middle-earth music between 1997 and 2005. The group set all the poems and songs of *The Lord of the Rings* to music and toured Europe performing their work, as well as excerpts from Howard Shore's movie scores with live narration from Christopher Lee, who has also contributed narration and vocals to their albums. Others drew upon specific stories or characters, such as Finland's Aulis Sallinen's 1996 symphony named "The Dreams of Gandalf," or the story of Arwen and Aragorn retold by Argentine-American composer Ezequiel Viñao in his string quartet *The Loss and the Silence* (2004).

\*\*\*

Perhaps the most obvious—and most widely heard—music associated with Tolkien are the movie scores and songs. Leonard Rosenman scored the 1978 Ralph Bakshi animated film, while the 1977 Rankin/Bass animated TV film of *The Hobbit* had a distinctive score and song-cycle by American folk singer Glenn Yarbrough, some of which was also used in the follow-up *The Return of the King: A Story of the Hobbits* (1980).

Howard Shore—a frequent collaborator of director David Cronenberg—tackled the music for the three films of *The Lord of the Rings*, and further built upon his widely loved themes in his scores for the trio of Hobbit movies. Songs included in the scores have been performed by the likes of Enya ("Aníron" and "May it Be" in *The Fellowship of the Ring*); Edward Ross ("In Dreams" in *The Fellowship of the Ring*); Emilíana Torrini ("Gollum's Song" in *The Two Towers*, with Torrini replacing the originally scheduled Björk who declined due to her pregnancy); Pippin actor Billy Boyd ("The Edge of Night" in *The Return of the King*); and Eurythmics' Annie Lennox (the Oscar-winning Best Song of 2004, "Into the West" from *The Return of the King*). Although given a thematic unity by Howard Shore, these songs display some of the diversity of approaches that are possible when it comes to translating the works of J.R.R. Tolkien to musical forms.

*Right: Annie Lennox won an Academy Award for Best Original Song for "Into the West" from* **The Lord of the Rings: The Return of the King.**

*Above: "Sauron" by Neil McClements.*

# CHAPTER 14
## Fan-Inspired Artwork, Film, and Music

Readers of J.R.R. Tolkien's fiction have a tendency to get more involved in his work than that of most other authors. The especially dedicated can find themselves inhabiting Middle-earth, such is the richness of Tolkien's creation. Each book and additional material like the appendices leads to new discoveries and new details that compound the impact of Tolkien's world building. Once the books have been consumed, the reader seeking more might turn to Tolkien's essays or his collected letters, or to the work of other authors who have written about Tolkien's worlds. For some Middle-earth fans that's simply not enough: they want to create something new that fits within Tolkien's magnificent creation.

While scholarly literary criticism has long surrounded Tolkien, of more creative interest is the fandom that grew following the American publication of *The Lord of the Rings*. It is rare for a literary character or setting to attract the kind of fandom usually attached to films or TV shows (characters such as Sherlock Holmes or writers like Douglas Adams being examples of the exceptions). While *The Hobbit* was a popular piece of late-1930s children's literature, it wasn't until the late 1950s into the early-1960s that Tolkien fandom properly developed.

*Right: "Gandalf the Grey" by Neil McClements.*

*Above: "King Theoden and Whitemane" by Neil McClements.*

It started as an offshoot of science fiction and fantasy fandom active since the 1930s (with groups such as the LA Science Fantasy Society starting in 1934 and New York's Futurians meeting since 1937), with the first Worldcon event taking place in 1939. Science fiction fan-produced magazines (fanzines) began to explore Tolkien's work (for example, the fanzine *Niekas*) in conjunction with the arrival of the epic *The Lord of the Rings*, a trio of books that set a template and would give rise to a whole genre of fantasy fiction dubbed "the heroic epic." From around 1958, people began turning up at Worldcons dressed as Tolkien characters, while there were discussions about establishing a dedicated Tolkien society by 1959.

The 1960 Worldcon held in Pittsburgh gave rise to an organization called *The Fellowship of the Ring*, and a fanzine named *I Palantir*, shortly followed by the first UK-based Tolkien fanzine, *Nazgûl's Bane*. The Tolkien Society of America was founded in 1965 and grew to over 1,000 members within a couple of years. The group sponsored the first scholarly Tolkien Conference at Belknap College in New York in 1969. The similarly scholarly Mythopoeic Society was founded in California in 1967, including the works of the other main Inklings as well as Tolkien, such as C.S. Lewis and Charles Williams. The UK Tolkien Society formed in 1969 and continues to publish the bimonthly newsletter *Amon Hen* and the annual journal *Mallorn*, as well as run the regular Oxonmoot conference. Since 1972, Sweden has boasted The Tolkien Society Forodrim with a strong focus on Tolkien's linguistic creations.

Writers for fan-driven amateur publications explored many aspects of Tolkien's creation, deepening their—and their

reader's—understanding of the worlds of Middle-earth. Some of the many who discovered Middle-earth at this time would go on to become prominent figures in the development of computing, gaming (desktop role-playing and on computers), and environmentalism or political activism, often inspired by Tolkien's writing.

Many wrote their own stories featuring further adventures of Tolkien's characters. There are now many Tolkien fan fiction archives on the Internet, and even various fan-run awards for best fan fiction or Tolkien-inspired poetry. While the legality of using other people's characters and settings in a not-for-profit venture can be a gray area, the Tolkien estate tends to discourage fan-written Middle-earth fiction, and they will certainly act if there is any suspicion of "commercial exploitation." Christopher Tolkien, the son of the author and his literary executor, has taken legal action in the past, in one case against a children's entertainer styling himself "Gandalf the Wizard Clown." During his lifetime, Tolkien received at least two proposals from eager fans to write authorized sequels to *The Lord of the Rings*, but both were refused, with him branding one request "impertinent." He mentioned being in receipt of a similar proposal "couched in the most obsequious terms from a young woman, and when I replied in the negative I received a most vituperative letter."

As serious Tolkien literary studies grew following the publication of *The Silmarillion*, as well as the first biography of the author and an edited collection of his letters (all in 1977), so Tolkien fandom prospered, but remained somewhat insular and limited to in-depth discussion of the existing texts. With wide online access and the rise of the Internet from the mid-1990s, Tolkien fandom migrated online spreading through discussion forums and Web sites (many orbiting TheOneRing.net). New digital tools allowed democratic access to the means of creation that previously were expensive or time consuming. With the arrival of the Peter Jackson movies, so followed the dedicated Tolkien fan film.

The much-anticipated first *Star Wars* prequel film, *The Phantom Menace* (1999), was greeted with dismay by many hard-core *Star Wars* fans. As digital filmmaking tools were becoming available, it wasn't long until someone reedited the film (removing the presence of the comic character Jar Jar Binks) and made it available on the Internet as "The Phantom Edit." The same fate befell Peter Jackson's *The Two Towers*, with the fan creation of *The Two Towers: The Purist Edit* aiming to eliminate the changes Jackson had made to the source material, such as including Elves

*Below: "Lake Town" by Nate Hallinan.*

*Above: "Thorin Oakenshield" by Anke Eissman.*

at Helm's Deep. Over 100 revisions were made to the movie, removing around 40 minutes. This was followed by an eight-hour reedit of the entire Tolkien film trilogy, dubbed *The Lord of the Rings: The Purist Edit*, in an attempt to bring Jackson's films more in line with the novels.

The most inventive Tolkien fan filmmaking was to be found in original fan films. Prime among them are two examples—Chris Bouchard's 38-minute *The Hunt for Gollum* (2009) and Kate Madison's 71-minute *Born of Hope* (2009).

*Above: "Gollum" by Anke Eissman.*

Drawing heavily from the Jackson films for its look, approach, and style, Bouchard's *The Hunt for Gollum* is based upon the appendices of *The Lord of the Rings*. The short film charts the attempts of Aragorn (working on behalf of Gandalf) to track down Gollum prior to *The Fellowship of the Ring*, fearing that the errant devolved Hobbit might reveal information about the One Ring to Sauron. Without access to Jackson's New Zealand locations, the amateur filmmakers had to make do with not-so-inspiring North Wales, and Epping Forest, and Hampstead Heath in England, with a total budget of only £3,000. Viggo

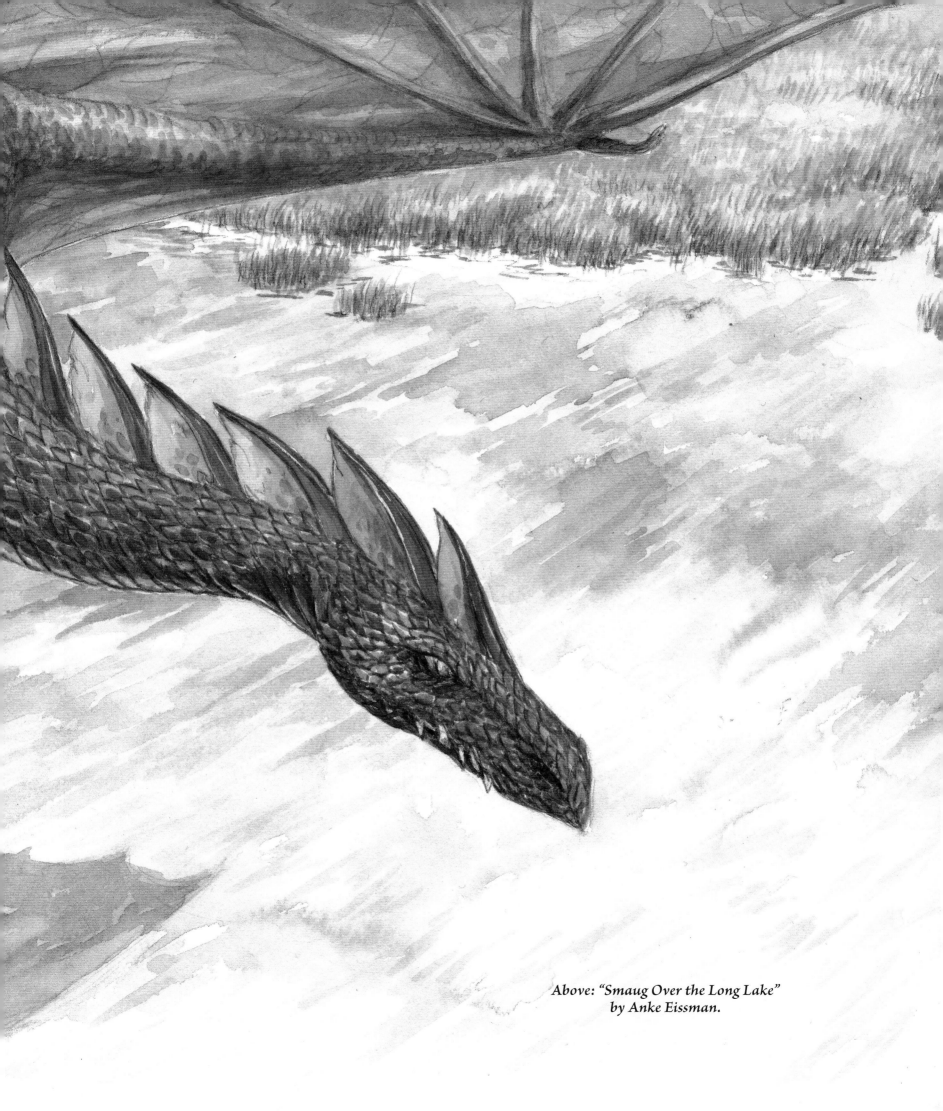

*Above: "Smaug Over the Long Lake"
by Anke Eissman.*

*Above: "Aragorn and Arwen" by Anke Tollkühn.*

Mortensen lookalike Adrian Webster took the part of Aragorn, with Patrick O'Connor channeling Ian McKellen's Gandalf.

Similarly, Madison's *Born of Hope* (written by Paula DiSante—credited as Alex K. Aldridge) also draws upon Tolkien's appendices for inspiration, this time focusing on the impact of Sauron's war upon diverse communities across Middle-earth and especially the relationship of Aragorn's parents, Arathorn and Gilraen. As well as also filming in Epping Forest, the filmmakers had access to the West Stow Anglo-Saxon Village in Sussex, raising the production values, along with the use of "fly-over" stock footage of Snowdonia National Park and Derwentwater in the English Lake District. The film premiered at RingCon 2009 before it was made available through YouTube. Madison spent £8,000 of her own money, and raised an additional £17,000 from fan investors following the release of a trailer, bringing the total budget to £25,000. The film was made over a period of six years and boasted a cast of 400. *The Hunt for Gollum*'s Chris Bouchard helped as a camera operator and on the special effects. "We stopped calling this a fan film a long time ago," Madison told

*The Observer*. "Guys running around in their back garden with a cloak over their shoulders, that's the popular image of fan films. We were aiming for a higher quality."

Web site Rotten Tomatoes included *The Hunt for Gollum* in its list of Top 5 Fan Films, noting "Made in widescreen . . . this mini-epic is an unusually serious, non-parodic, non-mash-up fan film . . . ." Lewis Wallace, writing at Wired.com, called the film "pretty stunning . . . with epic shots of Middle-earth." The *Daily Telegraph* dubbed *Born of Hope* "a prequel to the fantasy novels," while the *Observer* praised the film's "epic battle scenes, pitting man and Elf against Orc and Troll."

Other widely seen Tolkien fan films or trailers include *Halifirien: The Hallowed Mountain* (2009), made in County Sligo, Northern Ireland by Tom Robinson, and focusing on a young boy's quest to light the last fire beacon that will bring aid to Gondor from Rohan; the German *The Silmarillion, Arda—A World Is Rising* (2011), directed by Stefanie Mutzel and dealing with Tolkien's creation myths; and *Wings Over Arda: The First Age* (2011),

*Below: "The Ride of the Rohirrim" by Anke Eissman.*

written and directed by Richard Hartshorn from stories in *The Silmarillion* and *Unfinished Tales*, as well as Tolkien's poetry.

Many fans made music videos, often about the romantic relationship between Aragorn and Arwen, while others prioritized humor, as with "They're Taking the Hobbits to Isengard," an infamous fan-made music video mash-up based around dialogue from the Jackson movies.

Some fans took the nature of fandom itself as a subject, as in *Almost There and Back Again* (2005) that followed a group of Tolkien-obsessed friends who set out to cross New Zealand visiting the movie locations, or the similar *Bogans* (2003), a short that sees a trio of fans attempt to meet Peter Jackson. Peter Tait,

who wrote *Bogans* and starred as Luke, managed not only to get Jackson to appear briefly in his film, but also won the role of Shagrat in *The Return of the King*. There was also a documentary called *Ringers: Lord of the Fans* (2005) about the growth of Tolkien fandom in the wake of the Peter Jackson movies.

Perhaps the cutest Tolkien fan films are those made by or involving children—naturals for playing Hobbits. A production begun in 2005 by a group of home-schooled students and their families from Coweta and Fayette counties in Georgia, *The Peril to the Shire* (2007), drew upon the appendices of *The Lord of the Rings* to tell a story about the Hobbits who were left behind when Frodo left the Shire for the final time. The students of Tower House prep school in London raised funds, created

*Above: Movie poster for* **The Hunt for Gollum.**

*Above: Adrian Webster as Aragorn in* The Hunt for Gollum.

*Above: Still from 2009's* The Hunt for Gollum

*Above: Director Chris Bouchard and various Orcs on the set of the award-winning* The Hunt for Gollum.

*Above: Stills from Kate Madison's critically acclaimed*
**Born of Hope *released in 2009.***

costumes, and produced their own 90-minute version of *The Hobbit*. A premiere was held for the film at London's Curzon Renoir Cinema attended by parents, school staff, and pupils in September 2012.

Fans continue to be creative, whether in writing Tolkien-inspired stories or composing Tolkien-inspired music, creating art, or making fan films. *The Hobbit* movies have provided a new lease of life to Tolkien movie fandom, while publications by Christopher Tolkien (such as *The History of Middle-earth*) continue to throw new light on the origins of the novels. The Internet has become the primary means for fans to meet and discuss their Tolkien interests, as in the forums at www.counciloffelrond.com, and there's no reason to suppose that fandom's diverse creativity will dry up any time soon.

Above: A still from Bogans released in 2003 about a trio of fans attempting to meet Peter Jackson.

Above: Freddie, Hamfoot, and Rosie in Peril to the Shire released in 2007.

Above: Starring a group of home-schooled students and their families in Georgia, The Peril to the Shire began production in 2005.

Above: Movie poster for Ringers: The Lord of the Fans *narrated by* The Lord of the Rings *star Dominic Monaghan. It aired on HBO and illustrated how Tolkien's work has impacted pop culture in the past half century.*

# Middle-earth Beyond *The Hobbit* and *The Lord of the Rings*

### by Scott Pearson

In 1916, Tolkien began work on what would eventually be published posthumously as *The Silmarillion* (edited by his son Christopher, Tolkien's literary executor). It was in these stories that he created Middle-earth, literally and figuratively, for he tells of the creator Ilúvatar and his angelic Ainur, how they brought Middle-earth into being out of the void, and the coming of the Children of Ilúvatar, Elves, and Men, into Middle-earth.

Tolkien's Elves are effectively immortal if not killed by accident or battle, so characters such as Elrond and Galadriel have rich pasts only touched upon in *The Lord of the Rings*, and much more can be learned about them in *The Silmarillion* and its follow-up, *Unfinished Tales*. The first hint of these riches appeared in much condensed form in the appendices of *The Return of the King*, which filled in some backstories for Elves and others, such as the long romance of Aragorn and Arwen, and also moved beyond the fall of Sauron into the Fourth Age, revealing further details of the lives of the surviving members of the Fellowship. Peter Jackson and his fellow screenwriters Fran Walsh and Philippa Boyens drew on these details for creating additional scenes for Arwen.

Similarly, when Jackson turned to *The Hobbit* films, he and his cowriters used materials outside the book to expand the story. The appendices in *The Return of the King* and "The Quest of Erebor" in *Unfinished Tales* are sources for the struggles between the White Council and Sauron the Necromancer, that took place concurrently with Bilbo's adventures but are not dramatized in the original novel. Appendix A provided the flashback scenes of Thorin during the War of the Dwarves and the Orcs, and helped develop the orc Azog. Jackson did make one key change to Tolkien's account: in the original writings, Azog was killed at the Battle of Azanulbizar, but for dramatic purposes, Jackson kept Azog alive.

The most recent return to Middle-earth from Christopher Tolkien is his edited narrative *The Children of Húrin*, set near the end the First Age, more than 6,000 years before Bilbo found the One Ring. Although a bleak chronicle of a curse on Húrin's house by Morgoth, it's a welcome expansion of Middle-earth's epic history. Epic in its own way is Christopher's comprehensive *History of Middle Earth*, a 12-volume series tracing his father's ever-evolving manuscripts, including work done after finishing *The Lord of the Rings*. Scholarly in approach and heavily annotated, the tales are often presented more fully than the versions in *The Silmarillion*, and the previously unseen stories are a must-read for the seriously dedicated Tolkien fan.

# AFTERWORD

**P**eter Jackson's return to Middle-earth is not over yet. The middle movie in *The Hobbit* trilogy, *The Desolation of Smaug* (at one point subtitled *The Battle of the Five Armies*), follows Bilbo and the Dwarves in their journey through Mirkwood and their encounter with the spiders, to their adventures in Lake-town (Esgaroth—as it is properly known—was an expansive set, extrapolating Tolkien's descriptions into a habitation with an Eastern flavor), and their eventual arrival in Smaug's lair at the heart of the Lonely Mountain, once the Dwarf kingdom of Erebor.

Adding to the cast returning from *An Unexpected Journey* were Stephen Fry as the Master of Lake-town; Scottish comedian and actor Billy Connolly as King Dáin; Evangeline Lily as Tauriel; Lee Pace as Elvenking Thranduil; Mikael Persbrandt as the shape-shifting Beorn (often dropped from retellings of *The Hobbit*); and Luke Evans as Bard the Bowman.

Returning from *The Lord of the Rings* was Orlando Bloom as Legolas, although there are no authentic Tolkien sources for his involvement in the story (Jackson saw no reason why Legolas could not be part of Thranduil's court in the "Barrels Out of Bond" chapter of *The Hobbit*, and he was one of the most popular characters with a certain demographic in the earlier films). In fact, Jackson deliberately structured the second film in the new trilogy to resemble *The Two Towers*. "Bard and the Master and the humans of Lake-town are our first actual humans," said the director, noting that the two trilogies expand their worlds in their second installments to include human habitations: Rohan in *The Two Towers* and Lake-town in *The Desolation of Smaug*. After a minimal appearance in *An Unexpected Journey*, the great dragon Smaug (described by Tolkien as "vast . . . red golden . . . like an immeasurable bat") would be revealed in full in the middle episode of the trilogy. "He's not a monster, he's a character," insisted Jackson of the Dwarves' scaly nemesis. "A lot of his power isn't just that he's a huge beast, it's that he has a willfulness that makes him much more formidable. . . ."

The final film in the series—*There and Back Again*—was planned as a blockbuster summer release for July 2014, although at the start of March 2013, Warner Bros. decided to move it to December 17, 2014, to avoid competing with the second *X-Men* prequel, *Days of Future Past*. This covers the conclusion of the battle of the five armies and Bilbo's perilous journey home to Hobbiton. Additional material in this film explores Gandalf's discovery that the mysterious Necromancer is in fact Sauron, who would go on to be the motivating evil force for *The Lord of the Rings*. Much of the footage that would be used in the third film had already been shot when *The Hobbit* was originally a two-film project, but additional filming was required beyond the "pick-up" filming already planned for May 2013. This "supplementary shooting" involved expanding the battle of the five armies sequences, as well as other "bridging scenes" as Martin Freeman referred to them, to create a spectacular and coherent trilogy. For Peter Jackson, it meant an additional commitment of a further two years in shooting, editing, post-production, and the creation of additional scenes and behind-the-scenes material for the eventual DVD and Blu-ray releases of *The Hobbit* trilogy. Only then would he finally be done with Middle-earth.

Over the 75 years since *The Hobbit* was published, many other creative forces have tried to use their talents to translate J.R.R. Tolkien's Middle-earth into other media. A movie of *The Silmarillion* remains a possibility; in January 2013, *X-Men First Class* star James McAvoy expressed his desire to play Gandalf, or one of his ancestors, should that ever come to fruition. Further stage shows are inevitable; computer games tying in to the later *Hobbit* movies equally so. And with Hollywood's penchant for cannibalizing its own past to create its future, it's certain that at some point Peter Jackson's movies will be remade in such a way to make his trilogy look as dated as the 1993 Finnish television version did against his.

"Tolkien created an entire world that did not exist and because of that, it never gets old," Robert Thompson, professor of popular culture at Syracuse University, said when *The Hobbit* was released in 2012. "Years from now, *The Lord of the Rings* movies may look quaint the way the first *Star Wars* movies do now. But the strength of the source material is so great, there will always be more adaptations." Thanks to Tolkien's original creations and those who continue to reinvent them in a variety of media, the road goes ever on and on.

*Paul Simpson and Brian J. Robb*
*March 2013*

## COR BLOK

Cor Blok graduated from the Academy of Fine Arts, The Hague, with a teaching degree in 1956. Blok worked as an assistant and curator in the Gemeentemuseum, The Hague, and the Museum Boymans van Beuningen, Rotterdam, and taught in various art schools. He was also a professor of 19th–20th century art history at the Universities of Utrecht, Maastricht, and Leiden. He has written art criticism for various international periodicals and is the author of books on Piet Mondrian, the history of abstract art, museums, and the analysis of visual images.

Apart from a body of paintings and drawings produced during the 1960s, Blok's output as a visual artist consists mainly of long term projects. Between 1953 and 1960 he worked on an invented art history of a non-existent country called Barbarusia. For his next project he created 140 miniatures based on scenes from *The Lord of the Rings*, painted between 1958 and 1962, in a style derived from would-be Medieval Barbarusian painting. They attracted little notice at the time, but three of the miniatures were selected for the covers of the first paperback edition of the Dutch translation in 1965. J.R.R. Tolkien saw a number of these pictures when Blok visited him in 1961. Interest in them was revived in 1992, when a selection was included in a Tolkien Centenary exhibition at The Hague. Blok's third project is a graphic novel that experiments with combinations of images and text and of visual communication apart from text. This is now virtually completed and he hopes to publish it.

## DAARKEN

Daarken is a freelance illustrator and concept artist in the film and game industry. Some of his clients include Wizards of the Coast, Fantasy Flight Games, BioWare Mythic, Kabam, Trion, Crytek, Warner Brothers Games, Games Workshop, Applibot, Blizzard, Riot Games, among others. Daarken also has a free tutorial site located at www.enliighten.com and has taught at schools like Gnomon and the Academy of Art University in San Francisco. Visit his web site at www.daarken.com.

## JENNY DOLFEN

Jenny Dolfen is a teacher and illustrator from Germany, whose love for classical myths and the English language influenced both her choice of teaching subjects and the subjects of her art. She has been a fan of J. R. R. Tolkien's works since early childhood, and continues to illustrate scenes from the *Silmarillion*, her favorite of all of Tolkien's works. She lives near Aachen with her husband and two children. Visit her web site at www.goldseven.de.

## ANKE EISSMAN

Anke Eissmann is a professional illustrator and art teacher. Since studying Visual Communication at Bauhaus University in Weimar, Germany, and Graphic Design at Colchester Institute in Colchester, Essex, UK, she has worked for a number of international publishers illustrating children's books. She also teaches art and art-history at secondary school.

Her Tolkien and fantasy inspired work has been exhibited at galleries and international Tolkien gatherings. Her illustrated Beowulf and the Dragon has recently been published by Walking Tree Publishers, who have also used several of her Tolkien inspired watercolors as cover illustrations for other publications. An active member of the German Tolkien Society, Eissmann has been responsible for designing the Flammifer von Westernis, the society's journal, for several years as well as designing logos and other publications for the society.

Apart from the writings of J.R.R. Tolkien, many of Eissmann's works are inspired by historical and mythological subjects, and more recently by the brilliant BBC series Sherlock.

## MARY FAIRBURN

Mary Fairburn was brought up in London and Winchester, England, and studied art and art teaching at the Winchester School of Art, London University, and at the Slade. She worked as a teacher at schools in London and for two years in Iran. In the early 1960s she worked in Italy, and traveled in Africa. Travel has always inspired her painting. In 1967, she read The Lord of the Rings in Teheran, where she was wintering after abandoning an attempt to travel by Mini Moke to Australia. She was creatively possessed by the work, and began a suite of illustrations in colored ink, some of which she sent to Tolkien in May 1968 on her return to England. Despite Tolkien's enthusiasm for her illustrations, the project was abandoned. In 1976, Mary moved to Victoria, Australia, where she currently lives, and works as an artist and musician. Her work has been exhibited in England, Italy, and Australia.

## ROGER GARLAND

Roger Garland was born in 1950 and spent his childhood living in a small village on the Somerset Levels in the south west of England in sight of Glastonbury Tor. At the age of thirteen his family moved to Cornwall, where he still lives, works, and plays, surrounded by green fields.

In 1968, Garland began his career by studying art at Plymouth College of Art. In 1971 he obtained his degree in Graphic Design from Wolverhampton College of Art, where he met his wife and fellow illustrator Linda. From 1972 to 1984 he taught art in Cornwall and began his career in illustration. In 1980 he was represented by Young Artists, a major illustrators' agent in London, and it was through their contact that he was first commissioned to illustrate the titles of J.R.R. Tolkien, David Gemmel, and Mike Jeffries. Throughout the 1980s Roger created more than 150 illustrations for the Tolkien titles including The Hobbit, The Lord of The Rings, Unfinished Tales, and the Silmarilion. His Tolkien illustrations have been published worldwide by all the major publishers. In 1990 Garland fully illustrated Tolkien's Adventures of Tom Bombadil, The Smith of Wootton Major, and The Farmer Giles of Ham for Unwin Hyman London. In 1989 he and Linda established Lakeside Gallery to house a permanent Tolkien collection and to exhibit their work. From its success they went on to set up Lakeside Gallery Publishing, which produces limited edition prints, books, and greeting cards of their stunning artwork.

## PAUL RAYMOND GREGORY

Paul Raymond Gregory was born in Derby in 1949, the son of a builder. Although he was encouraged by his art teacher at school— where he created paintings less conventional than his peers—Gregory is totally self-taught. After school, he opened an art gallery and spent a great deal of time with contemporary artists. It was about this time he considered producing a series of paintings from Tolkien's *The Lord of the Rings* which had fired his imagination as a youngster and attracted him to the world of fantasy.

It was in the late 1970s that Paul embarked on his journey with Tolkien with his first canvas: a 10'x 6' titled *Ride of the Rohirrim*. In 1983, Paul's Tolkien series went on a touring exhibition throughout Britain, which was organized by Sotheby's Belgravia and culminated at the Edinburgh Festival. As a result, he was offered an exhibition at the Barbican in London in 1984. Over the last 30 years, Paul has worked on the rest of the series.

In 1984 Paul was introduced to the world of heavy metal and he had the good fortune to make the acquaintance of the band Saxon and their indomitable singer Biff Byford. Paul was commissioned to do the artwork for the Crusader album—now a classic in the annals of rock—and the stage designs. Paul has painted ten albums to date for the band. He also organizes Bloodstock—the UK's biggest heavy metal gathering—which is now in its 13th year. Visit Paul's web site at www.studio54.co.uk

## NATE HALLINAN

Nate Hallinan is a freelance concept artist who works in the film and video game industry. He began his career in 2007 and shortly became Lead Concept Artist at Supergenius Studio in 2010 and Senior Concept Artist at Microsoft Games in 2012. You can view his portfolio at www.natehallinan.com.

## BROTHERS HILDEBRANDT

The Brothers Hildebrandt were born in 1939. Greg and Tim worked both together and separately, winning awards and fame. They created a large body of work, from their fantasy novel *Urshurak* to the world famous poster for *Star Wars*, to the best-selling calendars illustrating J.R.R. Tolkien's *The Lord of the Rings*. Together they won the coveted Gold Medal from the Society of Illustrators.

Both Greg and Tim were strongly influenced by many great comic books and strips, science fiction novels and films, and illustrators such as Norman Rockwell and Maxfield Parrish. But perhaps their biggest influence was Walt Disney, especially his Snow White, Pinocchio, and Fantasia characters. They both dreamed of becoming Disney animators and while neither worked for Disney, they both became both animators and documentary film-makers.

In 1981 the brothers pursued separate careers. During the 1980s, Greg's art appeared on covers for *Omni* and *Heavy Metal* and he created work for the Franklin Mint & Lenox, advertising for ABC and Dr. Pepper. His work is licensed on dozens of additional products. He has illustrated 15 classics, including *The Wizard of OZ, Aladdin, Robin Hood, Dracula,* and *Phantom of the Opera.* There are over 3,500,000 copies in print of the combined titles. The *New York Times* has said of him: "Fortunate the child or adult who receives a gift of the classics richly illustrated by Greg Hildebrandt."

Tim illustrated calendars for TSR, *Dungeons & Dragons, Realms of Wonder* and *The Dragon Riders of Pern*. He painted sci-fi/fantasy covers for *Amazing Stories, The Time of Transference,* and *The Byworlder*. He was commissioned to paint the cover for *The Illusion of Life* by Disney animators Ollie Johnson and Frank Thomas. Tim's art has been featured in advertising for AT&T and Levi's and on packages for *Return of the Jedi*.

After 12 years of working separately, the brothers reunited in 1993. Together they worked on Marvel posters, pre-production art for Stan Lee and Michael Uslan (producer of the Batman films), a King Tut book, the 1994 Marvel Masterpieces card set, X-Men and Spiderman card sets, *Terry and The Pirates* comic strip, and an X-Men 2099 painted Bookshelf edition.

In 1999 Greg began to pursue a life-long dream: painting his American Beauties series of Retro Pinup art. There are presently 65 amazing paintings in this series and according to Greg, the possibilities are endless. In 2003 he began creating art for the Trans-Siberian Orchestra. Since Greg loves Rock Opera there could not be a better match than his art and the orchestra's music. Greg still paints almost every day and still loves what he does. Unfortunately, his twin brother Tim Hildebrandt, passed away in June of 2006.

Greg is represented exclusively by the Spiderwebart Gallery. You can see Greg Hildebrandt's and Brothers Hildebrandt's art and collectibles at http://www.spiderwebart.com.

## JOHN HOWE

John Howe has been illustrating for decades, and confesses to drawing steadily ever since he could hold a crayon. Over the years, he has created some of the iconic imagery which has defined Tolkien's *Middle-earth*. He provided concept art for Peter Jackson's Lord of the Rings films, and is now somewhere east of the Misty Mountains, drawing his way through the landscapes and battles of Jackson's *Hobbit* trilogy. This said, he's not been lost in Middle-earth all his life, and has written and illustrated dozens of books for both children and adults, including three books on drawing and painting, books he describes as "philosophical how-to manuals." Kingfisher Books recently published his *Lost Worlds*, a book for young readers that approaches places as diverse as Ultima Thule, Teotihuacan, Camelot, and Cahokia on equal footing.

Currently, though he is busy keeping up with a very determined pack of dwarves, Howe is working on the text for his next book, and taking long walks along the New Zealand coast, which, in passing, does bear a passable resemblance to the shores of Beleriand.

For more information, thoughts, and life wherever illustrating takes him, visit www.john-howe.com.

## ALAN LEE

Alan Lee was born and raised in London, where he studied graphic art and design. Enchanted by myth and folklore from an early age, he gravitated toward the field of book illustration, following in the footsteps of Arthur Rackham and Edmund Dulac, master illustrators of the 19th century. Lee worked as an illustrator in London until the mid-1970s, when he moved to Dartmoor with fellow-artists Marja Lee Kruyt and Brian Froud. At the urging of legendary publisher Ian Ballantine, Lee and Froud created the book Faeries, inspired by the Dartmoor countryside. It went on to become a bestseller, published to acclaim all around the world.

Since that time, Lee has established himself as one of England's preeminent book artists, creating exquisite watercolor paintings for, among other works, *The Mabinogion, Castles, Merlin Dreams,* and *Black Ships Before Troy: The Story of the Illiad* (winner of the prestigious Kate Greenaway Award), and for the lavish anniversary edition of J.R.R. Tolkien's *The Lord of the Rings*.

For the last few years, however, Lee has set book projects aside while he labors on the New Zealand set of Peter Jackson's films, *The Lord of the Rings* and *The Hobbit*. As conceptual designer for the films, it is Alan's job to create the distinctive look of Middle-Earth. A comparison of the films to Alan's prior illustrations for *The Lord of the Rings* gives a clear idea just how influential Alan's vision has been to the project. He has also designed for other films including *Legend, Erik the Viking,* and *Merlin*.

When he's not on location working, Lee still makes his home on Dartmoor in southwest England, where his studio takes up two floors of an ancient, rose-covered stone barn, in the same small village as mythic artists Brian and Wendy Froud, William Todd-Jones, Terri Windling, and others. He was one of the founders of the annual Mythic Garden exhibition of outdoor sculpture at the Stone Lane Gardens arboretum, and is involved in the creation of a woodland nondenominational spiritual retreat building along with Diana Marriott and the internationally known local sculptor Peter Randall Page. His interests include myth and folklore, literature, poetry, music—particularly jazz, blues, and the singing of June Tabor—archaeology, history, international travel, and long walks through Devon woodland. He has two children, Virginia (also a sculptor) and Owen. Their mother, Marja, from the Netherlands, is a talented painter herself, as well as a Celtic harpist.

## NEIL MCCLEMENTS

Neil McClements was born in a small village in Herefordshire and is still based in Middle England where he lives with his wife and young daughters. He is a freelance artist with work published in books, magazines, and comics for a variety of private and commercial clients. His work is often connected to the realms of fantasy, science fiction, and history, with a very detailed illustrative style that provides a real depth and realism. Much of his illustration work in black and white is influenced by great European artists such as Sergio Toppi.

McClements's preferred medium is pen and ink but he also exploits other techniques such as pastels, pencils, and watercolors and although he still prefers the traditional hand drawn illustrative methods, he also embraces digital mediums. Many of his pieces are now an amalgamation of hand drawn and digitally finished artworks. His portfolio, which can be seen at www.neil-mcclements.co.uk, continues to expand.

## IAN MILLER

Ian Miller studied at Northwich School of Art between 1963 and 1967, and then secured a place in the Sculpture Department at St. Martin's School of Art. He then switched to the Painting Faculty in 1968 and graduated in 1970 with Dip AD/BA and began working as an illustrator.

Between 1975 and 1976 Miller worked for Ralph Bakshi on his feature animation *Wizards in California*. This gave him an ongoing taste for animation that he still pursues. In the 80s he worked on a second Bakshi film, *Coolworld*. Since then he has done pre-production work on the Dreamworks animated feature *Shrek* and several other proposed features which sadly never made it to the screen.

Miller's first collection, *Green Dog Trumpet*, was published by Dragon's Dream in 1979. There have been two further collections of his work. He has also created graphic novels with M. John Harrison, including *Luck in the Head* and *The City* with James Herbert.. A new anthology of Ian's work will be released by Titan Books in 2014. *The Broken Diary*, a dysfunctional tome full of long words and suspect comments, is due for publication sometime in 2013 by Onieros Books

Miller has lectured part time at Sir John Cass College London, Brighton School of Art and Horsham School of Art. His work has been widely exhibited as solo exhibitions and in group shows internationally.

## TED NASMITH

 Ted Nasmith is a widely published illustrator of Tolkien and other fantasy fiction, and a long time Tolkien Society member. He is also an accomplished architectural renderer, and his career has also included book illustration and automotive portraiture, among other work. He lives in Bradford, Canada, and regularly appears at fan events, and also exhibits his art in the UK.

Gifted from an early age, Nasmith studied commercial art at Toronto's Northern Secondary School from 1969 to 1972 and graduated with honors. He was soon hired by Visual Concept, a studio where he was trained in architectural renderings, and settled into a career as a renderer.

Through the 1970s and 1980s Ted privately expanded his body of Tolkien art and dreamed of being published. Several frustrating years eventually lead to a breakthrough. He had created dozens of artworks, and in the years that followed, he began to consider Tolkien his main vocational calling as recognition increased and accolades accumulated. In 1990, Nasmith's first solo calendar was published and architectural work was soon eclipsed by his growing reputation as a Tolkien illustrator.

Nasmith has created several Tolkien cover pieces including the cover illustration for *The Silmarillion* (1998/2004). He also fully illustrated both of those editions in addition to games, puzzles, role-playing cards, and other secondary products.

Ted's other interests include music (listening, performing, and composing); reading in a variety of genres; film; live theater; and photography. He also has a deep love of skies, weather, and natural beauty. He recorded a highly praised music CD in 2007, fulfilling a longstanding ambition for his musician alter ego and hopes to explore this path more in the future.. He continues a lifelong affair with art inspired by J.R.R. Tolkien, while continuing to grow in other genres, most recently outdoor sketches of local rural scenery, as well as an increasing association with the *Ice and Fire* series of novels by George R.R. Martin.

## ANGELA RIZZA

 Angela is a freelance illustrator currently living and working in New York. She graduated from the Fashion Institute of Technology in 2011 with a BFA in Illustration. Since then she has been featured in a number of magazines and shows. Her work is a combination of traditional and digital media which is reminiscent of a classical storybook illustration. Besides artwork, Rizza enjoys traveling, birding, and photography. She is open to comments, commissions, or questions and is currently available for illustration jobs of any kind and is looking for an art rep. Visit her web site at angelarizza.com, and her blog at angelarizza.tumblr.com.

## WES TALBOTT

Wes Talbott comes from a land called Ohio, where he spent the days of his youth in a small village called Johnstown. As a young lad, he discovered that he had an eye for color and shape. When he grew to be a man, he set out in search of a place where he could continue to study and improve his skills. Wes found himself at the doorstep of a wondrous school known as the Columbus College of Art & Design and has remained there for three years' time having learned much. It was here that he discovered a fair maiden whom he has made his betrothed. Now that he is well within his fourth year, he is seeking to push his efforts to new heights and discover new ways to release his full potential.

## ANKE TOLLKÜHN

Anke Tollkühn is a self-taught fan artist from the Northern German seaside. She has been dabbling in digital image editing since the late 1990s, but was introduced to Middle-earth much earlier; in fact she taught herself to read using *The Hobbit* in her early childhood. Her fascination with Middle-earth was later rekindled by her home landscape, Tolkien's writings, and Peter Jackson's movie trilogy, which arrived at just the right time to start her down a path toward developing her own style, both in art and writing.

After studying English Philology and Classical Archaeology in Hamburg, she is now concentrating on her own explorations of fantasy writing alongside her (quite hobbit-like and unexciting) daily life. More of her artwork can be found in her gallery at http://ladyelleth.deviantart.com.

## DAVID T. WENZEL

David T. Wenzel is an illustrator and children's book artist. He is best known for his visualization of J.R.R. Tolkien's *The Hobbit*, illustrated in graphic novel format. *The Hobbit*, A Graphic Novel is one of the most successful graphic format adaptations of a piece of classic literature. It has recently been updated with a new cover, larger format, and 32 new pages of artwork recreated by Wenzel. Over his career, Wenzel has worked for most of the major publishers and been able to work with a cast of talented authors. Always intrigued by mythology, fantasy, and folk tales, some of his favorite projects have been the ones that gave him the freedom to visualize creatures and characters from his imagination. Wenzel has also left his artistic mark on a variety of non-book related projects including puzzles, greeting cards, and two entire miniature kingdoms of collectible figurines. Many may remember him from the days when he worked on *The Avengers* for Marvels Comics. He cites illustrators like Arthur Rackham, Edmund Dulac, N.C. Wyeth, and Howard Pyle as influences, as well as the Dutch painters Pieter Bruegel and Jan Steen. Wenzel lives in Connecticut with his wife Janice, an artist and high school art teacher. Their sons Brendan and Christopher are both artists. Visit his web site at www.davidwenzel.com.

# SELECTED BIBLIOGRAPHY

Carpenter, Humphrey: *J.R.R. Tolkien, The Authorised Biography* (London: Unwin, 1978)

Carpenter, Humphrey: *e Letters of J.R.R. Tolkien* (London: George Allen & Unwin, 1981)

Hughes, David: *Tales from Development Hell: Hollywood Film-making the Hard Way* (London: Titan Books, 2003)

Pearce, Joseph [Ed]: *Tolkien: A Celebration* (London: HarperCollins, 1999)

Porter, Lynnette: *The Hobbits: The Many Lives of Frodo, Sam, Merry & Pippin* (London: I.B. Tauris, 2012)

Russell, Gary: *The Lord of the Rings: The Official Stage Companion* (London: HarperCollins, 2007)

Schull, Christina and Wayne G. Hammond: *The J.R.R. Tolkien Companion and Guide* (two volumes) (London: HarperCollins, 2006)

Sibley, Brian: *Peter Jackson, A Film-Maker's Journey* (London: HarperCollins, 2006)

Sibley, Brian: *The Lord of the Rings: The Making of the Movie Trilogy* (London: HarperCollins, 2002)

Simpson, Paul: *A Brief Guide to C.S. Lewis* (London: Constable & Robinson, 2013)

Swann, Donald: *Swann's Way: A Life in Song* (London: Arthur James Ltd., 1993)

Swann, Donald: *The Space Between the Bars* (London: Hodder & Stoughton Ltd., 1972)

White, Michael: *Tolkien: A Biography* (London: Little, Brown & Co., 2001)

Audio: *The Lord of the Rings / The Hobbit* (liner notes) (Bath: AudioGO, 2011)

Blu-ray: *The Lord of the Rings: The Motion-Picture Trilogy (Extended Edition)* Appendices (Entertainment in Video, 2011)

# ACKNOWLEDGMENTS

The authors would like to thank the following people:

Grace Labatt at Voyageur Press, who championed this book for a long time, but wasn't able to see it through to completion. It wouldn't have stayed on the radar as long as it did without her support.

Jeannine Dillon, Heidi North, and Jeff McLaughlin at Race Point Publishing for picking up the baton and making the transition so smooth, and Lesley Hodgson for her sterling picture research.

All of the sidebar contributors, including Allyn Gibson and Robert Greenberger whose pieces became subsumed in much larger chapters as the scope of their subjects became clearer during the writing process. We had the pleasure of working with all the writers during our time editing *Star Trek Magazine*, and it's been good to revisit those times.

Tolkien scholar Dr. Una McCormack, who graciously read through the manuscript for us and provided some very helpful notes.

Anne Lindsay, for her time discussing the musical requirements of the stage show of *The Lord of the Rings*, demonstrating the very unusual instruments she had to play, and providing photographs of them.

Ross Plesset for access to his interview with Rospo Pallenberg, and additional details on the abortive John Boorman movie of *The Lord of the Rings*.

Sammy Humphries at AudioGO UK for her assistance with the BBC Radio adaptations.

Michael Killgarriff for his time discussing his version of *The Hobbit*, and Michael Stevens and Kate Doyle for help arranging that interview.

Joel McCrary and Kelly Bashar for their time reliving *Fellowship!*

Adina Mihaela Roman and Patricia Hyde for their usual research help.

The staff of the Hassocks branch of the West Sussex library service, who once again demonstrated why we need to maintain publicly-funded libraries, locating out-of-print books that were hidden deep within the county system.

And last, but by no means least, Barbara Holroyd and Brigid Cherry for their support (and Paul's dogs Rani and Rodo for not interrupting our Skype discussions too loudly).

*Shire!*

# PICTURE CREDITS

**Prologue:**
p. 6: J.R.R. Tolkien © Haywood Magee/Getty Images
p. 8: J.R.R. Tolkien, 1940s © Time Life Pictures/Timepix/Getty Images
p. 9, left: The Sarehole Mill, England © John James / Alamy
p. 9, right: *The Red Fairy Book* courtesy of Roger Hucek
p. 10: C.S. Lewis, circa early 1960s/courtesy Everett Collection
p. 11: J.R.R. Tolkien in the woodlands © Snowdon/Camera Press Ltd
p. 12: J.R.R. Tolkien with wife, Edith © Pamela Chandler/ArenaPal/ The Image Works
p. 13: "Three is Company" © Anke Eissman
p. 15: Middle-earth map by Pauline Baynes © Bodleian Library, University of Oxford, 2013

**Chapter 1: Audio Adaptations**
p. 18: BBC composers and sound engineers © Chris Ware/Keystone Features/Hulton Archive/Getty Images
p. 20: Radio script © courtesy of Michael Kilgarriff
p. 21, left: Portrait of Michael Kilgarriff: © courtesy of Michael Kilgarriff
p. 21, right: Mind's Eye audio cassettes: Courtesy of AnnieBananniesShop
p. 22: reel to reel recorder © INTERFOTO / Alamy
p. 23: Argo Records LP version from the 45 year LP collection of Mike Pascuzzi (www.myartsdesire.etsy.com)
pp. 24-25: J.R.R. Tolkien © Haywood Magee /Getty Images
p. 25, right: Actor Nicol Williamson © J Twine / Associated Newspapers /Rex USA

**Chapter 2: Television Adaptations**
p. 26: *Jackanory* still © BBC Photo Library
p. 29: Selection of stills from the Russian TV adaptation © Channel 5, St Petersburg

**Chapter 3: *The Hobbit* on Stage**
p. 30: The Canadian Children's Opera Company © Michael Cooper Photographic
p. 32, left and middle: poster and letter from the New College School © New College School, Oxford
p. 32, bottom: Hobbits in Susan Holgersson's adaptation of *The Hobbit* © Susan Holgersson
p. 33: Gollum in Susan Holgersson's adaptation of *The Hobbit* © Susan Holgersson
p. 34, top: Elves in Susan Holgersson's adaptation of *The Hobbit* © Susan Holgersson

p. 34, bottom left and right: Finnish National Opera Ballet © Pate Pesonius/Finnish National Opera
p. 35: Canadian Children's Opera Company poster © Michael Cooper Photographic

**Chapter 4: Comics and Games**
p. 36: all images courtesy of TolkienBooks.net © IPC Media
pp. 38-39: "Riddles in the Dark" © David Wenzel. Produced by permission of HarperCollins*Publishers* Ltd
pp. 40-41: "The Hobbit" © David Wenzel. Produced by permission of HarperCollins*Publishers* Ltd
pp. 42-43: "The Hobbit Game" images reproduced with permission of Hasbro. 3D Board game photo: Michael Kröhnert
pp. 44-45: LEGO® product shots © LEGO®
p. 46: "The Hobbit Board Game" © from the board game published by Sophisticated Games Ltd under license from Middle-earth Enterprises
p. 47: The Royal Mail's 20p "Hobbit" stamp © Royal Mail

**Chapter 5: Audio Adaptations**
p. 50: BBC Broadcasting House © Allan Cash Picture Library / Alamy
p. 52: J.R.R. Tolkien © Haywood Magee/Getty Images
p. 53, top: Norman Shelley © Keystone/Getty Images
p. 53, bottom: Prunella Scales © Popperfoto/Getty Images
p. 54: Young David Hemmings © Denis De Marney/Hulton Archive/Getty Images
p. 55: Radio 4 dramatization of *The Lord of the Rings* © BBC Photo Library
p. 56: "The Ride of the Rohirrim" © Anke Eissman
p. 58: "Boromir" © Anke Eissman
pp. 60-61: "Departure of Boromir" © Anke Eissman, as used in Walking Tree Publishers's book, *The Broken Scythe*
p. 62: Ian Holm © Evening Standard/Getty Images
p. 63: *Radio Times* cover © Eric Fraser/ Courtesy Immediate Media Company

**Chapter 6: Television Adaptations**
pp. 64-67: Finnish television adaptation of *The Lord of the Rings* © Seppo Sarkkinen /Yle (Finnish Broadcasting Company)

**Chapter 7: The Lord of the Rings on Stage**
p. 70: Charles Ross peering through the Ring. Courtesy Charles Ross. The Lord of the Rings and the characters, items, events and places therein are trademarks or registered trademarks of The Saul Zaentz Company d/b/a Tolkien Enterprises. All rights reserved.

p. 72: Charles Ross holding a sword. Courtesy Charles Ross. The Lord of the Rings and the characters, items, events and places therein are trademarks or registered trademarks of The Saul Zaentz Company d/b/a Tolkien Enterprises. All rights reserved.

pp. 72-73: New Zealand landscape © Panoramic images/Getty Images

p. 75: *Fellowship!* © Blake Gardner

p. 76: Hobbit feet ©Julian Anderson / eyevine/ Redux

p. 77, top: London production of *The Lord of the Rings* © Graeme Robertson/Guardian/Eyevine/Redux

p. 77, middle: Frodo and Sam in the London production of *The Lord of the Rings* © Ilpo Musto/ Rex USA

P. 77, bottom: Cast members from the London production of *The Lord of the Rings* © AlamyCelebrity / Alamy

p. 78: Nyckelharpa © Lebrecht Music and Arts Photo Library / Alamy

pp. 80-81: *The Lord of the Rings* cast from the London stage production © Ilpo Musto/ Rex USA

p. 81, top: Sewing costumes for *The Lord of the Rings* London stage production © Julian Anderson / eyevine/ Redux

pp. 82-83: Make-up room backstage for *The Lord of the Rings* production in London © Graeme Robertson/Guardian/ Eyevine/Redux

## Chapter 8: Comics and Games

p. 84: "Like the Crash of Battering Rams" game card © 1996 Middle-earth Enterprises. All rights reserved.

p. 86: *Lord of the Rings* board game © from the board game published by Sophisticated Games Ltd under license from Middle-earth Enterprises

p. 87: *Trivial Pursuit* board game image supplied by John Laddomada. Reproduced with the permission of Hasbro

p. 88: Commodore 64 © INTERFOTO / Alamy

p. 89: "Gravehammer" - Vore CD Cover © Daarken

p. 90: "Shadow of Mordor" game card © 1996 Middle-earth Enterprises. All rights reserved.

p. 92: Sinclair ZX Spectrum © SSPL via Getty Images

p. 93: *War of the Ring* © From the game published by Sophisticated Games Ltd under license from Middle-earth Enterprises

pp. 94-95: "The Edge of the Wild" © John Howe/From the role-playing game *The One Ring*, published by Sophisticated Games Ltd under license from Middle-earth Enterprises

## Chapter 9: The Early Attempts to Film

p. 98: Forrest J. Ackerman © Araldo di Crollalanza/Rex USA

p. 100: "Shelob and Samwise" © Neil McClements

p. 101: Gutwillig's *The Fugitives*. All reasonable attempts have been made to contact the copyright holders of all images. You are invited to contact the publisher if your image was used without identification or acknowledgment.

p. 103, left: Portrait of Arthur Rackham © Chris Beetles Ltd, London/ The Bridgeman Art Library

p. 103, right: Arthur Rackham's illustration from the tale of "The White Snake"

p. 104: Arthur Rackham's illustration from the tale of "The Water of Life"

p. 105: "Gimli and Legolas" © Anke Eissman

pp. 106-107: "The Shire" © Roger Garland

p. 108: John Boorman © Steve Pyke/Hulton Archive/Getty Images

p. 109: "Gimli and Legolas" © John Howe. Produced by permission of HarperCollins*Publishers* Ltd

## Chapter 10: Animated Versions in the 1970s

p. 110: Black and white ink study of a Black Rider © Ian Miller

p. 111: Arthur Rankin and Jules Bass. All reasonable attempts have been made to contact the copyright holders of all images. You are invited to contact the publisher if your image was used without identification or acknowledgment.

p. 112: Still from *The Last Unicorn* © Pictorial Press Ltd / Alamy

p. 113, left: Still from *The Last Unicorn* © Pictorial Press Ltd / Alamy

p. 113, right: Arthur Rackham illustration

p. 116: Ralph Bakshi © Evelyn Floret/Time & Life Pictures/ Getty Images

p. 117: A variant of the Tolkien bestiary © Ian Miller

p. 118: "The Black Rider" © John Howe. Produced by permission of HarperCollins*Publishers* Ltd

## Chapter 11: Peter Jackson's *The Lord of the Rings*

p. 120: Prince Charles, Peter Jackson, and Peter Hambleton © Rex USA

p. 121: Peter Jackson action figure image reproduced with permission of Hasbro

p. 122, top left: *The Lord of the Rings* movie tie-in paperback image reproduced with permission of HarperCollinsPublishers Ltd

p. 122, bottom left: Peter Jackson directing Heavenly Creatures © Miramax/Everett/ Rex USA

pp. 122-123: Gollum sculpture © Hagen Hopkins/ Getty Images

pp. 124-125: Statues of Giants from *The Hobbit* © Albert L. Ortega/Getty Images

pp. 126-127: Richard Taylor, Peter Jackson, etc. © Universal/ Everett/ Rex USA

p. 128: Sir Ian McKellen © Bill Davila/FilmMagic/ Getty Images

p. 129: Sean Astin, Elijah Wood, Peter Jackson, Billy Boyd, and Dominic Monaghan © Frank Micelotta/Getty Images

pp. 130-131: William Kircher © Tim Rooke/ Rex USA

p. 132: Peter Owen and Peter King © SOUTH WEST NEWS SERVICE/Rex Features